THE COMPLETE IDIOT'S GUIDE® TO

Digital Video

by Karl Bardosh

ALPHA

A member of Penguin Group (USA) Inc.

ALPHA BOOKS

Published by the Penguin Group

Penguin Group (USA) Inc., 375 Hudson Street, New York, New York 10014, USA

Penguin Group (Canada), 90 Eglinton Avenue East, Suite 700, Toronto, Ontario M4P 2Y3, Canada (a division of Pearson Penguin Canada Inc.)

Penguin Books Ltd., 80 Strand, London WC2R 0RL, England

Penguin Ireland, 25 St. Stephen's Green, Dublin 2, Ireland (a division of Penguin Books Ltd.)

Penguin Group (Australia), 250 Camberwell Road, Camberwell, Victoria 3124, Australia (a division of Pearson Australia Group Pty. Ltd.)

Penguin Books India Pvt. Ltd., 11 Community Centre, Panchsheel Park, New Delhi—110 017, India

Penguin Group (NZ), 67 Apollo Drive, Rosedale, North Shore, Auckland 1311, New Zealand (a division of Pearson New Zealand Ltd.)

Penguin Books (South Africa) (Pty.) Ltd., 24 Sturdee Avenue, Rosebank, Johannesburg 2196, South Africa

Penguin Books Ltd., Registered Offices: 80 Strand, London WC2R 0RL, England

International Standard Book Number: 978-1-59257-613-5
Library of Congress Catalog Card Number: 2007928977

09 08 07 8 7 6 5 4 3 2 1

Interpretation of the printing code: The rightmost number of the first series of numbers is the year of the book's printing; the rightmost number of the second series of numbers is the number of the book's printing. For example, a printing code of 07-1 shows that the first printing occurred in 2007.

Printed in the United States of America

Note: This publication contains the opinions and ideas of its author. It is intended to provide helpful and informative material on the subject matter covered. It is sold with the understanding that the author and publisher are not engaged in rendering professional services in the book. If the reader requires personal assistance or advice, a competent professional should be consulted.

Most Alpha books are available at special quantity discounts for bulk purchases for sales promotions, premiums, fund-raising, or educational use. Special books, or book excerpts, can also be created to fit specific needs.

For details, write: Special Markets, Alpha Books, 375 Hudson Street, New York, NY 10014.

Publisher: *Marie Butler-Knight*
Editorial Director: *Mike Sanders*
Managing Editor: *Billy Fields*
Acquisitions Editor: *Michele Wells*
Senior Development Editor: *Phil Kitchel*
Senior Production Editor: *Jan Lynn*
Copy Editor: *Jeff Rose*

Cartoonist: *Shannon Wheeler*
Cover Designer: *Kurt Owens*
Book Designer: *Trina Wurst*
Indexer: *Angie Bess*
Layout: *Chad Dressler*
Proofreader: *Aaron Black*

Contents at a Glance

 *Discover how you can rival Disney Studio ... using just your
 desktop computer.*

19 Building Menus and Burning Your Movie to DVD 261
 *Learn how to use computer software for finalizing your digital
 videos on DVD.*

20 Presenting Your Video 273
 *Develop a distribution strategy for sharing your videos with
 friends and relatives or making them available to the entire
 world on the Internet.*

Appendixes

 A Glossary of Video Terms 279

 B Resources 285

 C Sample Contracts and Forms 289

 Index 295

Contents

13 The Production Environment

14 Sound—It's Not a Silent Movie

Introduction

I am proud to be a complete idiot. You see, there are plenty of plain idiots out there who are convinced that they have nothing more to learn because they already know everything. On the other hand, a complete idiot, even though he or she already knows quite a bit, always wants to know more. The complete idiot is distinguished by a yearning for lifelong learning.

I have been involved in the filmmaking process my entire life, starting out at the age of 12 as a child actor in feature films in Europe. My first film was entitled *Professor, Please*, foreshadowing the fact that thirty-some years later, following my educational careers at both New York University and the American Film Institute in Hollywood, I would end up as a professor of Film and Television.

During my professional journeys in the past three decades, which included making videos and films in India, Sweden, Hungary, and Brazil, just to name a few, I have had opportunities to observe and experience the emergence of digital video around the world. From a technological point of view, the process has been characterized by miniaturization, making the early bulky equipment smaller, lighter, and more portable.

Today we can shoot with lipstick-cameras, edit on cell phones, and carry our Personal Digital Assistant (PDA) in our pockets. It is a different life altogether. The great visionary of the coming of the digital age, Marshall McLuhan, taught us that new technologies are the extensions of the human senses, and therefore computers would become the extensions of the human central nervous system. And all the computers of the world united form a collective consciousness of everything the human race can know, which includes film, literature, music, television, and video—all in digital form. The Internet is a World Wide Web of the human consciousness.

The entire history of these new media has been a process of democratization—of taking filmmaking from the privileged few and placing the tools of audiovisual communication into the hands of everyday people, as well. The digital revolution is the final, decisive phase in this great opening up of the moviemaking process.

The most important development in today's world of film and television is that the traditional methods of filmmaking have been altered—and even replaced—by digital methods and software. Today, anyone equipped with a small digital video camera and a computer can create a digital video and present it to an audience of millions.

So with all this possibility, how can you know where to begin? Right here … with this book. It contains all you need to learn for practical applications of digital video, and provides an overview of the entire process, from finding and developing ideas through turning them into high-quality digital videos to sharing them with your audience at home, in screening venues, or on the Internet.

So, my dear fellow Complete Idiots, let's embark together on a journey to the ever-shifting world of digital video.

Part One, "Digital Video Basics," gives you an overview of what you need to prepare yourself to immediately go into production. The basic knowledge and equipment necessary to shoot and edit with an understanding of how lenses and lighting work and what legal aspects you need to be aware of.

Part Two, "Preproduction," deals with developing the most important elements for the production of your digital video: Writing the script, previsualizing your scenes, and getting the crew, the talent, and lighting equipment for the production.

Part Three, "Production," describes how the written material on paper gets turned into digital video. We focus on directing and the production environment, audio recording, and tips for digital videos of unscripted events.

Part Four, "Postproduction," explains the capturing and editing of digital video and audio, recording the final edited product on DVD, and different methods of sharing and distributing your digital videos.

Extras

You'll see many sidebars throughtout the book that offer you a little something extra. Here's what to look for:

def•i•ni•tion

These sidebars will define important terms as they are introduced in the text.

Zoom In

These sidebars will include quick tips for shooting and editing.

Quiet on the Set!

These sidebars will include warnings whenever danger is involved.

Karl's Tips

These sidebars give practical advice based on personal professional experience.

Acknowledgments

This book simply would not have been written without the encouragement and support of Alpha Books acquisitions editor Michele Wells. I am also indebted to our technical reviewer, Joseph Faria, and the entire editorial, design, and publishing team at Alpha Books. I wish to thank technical editor Bob Shell for his help with this project, as well.

No one writes a book in a vacuum. New York University's Kanbar Institute of Film and Television, my academic home away from home, has been my creative environment for the past 15 years, and I wish to thank my deans, my colleagues, and my students for the exceptional experience of learning while teaching. With former student Matthew Kliegman, I edited my recent digital feature film on Final Cut Pro, assisted by another former student, Jason Baum, who also helped me with some of the line drawings, photography, and visuals. I thank you both, and give special thanks to Prof. Ken Dancyger of NYU for his inspiration and support.

Another source of inspiration has been the great Oscar-winning cinematographer, Vilmos Zsigmond. Working with him was an experience that taught me lifelong lessons in filmmaking, and I am happy to share some of them with the readers of this book.

Thanks to the American Film Institute for jumpstarting my career in film and video decades ago, and for offering me an insight to Hollywood.

I am also grateful to Professor Sandeep Marwah, Director of the Asian Academy of Film and Television in Film City, India, for inviting me to deliver lectures and digital production workshops that also served as a basis for this book. Thanks to the faculty and the motivated students there, as well. Thanks to producer/writer Arnon Louiv Dantas for inviting me to direct *Out of Balance*, a full-length digital feature film, which I used as an example in several chapters. And special thanks to my friends Gabor Kindl and Laszlo Nagy for working with me on this feature film in Rio and Miami, and for repeatedly inviting me to be artistic director of DIGI24, the first digital filmmaking competition in the entire world for three-minute shorts shot and edited in 24 hours. My lectures and workshops at this digital competition have also helped develop parts of this book.

Many thanks to poet Sharon Esther Lampert for her patience and suggestions as I read aloud some of the more complicated sections of this book.

Also, thanks are in order to Jules Apatini Jr. for some of the photography and for the virtual sets, and to Edina Zsarnai for collaborating on our digital television news series that I also used as a source for this book. The author is obliged to Abel Cine Tech and Tamberelli Lighting for the access to camera support, lighting, and grip equipment.

And finally, a thank you to my wife, Zoi, for her patience; and a special thank you to Bela A. Kovacs for assisting me with most of the visuals for this book.

Special Thanks to the Technical Reviewer

The Complete Idiot's Guide to Digital Video was reviewed by an expert who double-checked the accuracy of what you'll learn here, to help us ensure that this book gives you everything you need to know about digital filmmaking and editing. Special thanks are extended to Joe Faria.

Trademarks

All terms mentioned in this book that are known to be or are suspected of being trademarks or service marks have been appropriately capitalized. Alpha Books and Penguin Group (USA) Inc. cannot attest to the accuracy of this information. Use of a term in this book should not be regarded as affecting the validity of any trademark or service mark.

Part 1

Digital Video Basics

Today, video has replaced the "home movies" of the past, and also formed an important medium of communication for current generations. People make videos to put on their websites, share via their digital cell phones, and just have fun with. Some get more serious and create longer projects, even full-length movies. What will you do with digital video? Read on …

The Digital Video Revolution

In This Chapter

◆ Everyone can be a digital moviemaker

◆ Recognizing your needs and knowing the technology

◆ Technology and specifications

A painter cannot create without paint and a way to apply that paint on the canvas. Similarly, the moviemaker (whether recreational or professional) cannot create without a camera. Today, with the widespread availability of digital technology, anyone can be a moviemaker.

In generations past, moviemakers had no choice but to work with difficult film. But the advent of digital technology gives everyone, regardless of skill level or budget, the ability to express cinematic ideas easily, quickly, and inexpensively. Today's digital moviemaker has a far larger arsenal of available tools than his or her predecessors did.

Why Digital Is Dominant

Unlike working with traditional film cameras, digital technology has the distinct advantage of being affordably malleable. In other words, digital technology is relatively cheap as well as easy to use, especially compared to film.

When you shoot a project on a digital camera, exactly what happens? You download it, scene by scene, onto your computer. Then you view it, edit out the kinks, edit in effects, and (perhaps) burn your creation to a CD or DVD whenever you're finished

Of course, you may end up deciding to skip burning a DVD altogether. After all, why sit through a lengthy burn when you can just send your video off for viewing via the Internet just moments after you've finished shooting it? And how much did this cost you, after the initial investment of purchasing the camera? Very little.

Film, by contrast, is a much more involved medium. There is no way to immediately review your work, see where you might improve a shot or a scene, and then rectify your errors before you repeat them. And that's because film, of course, must be processed in a lab before it can be viewed. Not only is the development and processing expensive, but the film itself is much pricier when compared to the more cost-effective methods of digital technology.

What this means to today's moviemaker is simple:

- The cost of film is often prohibitive, but ...

- The opportunity for growing and learning through the experience of filming is essential, so ...

- A great alternative is digital video. Plus, the process of filmmaking is far faster with digital technology.

What Is Digital Video?

Today, video replaces the "home movies" of the past, and also forms an important medium of communication for current generations. People make videos to put on their websites and share via their digital cell phones. Some also get more serious and create longer projects, even full-length "movies." Many aspire to create their projects and share them with the world on websites like YouTube.

Before You Buy ...

Now that you realize just how lucky you are to be living in the digital age, where you don't need to haul bulky cameras and film containers to your location just to capture a shot, let's get down to the fundamentals.

Did you ever hear the saying, "The right tool for the job makes the work easy"? The same holds true for choosing a camera. Because most video cameras are a significant financial investment, you want to make sure that your money is well spent. This means putting your dollars into a camera that meets your requirements, whether they are recreational, professional, or somewhere in-between.

Know Your Needs

Price is usually one of the best indicators as to what kind of camera you're looking for. In a perfect world, we could all afford the perfect camera for our needs. In the real world, however, we have budgets to stick to. And in the world of cameras, you will likely be looking for one of the following:

- ◆ **The home-use consumer.** These cameras are often at prices under $800, and are mainly for recreational use. More often than not, these are the cameras used for shooting family get-togethers, graduations, births, birthday parties, and the like.

- ◆ **The "prosumer."** These are cameras priced between $1,000 and $6,000, approximately. This equipment is a bit more expensive than cameras found at the consumer level, but nowhere near as pricey as the professional-grade cameras used in mainstream productions.

- ◆ **Professional.** Talk about a price jump. Professional-grade digital video cameras start anywhere from the $15,000 to the over $100,000 price range. These cameras are used for the production of feature films and professional television shows.

Thanks again to digital technology, however, it has been possible to make even feature films with prosumer cameras and then blow them up to 35mm film for theatrical distribution. The new crop of prosumer digital cameras, the so-called HDV cameras, may blur the line between prosumer and professional products. That's why, for example, most wedding videographers today shoot with HDV cameras.

Of course, you don't want to bankrupt yourself with the purchase of a camera. Choose a camera that you can comfortably afford, but literally hundreds of options are available, so list your wants and needs down on paper before you begin. That's better than just going out shopping and buying the one that "looks the best."

And keep in mind that home-use digital cameras have made significant technological advances in the past few years. Many are capable of producing almost professional-looking results. So while George Lucas isn't likely to be fooled by a home-camera video, the average viewer can't tell the difference between higher-quality digital and film.

After you've found your level, you can consider price in order to help narrow your options down further. And the specifications listing a little later in this chapter will help you to narrow your focus even more.

Karl's Tips

Most people stick with mid-range products unless they have a pressing professional need to upgrade to the highest-quality cameras, in which case it is still smarter to rent than to buy them. Going prosumer is actually a good way to shop, as most digital advancements are taking place at the prosumer, or mid-range, level of cameras.

Know the Technology

The line between home use and professional use blurs more and more as technology continues to improve. In other words, less expensive cameras are now capable of producing higher quality images, so take the time to carefully consider what you'll be using your camera for—or what you *might* be able to use it for if you understand its capabilities.

For example, *The Blair Witch Project* was shot using Hi-8 analog cameras, which would fall somewhere between the consumer and prosumer price range and were not even digital. The film itself is an example of pretty shaky camera work, yet still ended up fetching in some $300 million with world wide distribution, on a budget of $10,000. Keep in mind that a professional camera cannot be purchased for less than $15,000 (unless you get a killer deal on an eBay auction). A camera with that kind of price tag would have completely blown *The Blair Witch Project*'s budget to smithereens. Or, worse, it could have shelved the whole project entirely.

Zoom In

The makers of *The Blair Witch Project* were the first group to digitally market their product. Through a series of Internet stories, they were able to scare the public into believing that the story was true. People came to the theaters in droves to see the supposed "real-life" story unfold. The *Blair Witch* creators proved that, ultimately, content is king. No matter what level camera you choose, if your story is compelling enough, audiences all over the world will flock to see it.

Specifications and Technical Stuff

I know you want to jump right in and decide on a camera (and there's more on that in the next chapter), but first you need to understand just what you're looking at. Some of this information is a bit complicated, but it's important to make distinctions with the technical information so that you don't pay for extras you don't need. Because getting more than you need is, at times, just as bad as getting less than what you need.

Codecs: Digital Video Compression/Decompression Formats

Depending on how much data a format retains in a file, there are several different compression formats:

- DV (720×480) is used in MiniDV as interlaced scanning.

- 720p in progressive scanning is high definition.

- 1080i in interlaced scanning is also high definition.

- MPEG-1 (352×240 resolution) stands for Moving Picture Experts Group. It's the first approved codec used for video CD and the popular audio format MP3. It is often used for Internet applications because of its relatively small size, and another advantage of this codec is that almost all DVD players and computers can play it.

- MPEG-2 (480×480 compression) is mostly used for broadcast-quality television video and audio, as well as for high-quality DVDs. It is becoming somewhat out-of-date but is still widely accepted.

- MPEG-3 was DOA, as modified MPEG-2 proved sufficient for developing High Definition Television.

- MPEG-4/H.264 (also called AVC) is a new format gaining ground in high-definition recording as well as on Blu-Ray Discs and HD-DVDs.

- QuickTime was developed by Apple computers and widely used on the web as well for streaming video and audio.

- Audio Video Interleave (AVI) is Microsoft's most well-known and widespread codec. Because it does not work with the newly emerging High Def (H.264) formats, a new codec, WMV, was developed.

- Windows Media Video (WMV), Microsoft's codec and a variation of MPEG-4, has been used on all levels of compression from small sizes (100:1) for Internet use all the way up to high definition.

◆ Real Video/Audio, version 10, developed by Real Networks and requiring a downloadable RealPlayer, has been used for Internet applications.

Karl's Tips

If you've accumulated a library of precious memories on analog (such as VHS tapes of family events), you may want to consider purchasing some inexpensive analog-to-digital converters or capture cards to compress the videos on your computer's hard drive. You can then save them to an external hard drive for more secure storage (VHS tapes tend to deteriorate with time), and revisit them for editing in the future.

FireWire and USB

With a grain of salt, we might say that the entire digital revolution came down to us through the wire. And that wire is Apple's FireWire or the IEEE-1384 connection that is also called iLink by Sony. This cable connection delivers the digital video, audio, and *time code* from the camera to the computer, and vice versa. It makes it easy for us to move the digital video to a computer for editing and burning and ultimately, distributing.

From left to right, examples of FireWire, IEEE 1394 port, and USB cables.

FireWire

IEEE-1394

USB 2

def•i•ni•tion

The **time code** is the signal that is electronically and invisibly "stamped" on each frame of a digital video. It identifies each frame by hour, minute, second, and frame number, and is important in editing.

Another essential connector is Intel's USB 2, a Windows connector released to compete with FireWire. Do not purchase a camera or computer without one of these matching cable connections, or you will not be able to upload your movie to the computer for editing, storage, or burning.

Formats

Digital videos differ in the following ways depending on the tape recording format:

Digital8

This is a format by Sony, introduced at the end of the '90s with the intention to switch over from analog Hi-8 to digital without having to come out with a different tape cassette. Digital8 uses the same size cassette, except with a better quality (metal evaporated) coating. The tape inside the cassette is 8mm wide. Obviously, Sony designed this format to finish the job of eliminating 8mm and Super8mm film from the home movies market. Today, it is Digital8 that is being marginalized by the other DV formats, even though—contrary to popular belief—Digital8 is not inferior to the other DV formats, as both use the same DV codec.

DV

Three different types of DV formats exist. They are the MiniDV, offered by all major manufacturers; DVCAM by Sony; and DVCPRO by Panasonic. Only MiniDV is available in the consumer market; DVCAM and DVCPRO are professional digital video formats.

Canon and JVC MiniDV camcorders.

Sony DVCAM camcorder.

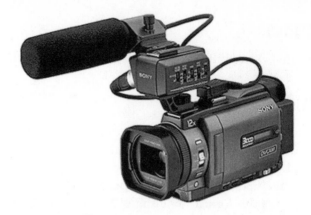

Panasonic DVCPRO camcorder.

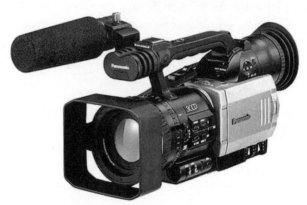

All of them use the same compression method, called DV25. This indicates a 5:1 compression at the data speed of 25 Mbps (megabites per second), which results in recording almost 5 minutes (4:40) per 1GB (gigabyte) of use. Their sampling rate is 4:1:1, meaning that the color is sampled once, while frame information for brightness is sampled four times.

HDV

To bring high definition to the consumer market, the Japanese giants of digital video formed a consortium and came up with an interim format that is positioned between true HDTV and the DV formats. Characterized by higher resolution recording either in 720p or in 1080i but still using DV25 (MiniDV tapes), the HDV format has been taking the consumer and the prosumer markets by storm.

 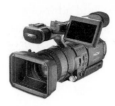

Examples of prosumer-level HDV camcorders.

The latest developments in inexpensive HDV cameras are available for the consumer market—practically for the same price as MiniDV camcorders.

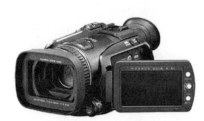 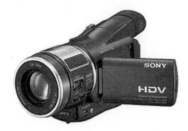

Examples of consumer-level HDV camcorders.

HDV 720p uses a resolution of 1280×720 square pixels. HDV 1080i uses a resolution of 1440×1080 pixels but is still displayed with an aspect ratio of 16:9 (like SD widescreen formats). Similar to film, HDV's optional recording modes in 24p simulate a film look for those who intend to transfer the final edit of the digital video to film. The introduction of solid-state recording on discs and cards represents the new wave in digital video's move toward a tapeless era.

Prosumer-level HDV camcorders may record on both cassettes and hard drives, or cards, simultaneously. The cassettes are used as a backup.

Two forms of storage: cassettes and hard drive.

So now that you understand a bit of the terminology, it's time to move on to choosing the right equipment for your digital video needs. Jump ahead to the next chapter and let's get started.

The Least You Need to Know

- Increases in technology and decreases in price have made it possible for anyone to make a movie with digital video equipment that can hold its own with today's big-budget films.

- Outlining your digital video needs, whether they are consumer level, prosumer level, or professional level, will help determine the level of equipment you buy.

- You don't need to break the bank with digital video equipment. If your material is compelling enough, people will want to watch it, regardless of the perceived level of quality.

2

Getting Equipped to Shoot Video

In This Chapter

- ◆ Choosing the right camera
- ◆ Tripods and other support options
- ◆ Digital video capture devices
- ◆ Media recording/storage options

Even if you have the wrong equipment, you might still be able to make lemonade from lemons, but you'd be better off to do some research in advance and buy the right tools. Time spent up front will make the rest of your work easier and eliminate a lot of frustration caused by trying to cobble together solutions. In short, any preparation now will save you money and much more time later.

The Important Decisions

When getting into digital video, you have three very important decisions to make. First, decide which *camera* you will use to shoot your raw video. This largely depends on what kind of videos you will shoot: family events strictly for home use or videos to be shown to the outside world.

def•i•ni•tion

Use the term **camera** when there is no recording unit attached to it, otherwise it's a "camcorder." This is because in the early days of video, recording systems used separate cameras and recorders linked by cable, and it was considered a great breakthrough when both were combined into one. Camera + recorder = camcorder.

Then you need to choose a computer that will serve you best during editing. Finally you need to decide which editing software to install on that computer. I cover selecting your computer in Chapter 4 and review many of the available software applications in Chapter 16. You will have many other choices to make, but these first three are crucial to your success as a video maker.

Your task before buying anything is to set a realistic budget for your video purchases. This is something of a balancing act, because it makes no sense to buy a top-of-the-line camera and couple it with a really cheap computer and software with limited capabilities. The reverse is also true, of course. It's reasonable to split your budget into about 30 percent for the camera, 30 percent for the computer, 20 percent for editing software, and 20 percent for all the accessories and odds and ends you'll need. This is only a rough guide, of course. Your individual needs and aspirations will alter these rough numbers for a perfect fit for you.

But for now let's talk about picking out your camera.

Camera Types and How to Choose the Right One

When you first begin looking at digital video cameras, you'll probably be intimidated by the sheer number and variety of brands and models on the market. Let's unravel that confusion by classifying cameras into basic groups. Because technology progresses so rapidly and new camera models are introduced frequently, we will not recommend specific camera brands/models.

Low-End Consumer Digital Video Cameras

I'll call the first group of cameras low-end digital video cameras. This price bracket includes still cameras that can also shoot video. These are the consumer cameras you will most likely find on display at your local mass merchandisers with camera departments, discount camera store chains, and electronics dealers. Prices will range from a few hundred dollars up to around $1,000. Generally speaking, the price determines the feature range.

Now many digital still cameras can also shoot short videos. If you just want to make short home movies to post on the Internet, one of these might be adequate, but the serious limitations on length and video quality make these cameras unsuited for any sort of serious video work. Recent developments added sound recording capabilities to these digital still cameras with "movie mode" features and the higher priced ones (between $400 to $600) can record images at 7 or even at 10 *Megapixel* quality.

All the cameras in the low-end category capture the video image on a single *CCD* sensor chip. This is one way that manufacturers reduce the price. CCDs are sensitive only to the range of brightness, and therefore, basically only capable of recording black and white images in their native form. To achieve color images, the CCD has a tricolor filter on its front surface with alternating areas of red, green, and blue filtration. This provides full color information for realistic color images, but reduces the resolution for each color. Image quality from some of these cameras is surprisingly good but will never achieve the quality of the next group of cameras.

CCDs vary in size and resolution. As with still cameras, larger size and higher resolution produces better image quality. Another image sensor that is regaining popularity with the new HDV format cameras is called CMOS (complementary metal oxide semiconductor). These were originally used not as imaging devices but as semiconductors in applications like portable computers. A CMOS works on the same principle as a CCD but with different technology. Because it is cheaper to manufacture, the CMOS has been one of the main reasons the price of digital cameras has come down.

def•i•ni•tion

A **Megapixel** is a resolution equal to one million pixels; the higher the number of pixels, the better the video quality.

def•i•ni•tion

CCD stands for *charge-coupled device*, a type of image sensor in which the light striking the individual sensor elements produces an electrical charge proportional to the brightness of the light. Attached amplifier circuits amplify those electrical charges and convert them to digital signals. The camera then processes the signals to reproduce images.

On the left is a CCD imaging device; on the right, a CMOS imaging device. They are amazing examples of modern electronic miniaturization.

Mid-Range Prosumer Cameras

Starting around $1,000 and going up to about $6,000 are the mid-range cameras, also called "prosumer" cameras. These cameras have better image quality, better lenses (often with greater zoom range), and are often housed in more rugged bodies. Many of these cameras are capable of producing fully professional video quality. Some prosumer cameras, such as the very popular Canon XL series, also offer the feature of interchangeable lenses—it's not just available in professional cameras.

Zoom In

HD or DV format? Most of the cameras you will encounter are designed for the DV format, also sometimes called SD. This is standard definition, the definition of ordinary television sets. But you've surely noticed the new type of television, the HDTV or high definition TV. HD digital video cameras are now available to match the higher resolution and wide screen of HDTV. The problem with HD at the time of writing is that no standard has been agreed to for HD DVD, so you can only show your HD videos by connecting your HD camera directly to an HDTV. Once a standard is agreed upon and HD DVD recorders and players become available, it will make much more sense to invest in an HD camera, and by then prices should have come down on those cameras as well.

Generally prosumer cameras are three-chip cameras. This means that they use three separate CCD or CMOS sensor chips, one for each color: red, green, and blue. This produces essentially three times the resolution of a single-chip camera, leading to sharper, crisper images.

High-End Professional Cameras

Most readers of this book probably will not need or have the budget for high-end cameras and the additional capabilities these expensive cameras offer. Starting at around $15,000 and going up from there, these cameras feature larger CCD or CMOS image chips for even better quality, metal alloy bodies, and lenses that are interchangeable, as with better still cameras. If you do both still and video work, you can sometimes mount your still camera lenses on these cameras. The downside to these cameras is size and weight, as well as the higher price tag.

Professional Features for Prosumers

If you are serious about your video, you will want professional quality even if you don't expect to be working in professional video production. So one of the new mid-range or prosumer cameras is probably the best choice for you.

Here are some features you will probably want for maximum versatility, all of which are explained in detail in later chapters:

◆ **Manual control of aperture and shutter speed:** In addition to any auto exposure modes the camera may have, look for one that allows manual control of the aperture and shutter speed.

◆ **Manual white balance control:** In addition to any auto white balance capability the camera may have, manual white balance control is preferred.

◆ **Manual focus:** Moving subjects are very difficult for automatic focus to lock onto, as auto focus always adjusts for whatever is closer to the lens. Nothing looks worse than a scene in which the camera is continually hunting back and forth for focus.

◆ **Direct digital output via FireWire (IEEE1394) port:** For fast and easy transfer of video to computer, FireWire is ideal. S-Video output is also useful if you expect to connect the camera directly to a TV, VCR, DVD recorder, and so on. (Sony calls FireWire iLink on their cameras.)

◆ **Foldout LCD monitor:** For easier work when the camera cannot be located at convenient eye level, the foldout LCD monitor is ideal—the larger, the better.

Many prosumer-level cameras do *not* come equipped with foldout LCD monitors, and shooting without one becomes extremely uncomfortable after a long period of time. However, you can purchase decent camera-mount LCD monitors, often in the $200-$400 range. Also, neither foldout nor camera-mount monitors should be relied on for color accuracy or precise framing, because all too often the monitor edges vary from those of the camera, and the picture will look different when imported and seen on an NTSC monitor. Foldout and on-camera monitors should only be used as a basic frame of reference while shooting.

Zoom In

If you do not have it factory installed, make sure to buy an external LCD monitor in the 3-4 inch range and attach it to your camera with a cable, as shooting without it may strain your eyes and will also limit your body and camera movements.

◆ **Broad zoom range on lens:** The more range you have, the more versatile the lens will be. A zoom range of 12X to 20X is very versatile.

◆ **Close focus lens attachment for "macro" capability:** This will allow you to take close ups of miniscule objects or details of any object within a few inches of distance.

◆ **Wireless remote control:** This is very useful if you like to put yourself in the action, and is also useful when using the camera as a VCR connected to a TV.

◆ **Battery packs:** Battery packs which charge quickly and can be changed easily in the field are a must-have. An AC power adapter is also very useful for indoor shooting.

Other Features

You will also see many other features touted in camera brochures and advertising. Some, such as in-camera editing capability and special effects, are rarely used by anyone who is going to do their video editing with a computer.

Video Storage Media

As an adjunct to learning about cameras so you can make an informed purchase, you also need to know how your camera records and stores digital video. Most cameras store the digital data on magnetic tape in cassettes. There are several common digital videotape formats.

MiniDV

The most common digital videotape format is MiniDV. Most of the digital video cameras you will encounter use this type of tape cassette. Typically these cameras will record one hour of video on each tape cassette. Some cameras let you record 90 minutes at slightly reduced image quality in an LP setting.

MicroMV

Some of the very small camcorders use MicroMV tape cassettes. The obvious advantage of the MicroMV tape cassette is its size, which allows the cameras to be smaller, but this comes with some serious drawbacks. Because MicroMV uses MPEG compression to

reduce the size of the image data, it also reduces overall image quality. A peculiarity of the MicroMV recording system also causes the camera to record a still image for several seconds every time you stop shooting. MicroMV video is also only compatible with Microsoft Windows, meaning that there is no practical way to import MicroMV videos into Macs.

Karl's Tips

Buying tape can be almost as confusing as buying your camera, because of the many brands and different grades of tape. Pick a name brand and buy the best quality from that brand. You can generally save money by buying your tape on the Internet from a mail-order company.

DVD

As well as cameras that record directly to tape, there are direct to DVD cameras. These record video onto miniature DVDs that are loaded directly into the camera. Like MicroMV, they use in-camera MPEG compression, which reduces image quality. The MPEG format they use cannot be directly imported into most editing software. These cameras are unsuited for serious video work as well.

There is also a new crop of HDV-DVD camcorders coming out that can make editing applications easier and raise these camcorders to a higher prosumer level. Check on the specs carefully to avoid the old systems.

Memory Card Storage

The tape drives used in digital video cameras that record to tape are complex, with many moving parts. They use a spinning video head that must be precisely regulated. This makes them somewhat delicate. We are now in the early stages of a transition to solid-state storage. As the price for many gigabytes of memory in the form of small CF, SD, XD, and other memory cards declines almost daily, solid state data storage is becoming practical. Just as future computers will most likely rely on flash memory and not have hard drives with moving parts, some high-end digital video applications now use storage cards, which in time will replace all tape cassettes.

This is already happening on the higher-end prosumer and professional levels. With the advent of the prosumer-level HDV cameras, both the specific HDV cassettes as well as storage cards and attachable portable hard drives have become available. Their price—of course—depends on the amount of video they can hold. The great advantage of the recordable hard drives is their ease of use in editing. You only need to connect them to your computer and start editing without having to transfer your footage into the computer. The future trend is definitely moving away from tape to hard disk recording. However, many of these cameras still run tapes as well, to provide safety backups.

No wonder that many of the big guys in Hollywood have already adapted this new method and keep their editors on the spot to put together a rough cut of the scene before leaving the location or striking the set.

Karl's Tips

Using a FireWire connection, you can transfer your video to your laptop computer's hard drive the same way you record to tape and start editing in between shooting. This way you will never leave a location without knowing that you have covered everything, and that what you have just shot will also edit well.

Here are some examples of portable digital video storage for location shooting. From left to right: MiniDV and HDV cassettes, a FireStore hard drive, and a P2 card.

How Digital Video Works in Basic Terms

In the beginning, television and then video were introduced as analog systems. Analog means that light gathered by the camera lens is converted into electricity (voltage) that is then amplified into the video signal. This takes place through scanning the reflected light off the subject on the face of the imaging device inside the video camera.

This scanning (reading) of the light is done by an electron gun that sprays a beam at the back of the photosensitive cells of the imaging device. The scanning—like reading—moves the beam line by line from the upper left corner to the lower right corner.

In the NTSC (National Television Systems Committee) system that prevails in the United States, 525 scanning lines appear in each frame of a shot and 30 frames appear per second. Each frame is then made up by two fields, $262\frac{1}{2}$ lines of each, and by interlacing they form a frame. Hence the letter (i) after the number of frames per second shows the recording format. Because a frame contains two fields, the 60i format records 60 fields, or 30 frames per second for standard television in the United States.

A marriage between analog video and the computer gave birth to digital video. "Digital" means that an analog signal is converted into a series of binary numbers: zeros and ones. In digital cameras, this is facilitated by an analog-to-digital converter (ADC) that turns the electronic signals of the imaging devices (CCDs) into sets of binary numbers and reconverts them for playback by a DAC—a digital to analog converter.

Compression

Compression reduces the digital video information to a mathematical representation of the original voltage by taking samples from the original analog signal and compressing them into digital formats and vice versa. The set of numbers indicate how frequently the samples are taken to represent the original. Each time a sample is taken, it actually consists of smaller units (like 8 bits) forming a larger unit (like a byte).

Obviously, the higher the sampling rate the higher the quality—but the higher the size of the data, as well. Higher size necessitates compression of the data, meaning that certain elements of the original information will be omitted, preferably without much loss of quality. This is called *compression*. A lossless system works when you do not want to lose any data, but unlike compression, it requires a very high storage capacity system.

Very high-level professional digital video is lossless. Lower priced systems all use some kind of "lossy compression," where certain information that is constant from frame to frame would be taken for granted using perhaps only one time reference instead of

def•i•ni•tion

Compression is the process of reducing the number of bytes required to store or transmit data.

repeating that data on each digital frame. (For example, a shot of the bride in a glowing white dress. The white of the dress is unlikely to change during that shot, so it's not important to repeat that information in every single frame.)

Resolution

Image quality ultimately depends on resolution of the picture. Vertical resolution means the number of scanning lines per frame and, as I pointed out, the NTSC system has 525 lines in a frame but only about 480 are visible inside the picture frame. On the other hand, horizontal resolution means the number of dots (pixels) per line next to each other. In NTSC, we have 440 dots per line, so the picture resolution is about 480×440.

World Standards

NTSC or PAL? Or SECAM? You will find these mentioned in camera specifications, but what are they? Video is transferred to your TV in one of two formats depending on where you live. In the United States, we use the NTSC (National Television Systems Committee) format. Much of Europe and Asia uses the PAL (Phase Alternating Line) format. PAL runs at 25 fps. SECAM (Sequential Color with Memory) was also introduced in Europe by the French and was adopted by Russia and her satellite countries in Eastern Europe, but has been co-existing with and gradually getting replaced by the PAL system.

If you are planning to import your video into a computer for editing, it won't matter which setting you use in most cases, because the editing software detects which one your camcorder is outputting and adjusts itself accordingly. However if you intend to connect your camera directly to a TV, VCR, or DVD recorder, you need the correct camcorder for the standard used in your country. Dividing the Hertz of the electricity by two is the easiest way to tell which one of these world standards is used in a country. We have a 60Hz cycle in the United States, divided by 2 gives us 30, the frames per second in NTSC video. In Europe you need to divide 50Hz cycles by 2, which would yield 25 frames per second, the standard in PAL systems.

The newest trend in digital video is that you can actually switch between NTSC and PAL system recordings on your camcorder depending on which system you want to use.

Necessary Accessories

You can do a lot with most digital video cameras right out of the box, but you'll most likely want to add some accessories to enhance your versatility. Most video stores and catalogs are full of accessories, many of them not necessary for basic operations, but we consider some accessories essential to successful digital video shooting.

Tripods and Other Visible Means of Support

Your most important accessory will be a tripod. You might think you can hand-hold everything, particularly with a modern camera featuring image stabilization, but you will quickly learn that this is not the case. You want a tall, sturdy, lightweight tripod, and it's important that it have a fluid head that makes smooth camera movements possible.

Zoom In _____

One of the most exciting bits of new technology that has improved video quality is image stabilization. Different manufacturers have different types, but essentially it works in one of two ways. Optical image stabilization uses sensors that detect camera shake and move optical components within the lens to compensate. Electronic image stabilization also uses sensors to detect camera motion, but compensates by electronically "moving" the image in the opposite direction on the surface of the image sensors. Both work, but I have found that optical stabilization produces better video quality.

Some experts feel that the best tripods have wooden legs because wood absorbs vibration. Others favor tripods with legs made from metal, carbon fiber, or other composite materials.

The tripod head goes between the tripod and camera, and allows pan and tilt movements. For best results in video work, you should have a tripod head made for video, and if you plan to do much panning during sequences, you may want to get what is called a fluid head, which has a thick fluid inside to smooth out movements and produce smooth pans.

When buying a tripod and head, don't skimp. You don't need to spend thousands of dollars, but a really good tripod will cost over $100 and a good fluid head will cost several hundred at minimum.

Example of a video tripod with a simple fluid head.

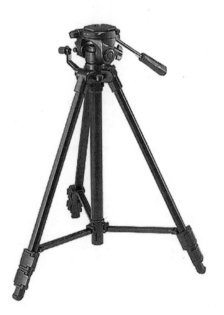

Karl's Tips

Sometimes an inexpensive monopod can do the job when shooting alone. Other times, you can get a wheelchair and, with some assistance, you may perform Hollywood-level camera movements: dollying in and out on a subject.

Many alternatives to tripods exist for camera stability, including some creative on-the-fly solutions. You can buy devices to mount your camera on a partially open car window, car hood, or fender; or clamps that let you mount it on a tree, tree branch, fence, wall, or just about any other convenient support. You can also buy steadicam devices that mount the camera on your body so you can shoot video as you walk, climb, run, and so on. With some photographer's clamps and a few rolls of gaffer's tape, you can improvise camera mounting in a wide variety of locations.

An example of a monopod—a camera support which is more flexible and portable than a tripod. Some can even fit into a woman's handbag.

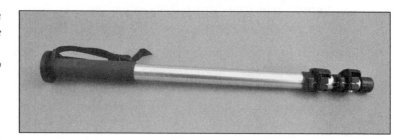

Alternatives to Tripods

One of the most inventive and least expensive camera supports is the CineSaddle, which looks like a sandbag but is actually stuffed with balls of foam that absorb tremble. With attachments provided by the manufacturer, you can easily rig it up practically anywhere, even on the hood of your car.

Due to their size and versatility, CineSaddles may out-perform tripods in many applications, especially when the camera must be attached to moving objects. In ground-level shots, CineSaddles provide an alternative to the special close to the ground tripods, called Hi-Hats.

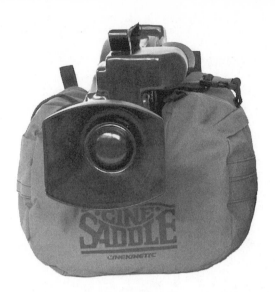

A CineSaddle, which is an alternative camcorder support.

Two giants of the movie industry, Tiffen, the well-known manufacturer of lens filters, and Garrett Brown, the inventor of the Steadicam teamed up to market Merlin, the prosumer camera's Steadicam, replacing an earlier version called Steadicam JR. With this simple yet sophisticated camera support device you may run, walk up and down stairs, or ride in the back of a car and the camera shots will stay smooth and steady.

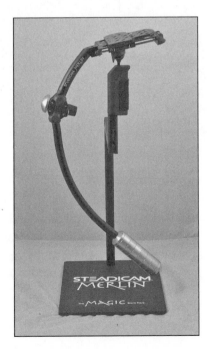

A Merlin, designed by Garrett Brown, is used for the smoothest handheld shooting possible.

Considering that the full-fledged Steadicam costs many thousands of dollars and requires a certified operator, less expensive variations of the full Steadicam have also become available. One of the best known is the GlideCam.

The Oscar-nominated filmmaker, Mike Figgis (*Leaving Las Vegas*) has also designed a wheel-shaped camera support for handheld shooting, aptly named the Fig Rig. By securing the camera in the middle of a steering wheel like device, moving the camera feels almost like driving a car.

This steering wheel–shaped Fig Rig was designed by Mike Figgis for improved flexibility in handheld shooting.

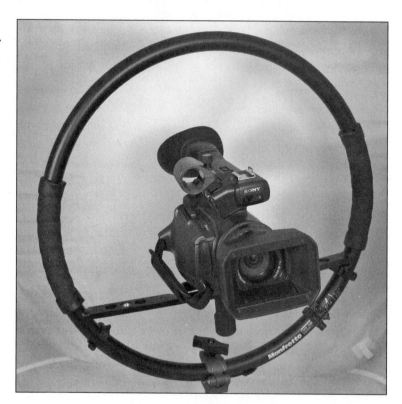

For high angle movements, which are a must for shooting above the heads of a crowd, lightweight versions of *jibs* have been designed. Some are even attachable to tripods. While professional jib operators work with remote controls and monitors, prosumers can monitor their shots by attaching their tiny digital cameras to the tip of a lightweight jib and running a cable from the video-out plug of the camera to a small TV set.

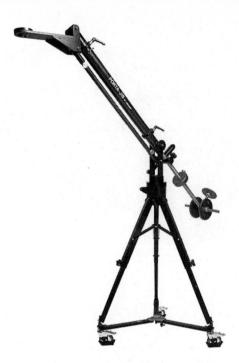

This mini-jib, which is very lightweight and inexpensive, can be used for low- to high-angle moving shots.

def•i•ni•tion

A **jib** is a crane-like device with a camera mounted on one end. It's counterbalanced by a weight on the other, and the camera is operated by controls set up on the weighted end.

Other Accessories

Of course, you need some other accessories before you can make full use of your video camera.

Lens Hood

No matter what camera you end up with, you will absolutely need a proper lens hood. This blocks out stray light, which can reduce overall contrast and produces unintended lens flare and hot spots in your images. Many good digital video cameras come with hoods, but for some they are sold as extra accessories.

This lens hood protects the camcorder's lens from flare (extraneous light).

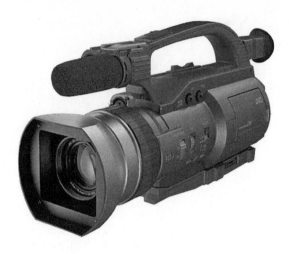

Lens Filters

You may want to buy some lens filters to produce specific effects.

White-Balance Card

For manual white-balance setting, you will need to have a white-balance card in your camera bag. You can use the white side of a Kodak Gray Card, the industry standard for many years. For more variety in white-balance settings, a set of Warmcards in the camera bag is very useful. See Chapter 11 for more detail on white balance.

Battery Options

Some camera makers offer battery options for their cameras in the form of different batteries with different capacities. It's a good idea to have a few one-hour batteries in the camera bag along with a couple of the three-hour batteries. This will allow you to be prepared for almost any eventuality. An AC adapter normally comes with your camera; if not, you may want to buy one. When working indoors, it is often convenient to just plug into a wall socket and forego the battery altogether. Luckily, each time you use the AC adapter, you automatically recharge the battery attached to your camera as well.

Other Useful Kits

Other useful kits for your camera bag include a good blower brush for getting dust off all parts of the camera, a pack of lens cleaning tissue or a microfiber cloth for cleaning the lens, and a bottle of lens-cleaning fluid for the stuff that just won't come off with anything else. A small flashlight is handy for looking at camera settings in dim places. It's also not a bad idea to slip the camera instruction manual into a pocket of the camera bag, because you may forget how to access and operate seldom-used features of your camera.

The Least You Need to Know

- Match the camera you buy to your budget, but try to make sure it will have at least the features you really need.

- Always use the same brand and grade of tape, disk, or memory card—and keep plenty on hand.

- For top quality video, choose a higher-end prosumer HDV camcorder with near professional features.

- Make sure you have a good tripod and head for sturdy camera support, but don't ignore alternative ways of supporting your camera.

Lenses

In This Chapter

- ◆ Learning what a lens is
- ◆ Understanding how to extend your vision with lenses
- ◆ Knowing the difference between prime lenses and zoom lenses
- ◆ "Digital zoom" and its uses

Because light is gathered by the lens before it enters into the camera, the lens is the next most important link in the chain between optical image and video. The choice of lens therefore makes all the difference in the world in the look of your video.

What Is a Lens?

A lens is defined as a transparent object that gathers and refracts light. Refracting light is "bending" it, changing its course. The lenses we use in photography and video refract light toward their centers, which allows them to form a focusable image.

There is a simple way to observe refraction. Next time you go out to eat and order a drink, look at how the plastic straw seems to be "broken" where it enters the liquid. This is an optical illusion created by the light

def•i•ni•tion

Optical glass is very different from ordinary glass. It is made in the same way, by melting sand, but optical glass formulas add other substances to alter the refractive index (a measure of how much the glass bends light) and other characteristics.

bending (refracting) upon entering another medium, the liquid. This phenomenon serves as one of the main factors for optical scientists to design and grind lenses.

Most lenses today are made of *optical glass* or optical resin (plastic). The simplest lens has a convex curve on one side and is flat on the other. Most simple lenses, such as magnifying glasses, are convex on both sides (biconvex). If you've ever used a magnifying glass to burn something by focusing the rays of the sun, you have demonstrated what makes a lens useful: its ability to bend light and bring the rays to common focus.

The straw in this glass seems to be broken because the light entering the liquid is refracted, or bent.

Basic Optical Terminology

You don't need to be an optical scientist to make proper use of your lenses, but you do need to have a basic understanding of optics. The more optical principles you understand the more you can make use of them in your video making.

Focal Length

The focal length of a simple lens is the distance from the center of the lens to the focused image when that image is at infinity (defined as 20 times the focal length or

more). So if you take a magnifying glass and focus the image of a distant mountain onto a piece of paper, the distance from the center of that lens to the paper will be the focal length of the lens.

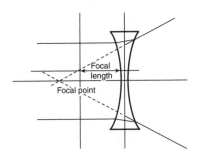
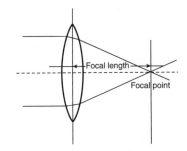

These illustrations show the focal length and focal point of concave (left) and convex (right) lenses.

Finding the focal length becomes a bit more complicated with complex lenses, composed of multiple optical elements. The point from which we would measure is not in the middle of any of those elements, but is a virtual point from which the rays emerging from the lens all seem to emanate.

You may be wondering why you would need multiple lens elements in a camera lens if a simple lens can bring an image into focus. The problem is that simple lenses have what are called *aberrations*. Many different aberrations exist, but the most important one is spherical aberration. Simple lenses have convex surfaces that are part of a sphere. Such lenses can only focus all parts of an image on a curved surface, like the retina in our eyes. A simple lens cannot focus all parts of the image on a flat plane, like film or an imaging sensor. If you get the center in focus, the outer parts will be out of focus, and vice versa. A lens with more than one piece of glass can control spherical aberration.

Elements of lenses that are used together in the design of photographic lenses.

Biconvex Plano-convex Convex concave Meniscus Plano-concave Biconcave

Chromatic aberration is a rainbow-like color fringe in the image caused by a simple lens. This is what you may see while looking at your family photo album with a magnifying glass. These lenses are good enough for applications like photocopy machines,

where the color fringe will not show up on the paper copies, but they are not good enough for the higher quality optical reproduction of images required in videography.

To cancel out optical aberrations and produce high quality images, you need to use several optical elements together, called *lens elements.* That is why photographic lenses are arranged in a tube. Modern lenses have multiple elements so that spherical and other optical aberrations can cancel out. This book can't go into detail about optical aberrations, but if you are interested you can find detailed information in just about any textbook on optics.

Illustration of a modern photographic lens, showing the multiple lens elements. The light converges at the imaging device (CCD).

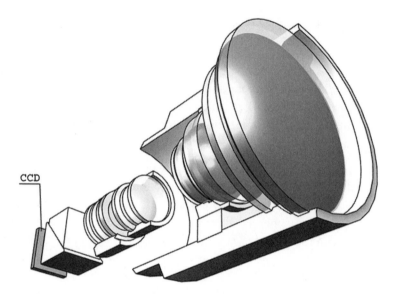

CCD

Cleaning Your Lens

Always protect your lens with a lens cap when not in use. No matter how careful you are, you will get dust and dirt on the front of your lens. Optical glass is typically much softer than ordinary glass and more easily scratched. Camera lenses have protective coatings applied to the glass surfaces to make the glass tougher and to cut down on reflections.

That is why people often use UV filters. These are not only for filtering out the ultra-violet rays; they are also used for protecting the lens. And they're extremely cheap!

Because of the softer glass and the risk of damaging coatings, you must clean lenses carefully. Cleaning the lens too often, however, risks scratching it. A small amount of dust on your lens will do no harm, so don't become obsessive about lens cleaning.

Most of the time, you can clean your lens with nothing other than a soft "camel hair" lens brush. Some prefer to use a blower brush, a combination of air blower and brush. The correct way to do this is with the lens pointing down so that the dust will fall and not go right back onto the lens. You really only need to use liquid lens cleaner when you have something too stubborn to come off with a puff of air or gentle brushing. If you must use liquid lens cleaner, use it very sparingly, applied to lens cleaning tissue. Clean in an outward spiral, starting in the center of the lens. Any good camera shop will carry lens cleaning supplies.

Aperture, or F-Stop—How Fast is Your Lens?

The lens aperture is the opening and closing diaphragm behind the lens that controls how much light passes through the lens. Just like the pupil of your eye, it needs to be opened wider in dim light and contracted in brighter light, so that a constant level of light reaches the image sensor for proper exposure.

The size of the aperture is the f-stop, a ratio of the diameter of the opening to the focal length of the lens. For example, if the focal length of the lens is 50mm and the diameter of the opening is 25mm, the lens f-stop is 1:2 or $\frac{1}{2}$, normally expressed as f/2. The numerator of the fraction is omitted for the sake of brevity. So when you see f-stops like f/4, f/5.6, f/8, these actually represent $\frac{1}{4}$, $\frac{1}{5.6}$, and $\frac{1}{8}$ respectively.

Normally, each change in f-stop on a lens will either double or cut in half the amount of light passing through the lens. The progression of full f-stops runs like this: 1.0, 1.4, 2.0, 4.0, 5.6, 8, 11, 16, 22, 32, and so on.

Going from f/1.4 to f/2.0 cuts the amount of light exactly in half. Going from f/5.6 to f/4.0 doubles the amount of light.

What about odd apertures you sometimes see, such as f/1.2, f/1.7, and so on? These are points in between the full f-stops. F/1.2 is in between f/1.0 and f/1.4, and f/1.7 is in between f/1.4 and f/2.0.

Lenses with lower f-stop numbers as their widest apertures, such as lenses with f/1.2, are called fast lenses. Lenses with higher numbers as their widest apertures are called slow lenses. Slow lenses may produce sharper images, but are ill suited to working in dim light.

Lenses under f/2.0 are also referred to as XL (existing light) lenses, as you may shoot with them under dim lights without additional lighting. This clearly shows the relationship between f-stops and focal lengths. With lower light, wider aperture and shorter focal lengths are needed. With more light, like bright sunlight, smaller

aperture and longer focal lengths are required. If you have too much light, you may have to switch on the neutral density (ND)-filters that act as windows, cutting down the amount of overall light going through the lens.

Diagram showing lens apertures—how the diaphragm opening changes according to different f-stops to let varying amounts of light through the lens. It should be noted, however, that the option to change f-stops manually is available only on semi-professional MiniDV and HDV camcorders.

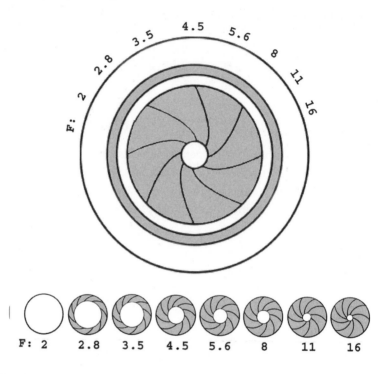

The Difference Between F-Stop and T-Stop

Although you won't see it as often today, you still may come across the term t-stop. The mathematically calculated f-stop assumes 100 percent transmission of light through the lens elements. In an ideal world this would be true, but in the real world, a small amount of light is lost through reflection each time the light passes into a lens element. Lens elements also absorb some light, although this is typically minimal. In a simple lens with only a few elements, the amount of loss is negligible, but in a complex lens with many elements—some modern lenses have more than 20—the small light loss at each element can make a real difference.

The t-stop stands for transmission stop and is a measurement of the amount of light that actually gets through the lens. A lens marked in t-stops will give a much more accurate exposure when used with an external light meter. Because almost all video cameras today have built in TTL (through-the-lens) light metering, the loss of light is

automatically compensated for, but you may need to take it into account when using a hand light meter.

Selecting the Right Lens(es) for Your Video Project

Why does all of this optical stuff matter to you as a video maker? If your video camera has a permanently attached lens, it may not, because you can't take off the lens and put on a different one. But some of the high-end video cameras do have interchangeable lenses and provide you with far greater versatility.

The most important thing you can change with interchangeable lenses is the angle of view. If you've ever worked with a 35mm still camera you are probably familiar with the concept of a "normal lens." A normal lens is one that renders an image field of view similar to what we see with our eyes.

Zoom In

Perspective is how distant objects are rendered with respect to closer objects. Many people think that changing lenses also changes perspective, but only the distance to the subject controls perspective. People think lenses alter perspective because they tend to move closer to the subject when using wide-angle lenses and farther away when using telephotos. If you make two still images from the exact same spot, one with a wide-angle and one with a telephoto, and enlarge just the part of the wide-angle shot that is covered in the telephoto shot, they will match perfectly in perspective.

Sensors used on digital video cameras are much smaller, of course. This smaller image size gives us normal lenses in the 7 to 12mm range. Anything with a shorter focal length is considered a wide-angle lens, while anything longer is considered a telephoto.

If you want to shoot a lot of video in very dim light without building up a lot of image noise, you might want a faster lens. If you need to use a lot of extreme close-ups of tiny objects, you may want to put a macro lens onto your camera.

If you do still photography on film or with a digital SLR camera and already own a

Zoom In

The first prosumer level camera with interchangeable lenses was the Canon XL1 in 1997, but even today only higher level HDV prosumer and professional cameras offer these features. Most consumer and prosumer cameras come with a single, built-in zoom lens only.

selection of lenses, you can use these lenses with some digital video cameras via an adapter.

If you can't change the lens on your video camera and you need a wider angle or a telephoto effect, you can screw modifier lenses onto the front of your existing lens. The cheap ones will usually cause considerable degradation of image quality, but the better ones—like those from Century Precision Optics—are fully professional equipment and will produce excellent image quality.

An example of a wide-angle converter, which provides a wider shot than the standard camcorder's zoom lens can offer.

What Is a Zoom Lens?

In the early days of cinematography and television, the only way to change the angle of view was to change to a different lens on the camera. Three or four lenses were placed on a turret plate on the frontal face of the camera and had to be manually dialed in to the front of the opening to change the angle of view. All disposable still cameras and even some video cameras sold today offer a single, fixed focal length with a fixed angle of view. Obviously this is not ideal, because you can't change focal length while shooting, which is essential in controlling the image.

In the 1930s, several optical designers were working on a lens that could change focal length by moving elements internally. The first practical lens of this type was made by Carl Zeiss in Jena, Germany, and used by Leni Riefenstahl to film the 1936 Olympics. These first variable focal length lenses were enormous, very expensive, and optically not as good as fixed focal length, or prime, lenses.

After WWII, development on such lenses progressed rapidly. By then they were being called zoom lenses, and they've become standard today. The greater the zoom range,

the difference between the minimum and maximum focal lengths, the more versatile the lens will be. Keep this in mind when looking at cameras. Also, make sure that the short end of the zoom range is actually wide angle, because you will probably do a lot of your video shooting in the wide-angle range. A lens that requires you to screw on an attachment to go wide will be very frustrating.

Zoom In

The origin of the name zoom lens is not really known for certain, but many believe it came from the German name *gummilens* (pronounced goomy-lens), meaning "rubber lens," for its stretchable focal length.

Optical Zoom vs. "Digital Zoom"

Optical zoom is "real zoom," accomplished within the lens. You'll often see "digital zoom" listed in the specifications of cameras, but this isn't a real zoom at all. Digital zoom systems just crop to a smaller area of the image. This fills the frame with fewer pixels and produces images of lesser quality. Avoid using digital zoom unless absolutely necessary. If you need more reach than your lens can give, you'll be better served by adding an optical telephoto attachment to the front of your lens.

Digital Lenses

Digital lenses are lenses specifically designed for digital imaging systems. The requirements for film imaging and digital imaging are similar but not identical, so video cameras are fitted with digital lenses. Digital lenses take into account the spectral sensitivity differences between film and digital image sensors. Lens coatings are also optimized for the requirements of digital image sensors. If you're able to use still camera lenses on your video camera, make tests with each lens before shooting anything important, to make sure the lens is capable of producing professional image quality.

In particular look for *color fringing*, which would indicate under-correction for spherical and other aberrations. A good test is to shoot some footage of bare tree branches against a blue sky, because the small branches will clearly show color fringing if it is present.

def•i•ni•tion

Color fringing occurs when bands of light appear at the curvature of a lens as a result of chromatic aberration.

Reading the Specs

It is very important to read and understand all the optical and performance characteristics engraved on the lenses. The lowest f-stop marked on the lens is the widest possible lens opening. The *zoom range* indicates the shortest focal length (the widest angle of view) and the longest focal length (the most narrow angle of view) of the given zoom lens. The *optical zoom ratio* is the difference between these two extremes; for example, a 10-100mm zoom lens's ratio is 10:1 meaning that the telephoto position (zoomed in all way) provides 10 times the optical magnification of an image as a shot taken at the widest zoom-out position.

On professional lenses there are markings both on the focus and on the f-stop (iris) rings of the lens. These are the f-stop numbers between the highest and the lowest one of the particular lens. There is an inverse relationship between the f-stop number and the amount of light going through the lens. The higher the f-stop number, the smaller the opening of the lens's diaphragm is and the less light will go through the lens and vice versa.

The focus ring shows the object-to-lens distance in two sets of numbers both in feet and in meters. It is very important to understand the object-to-lens minimum distance requirement, within which it is not possible to focus: usually about three feet. Shorter distances require a "macro" feature, which most higher end zoom lenses do provide. In the macro mode operation, the zoom lever operates the focus ring.

Focus Pocus—Working with Lenses

In the world of digital video, we are constantly cheating by creating optical illusions, rendering reality in carefully distorted images. And most of this trickery is done by the skillful use of lenses. No wonder professional videographers and directors are obsessed with different lenses.

As I said, before you purchase a camera, you must understand the "specs" engraved on the lens. The first consideration is whether it is a fixed or an interchangeable lens camera. Most consumer and prosumer level cameras do not allow you to change your lenses. The option of interchanging lenses is the hallmark of professional cameras.

Why is this so important? You will quickly understand if you try to take a shot in a tight room, let's say in your bathroom, and the lens doesn't give you a wide enough angle to show the entire room. This is called *horizontal angle of coverage*, related to the focal length of your lens. The shorter the focal length, the wider the area it can show.

Professionals go out on location scouting with a "director's viewfinder," a zoom lens without a camera. They use this to find out in advance what lenses they will need to cover a scene and avoid the surprise of not being able to show a narrow bathroom or prison cell.

Most consumer and prosumer cameras use lens extensions that you can screw on your built-in zoom to change its focal length to wide or narrow angle.

Karl's Tips

Here is a playful way to find out the angle of view (the horizontal angle of coverage) of the lenses of our own eyes. Take a short break from reading this book and stretch. Extend your arms in front of you and look at the tip of your forefingers. Now stretch your arms pulling them back 180 degrees to align them with your shoulders while still staring forward without blinking or moving your eyes. You can probably still see the tips of your fingers, which means the horizontal angle of coverage of your eyes is about 180 degrees.

Insects and fish can see behind themselves up to 270 or even 360 degrees, hence we call extreme wide angle lenses "fish eye" lenses. They have very short focal lenses under 6mm, typically 5.9mm or 5.6mm lenses in the 16mm lens format. Although these lenses can show an extremely wide area of coverage they also distort the lines of perspective. Once I shot a commercial that called for a helicopter shot over New York. Using a 5.6 fish eye lens, I turned the entire island of Manhattan into a ball.

The proper use of lenses obviously has a great stylistic and even psychological impact on the viewer. For example, the extreme wide angle lenses with virtual distortion of the lines of perspective have been used by horror filmmakers to create unexpected, surprising visuals. The same is true for crime dramas where suspense is created by extreme wide angle lenses. Think of the famous murder scene in Hitchcock's *Psycho* and other dramas.

On the other hand, telephoto lenses have long focal lengths and narrow angles of view. They start around 75mm in the 16mm format. Opposite to wide angle lenses, these seem to compress the lines of perspective—so much so that very long telephoto lenses can virtually slow down the head-on movement of subjects.

An extreme example of this was in a short feature I directed at AFI in Hollywood that was photographed by one of the greatest cinematographers of all time, Oscar-winner Vilmos Zsigmond. The scene was about a middle-aged female teacher, played by the wonderful Oscar nominated actress, Lynn Carlin, who suffers a heat stroke driving through the Mojave Desert in her convertible car. Shooting the car driving head on

toward a 1000mm extreme telephoto lens in the 35mm Panavision format, Vilmos Zsigmond compressed the perspectives so much that the car not only seemed to be moving in slow motion but the hot air around it seemed to be waving, creating a sense of heat waves enveloping the teacher driving the car.

Depth of Field

The shot of the car taken by an extreme telephoto lens was also extremely difficult to focus because it had a very shallow depth of field. Depth of field (DOF) is the distance within which everything (all objects and subjects) is in acceptable focus.

How many different focuses can we find? Is it better to have everything in sharp focus from the camera to infinity? The tiny, built-in lenses of disposable still cameras keep everything in focus, but that also means we cannot control what could be in focus and what could be out focus. It's much better for shooting a video if some things can be left out of focus and we only focus on things or subjects we want to be in focus. This is called "selective focus," and it can be done by manipulating the DOF. It's like framing, where we keep things not essential out of the frame.

F-Stop and DOF

The more light coming through the lens, the larger the DOF. In bright sunlight, we have to choose a larger f-stop—a narrower circle of the aperture—because there is too much light. Overcast weather is much better for shooting videos than bright sunlight, not only because of lower contrasts and better half-tones, but also because of shallower DOF that can allow for selective focus. For example, you can select the face of one person while the crowd behind her is blurred.

Selective focus in movement is called *rack focus*, for example, when you shift the focus from the face to the crowd behind. Another example often used in crime dramas is when a person walking on the street gradually goes out of focus while the gun of a sniper aimed at him comes into focus in the foreground.

> **Karl's Tips**
>
> You can get a selective focus shot even in bright sunlight if you have a very long focal length lens. Shoot the subject from a distance where the face fills the entire frame and focus your lens on the eyes; the background will be blurred.

You can make an interesting transition, a virtual in-camera dissolve—often called the "poor man's dissolve" because dissolves cost money in the film lab—by finishing a shot with turning the focus ring out of focus, then starting the next shot with bringing the image into focus again.

Auto-Focus vs. Selective Focus

Practically all video camera lenses come with auto-focus, which you can activate with the flip of a switch. It will try to keep the subject in focus. Most amateur videos shot with auto-focus are full of momentary out-of-focus shots, which is just the nature of auto-focus. Slower movements provide for better adjustments, but fast movements result in more blurs as the auto-focus tries to keep up. For example, the best man's face during his speech at a wedding reception will get momentarily out of focus as he moves the hand-mike in front of his face. The fast movement of his hand will confuse the auto-focus of the lens that is mostly set on his face.

It used to be that the more skilled the camera operator was, the more likely he was to avoid the use of the auto-focus. No longer: the sophisticated auto-focus mechanism on today's professional cameras can match skilled professionals.

There are two basic types of auto-focus: passive and active. Both use ultrasound or infrared light emanating from the camera to estimate acceptable focus, or an area within which objects appear to be acceptably sharp. Active systems do this independent of the optical system, whereas passive auto-focus is achieved with through-the-lens focusing. Active is the system used today in most of the lower and intermediate digital cameras as well as professional.

Front Focus vs. Back Focus

These are technical problems associated with removable lenses only. *Front focus* means that the lens focuses on an object in front of the intended target. *Back focus* is the opposite, or when shooting with a wide angle lens the entire image is blurred. These problems are caused by the improper calibration and setting of the lenses in attaching them to the camera's lens opening.

To avoid front and back focus problems and properly operate a removable zoom lens, you must follow a standard setup procedure. Whenever you zoom in on a subject at random, your image will go out of focus, because zooming in means you are gradually changing the focal length of your lens from a wide angle (low number, long focal length) to a narrow angle, telephoto (high number, shallow focal length) shot.

Karl's Tips
Whenever you need to zoom in to a close-up shot, zoom in quickly to the extreme close-up before actually recording to set your front focus. Then, during the actual shooting, everything will stay in focus, provided the subject hasn't moved away from that spot.

To get your subject into focus, turn the focal ring of your zoom lens in manual operation or allow your auto-focus to get the shot in focus.

Because zooming out means gradually changing the focal length from a shallow plane to a wide and longer distance, everything should come into focus as you zoom out. If the image gets out of focus while you zoom out, you have a back focus problem and the zoom lens is not properly aligned to the image sensors. To set up your zoom lens, zoom in to a focus chart, then zoom out to check focus for the wide-angle shot (back focus). Repeat this procedure until the image stays sharp both zoomed in and zoomed out, then tighten the lens's screw at the bottom of the lens. This is, of course, an issue only for cameras with removable zoom lenses.

Zoom vs. Dolly Shots

These shots have definite stylistic and psychological differences due to their different operation and the way they render perspectives. Dollies, being actual movements of the camera, carry the audience closer or farther away from the subjects. Dollies have the feel of natural movement and don't seem to change the lines of perspective.

Zooms, on the other hand, are artificial movements. By the gradual changing of the focal length inside the lens, zooms seem to either compress the lines of perspective while zooming in or expand them while zooming out. An example of the psychological effect of zooming in is artificially drawing attention to a detail or a person, while an example of zooming out is losing a detail or a person in the crowd. The interesting but rarely used combination of frontally zooming while dollying in the opposite direction can express imbalance or mental confusion.

Zooms are essentially an artificial "special effect," which is why narrative films use them sparingly—at least they did, prior to the increasing influence of zoom-happy music videos! Television, unlike theatrical films, became "zoom happy" as soon as zoom lenses become available; on the small screen, the slightly softer nature of zoom lenses wasn't as apparent as it is in the 340 times magnification required by theatrical projection. Zoom lenses have evolved so much that in today's high-end cameras they seem to approximate the image quality of fixed focal length, prime lenses. Therefore, they can be used to simulate dollies—especially while zooming out on subjects approaching the camera.

Video vs. Motion Picture Lenses

The tendency in developing lenses for digital cameras is to approximate the lenses of film cameras as much as possible, but cinematic operation of lenses has not been available until very recently. Unlike the manual operation of film camera lenses, the zoom, focus, and iris (f-stop) rings of even higher level prosumer cameras didn't give you fluid, gradual changes in manual override.

The Panasonic DVX100 introduced cinematic features in a zoom lens in 2002, a manual zoom option in addition to the standard electric servo-zoom with built-in speeds. The DVX 100A and B both accept cinematic follow-focus gears as well.

Another important cinematic feature is the manual iris, which is also a new development on prosumer cameras since Panasonic introduced it with the DVX100. The advantage of auto-iris is its possible use as a through-the-lens spot lightmeter and its ease of use when there isn't too much contrast between dark and bright areas. On the other hand, auto-iris can cause some problems.

By its inability to handle rapid change from sunlight to shadow. The auto-iris often makes the lens "blink to black" when it can't process rapid changes quickly enough.

The zoom lens's manual iris mode, which has been available for many higher level prosumer cameras for a long time, hasn't been able to make truly gradual changes without the iris jumping between preprogrammed increments.

We shot my feature film, *Out of Balance*, in Rio de Janeiro and in Miami with the Sony 150 (which, by the way, is also David Lynch's favorite camera), but we were unable to make smooth changes in iris control when panning from light to shadow.

These problems can only be avoided by the professional, film-like manual override introduced by the Panasonic 100 series cameras in the prosumer market. Other manufacturers quickly followed suit and the majority of the new, prosumer HDV camcorders do offer these cinematic features along with their 24p format shooting, all aimed at emulating the look and feel of film in digital video.

The Least You Need to Know

- Lenses bend light to focus images.
- The focal length of a lens determines its angle of view.
- Lens f-stops determine how much light gets through the lens.
- Zoom lenses allow you to change the focal length without actually changing lenses.

Getting Equipped to Edit Video

In This Chapter

♦ Choosing the right computer

♦ Picking the best monitor

♦ The importance of your working environment

Before you can begin editing your raw video, you will need some hardware and software. It's often difficult for beginners to know just what they need, so this chapter will demystify the process.

Why the Cheapest Stuff May Not Be a Bargain

In Chapter 2, I talked about choosing your camera, which is certainly an important decision. But the camera is no good by itself unless you don't want to edit the output, or expect to use only the limited editing capability offered by some camcorders. All DVD cameras offer in-camera "editing," for those who do not want to transfer their footage to a computer for editing. This is not real editing, as it involves only omitting unwanted shots and reprogramming the order of the selected shots in the playback mode of the in-camera DVD.

Other options for consumers who don't want to bother with editing but are willing to transfer the camera's footage to the computer are the "auto-edit" modes on newer computers' built-in software. Similar to the auto-iris and auto focus functions of the camera, consumers rely upon this feature of the software to automatically edit their videos.

Often referred to as "muvees," this "auto-editing" operation simply gives single-click options to select the overall mood, such as comedy, music video, and so on. Add some music and titles and the computer will then automatically select out the shots (avoiding out-of–focus and shaky shots) and "cut together" a presentation for playback.

This means you do not have to view the entire six hours of footage you shot during your family trip to the Bahamas to whittle it down to a more enjoyable half-hour show at the family gathering—the computer will do it for you. On the other hand, you give up selection and control over the material.

Most built-in auto-edit software functions also offer some degree of manual override for consumers who don't trust the computer's choices and are willing to learn some of their software's simple editing functions.

These auto-editing and simple manual functions have become such a staple of computers that even some camera cell phones have started to offer these features. Nokia 90 and 93 phones, for example, have built-in auto-editing of "muvees" as well as more advanced editing right on the phone. They also come bundled with Adobe Premiere Elements editing software for transferring and editing the footage on the computer. (More about these functions in Chapter 17.)

If auto-edited "muvees" are all you wanted to do, you probably wouldn't be reading this book. So we'll assume you want to produce finished videos of the best possible quality, even if you aren't creating them commercially. Generally speaking, you can assume that your budget will be split about 50/50 between the camera and its associated accessories and the computer and its associated accessories. This ratio may vary considerably depending on your exact needs and preferences.

Karl's Tips

During my recent lecture and workshop tour in India at the Asian Academy of Film and Television, I stunned the students and the press by demonstrating the shooting and editing options of cell phone "muvees" on my Nokia 90 phone.

We recommend that you avoid cheap, bargain computers unless you're relatively computer-savvy and don't mind fixing things yourself. Really cheap computers are built from bargain components and you will probably end up spending a lot of time and money to get them to work for you.

Monitors—Is Bigger Always Better?

You ultimately want your video to look the same to your viewers as it did to you. You may have no control over what screen your viewers see your video on, but you should have control over the variables at your end. One key is to do all of your own viewing and editing on a calibrated monitor.

Not long ago, just about all graphics and video professionals preferred the big, heavy CRT monitors, because the early flat panel monitors could not be calibrated very well. Times have changed, and today you will find most professionals using flat panel monitors. Even some inexpensive ones can deliver exceptional quality.

Several different systems for monitor profiling and calibration are on the market today. All of them work in similar ways and have a hardware and software application. The ColorVision Spyder system comes with software you load onto your computer, and a gadget called a Spyder that fits onto your monitor and analyzes its output. The software and Spyder work together to create a feedback loop and analyze the performance of the monitor. Unlike basic calibration programs in the computer's operating system, such closed loop systems do not require you to judge colors and tones. This makes them completely objective. Be sure to include such a calibration system in your overall budget. The Spyder is not that expensive, currently priced between $79.00 for the "Express" unit for consumers and $249.00 for professional Spyder2-Pro. Check it out at the website: www.colorvision.com/product-mc.php

 Zoom In

CRT (meaning cathode ray tube) monitors and TV sets alike are becoming obsolete as the LCD (liquid crystal display) flat panel monitors and TV sets are taking over the market.

Getting it right on your end makes it much more likely that your video will be displayed properly on other systems/monitors.

Because video-editing software takes up a lot of space on your monitor when you are working with it, you will want a large monitor. A 17-inch is about the smallest monitor suitable for video editing, and if your budget allows something larger, so much the better. Monitors also come in different aspect ratios, standard and wide screen. Wide-screen monitors are preferable for video in most cases.

Why Mac Computers Are the Industry Standard

This is not the place to debate the relative virtues of Macs versus Windows PCs. Graphics professionals, photographers, and other visual artists have favored Mac computers because they are very easy to use, they are built of high-quality components, and some of the best software was originally offered only for Mac.

If you were to visit many of the motion picture studios in the Hollywood area, you would find Mac computers in the majority. Part of this is the legacy effect, older users teaching younger ones and using what they are familiar with. Part of it is the great durability and reliability of Mac computers. And part of it is the lower vulnerability of Mac systems to virus and worm attacks.

The only downside to a Mac for the aspiring video producer is that Macs do cost more than comparable Windows computers. But when you consider all of the software applications that come with a Mac, the price difference becomes less of an issue. You can do most of the editing you want to do with iMovie, a very good video editor that comes with Mac computers. It's great to learn on, even if you later move up to its big brother, Final Cut Pro, or another advanced video editor.

The PC Alternative

Many today choose to do their video editing on a Windows computer. Most of the important editing software programs come in Windows versions, although a favorite for many, Final Cut Pro, is still Mac-only.

When figuring out which computer to buy, the most important thing to remember is that video files are *huge*. Most computer users never need to work with, store, or move files of this size, so most computers are not set up for it. Make sure the computer you buy has the fastest possible processor (some use dual processors or a single dual-core processor for maximum speed). A fast processor is important for two reasons. First it will give you a smooth flow when viewing your clips during the editing process, without stops and starts. Second, it will speed up rendering of effects during editing and the final rendering of your project.

Computers change all the time, so I'm not putting specifications in this book; check out some current computer catalogs and/or websites.

After the processor, the next most important thing is having enough *RAM*. The rule of thumb on RAM is that you can never have too much. You will want a minimum of

1 GB of RAM, more if you can afford it. RAM has come down considerably in price in recent years, so you can afford to max out your computer with as much as it is capable of supporting.

The next vital component for video work is the video card. Your computer will have several different circuit boards in it. The main one with the processor(s) on it is called the motherboard. The other boards, also called cards, plug into the motherboard and add capabilities. Video cards have their own video processors and memory. Again, because new ones come out so frequently, I advise studying some computer catalogs and/or websites to find out the state of the art in video cards. The video card feeds its signal to your monitor and controls the colors and motion you see there. Get the best video card your budget allows.

def•i•ni•tion

RAM stands for Random Access Memory. This is where the computer stores information temporarily while you work before writing to disk for permanent storage.

You need to store your video clips, transitions, finished edits, and other items somewhere until you are ready to burn the finished project onto DVD or some other more permanent storage medium. This is what your computer's hard drive is for; video files are quite large, so you will need lots of storage. You can accomplish this in two ways, internal and external.

Your computer will come with at least one internal hard drive. This may be enough if you plan on doing very short videos and not very many of them. But you will run out of space quickly if you create long projects or a lot of short ones. Even if the internal hard drive is large enough, you will want some means of backing up your files. A video is a lot of work, and you don't want to lose it to a hard drive crash. Hard drives don't crash often, but when they do, you generally lose everything on them.

One strategy is to have two internal hard drives. The second one can be set up to automatically mirror the main one, so that you always have a backup of all files. Another way to handle this is to get one or more external hard drives. External hard drives work just like internal ones, but are in their own separate housings and are set up somewhere near your computer and connected via USB 2.0 or FireWire (IEEE 1394) cables. Hard drives have also come down considerably in price in recent years, so you can have a lot of drive space for storage and backup without spending a fortune.

Karl's Tips

Whenever you purchase an external hard drive, make sure that it has the following important features: both USB 2.0 and FireWire (IEEE 1394 or iLink) connections for in- and out-putting digital video and audio. Most hard drives work with 400Mbit (50Mbs) data transfer rates; however, the newer types come with an additional connection for 800Mbit (100Mbs) transfer speeds.

USB 2.0 and FireWire 400 and 800 each have different cable connections. FireWire 400 requires 6pin, FireWire 800 needs 9pin, and the camera requires a 4pin to 6pin FireWire cable connection.

FireWire, USB, and USB 2 cables and a computer's external hard drive with connector ports.

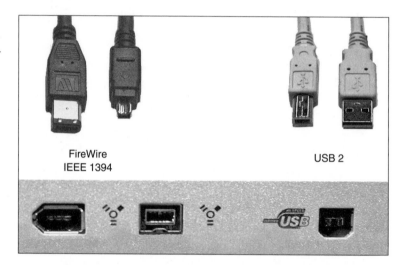

Media/data storage is measured in gigabytes (gigs, or GB); 1 GB roughly equals 4.5 minutes of video, which means a 60-minute MiniDV cassette needs about 13 GB storage space on the hard drive. Hard drives used to be quite expensive, but the good news is that, due to increased demand, technology and competition prices have been coming down quite a bit in recent years. For video editing, the hard drive's rotation speed should be no less than 7200 RPM (rotations per minute.) The hard drive's *cache* indicates the amount of temporary memory used during operational activity. It is measured in MB and 8 to 16 MB is considered a good size for video editing.

Examples of external hard drives.

Long-Term Storage

Once you finish your video project, you will most likely want to save it to DVD for presentation and long-term storage, so your computer should have a DVD writing drive. The latest ones can also read and write double-layer DVDs, which hold twice as much as single-layer DVDs. They can of course read and write CDs as well, and that is important for the music input for your editing. Also, some shorter (a couple of minutes long) video programs you can record on CDs. In addition, your finished programs can also be stored on CDs and DVDs.

Because you will be editing the sound track as well as the video, you will want good speakers. If you do your editing work at home and don't want to bother others, a good pair of headphones is a wise investment. With speakers or headphones, beware of turning the volume up too loud. Research has shown that listening to music or other audio too loud can do permanent damage to your hearing. If you want to still hear those high and low notes when you get old, take care of your hearing.

Other features may be desirable depending on your own needs. For example, I really hate to fiddle around on the back panel of a computer when connecting our video cameras. So a computer with FireWire connections on the front panel is much better. You may also consider obtaining a breakout cable or breakout box that will provide easy to access connections between your video-audio equipment and your computer.

A USB breakout box, such as this one, provides an easy way to connect your audio/video equipment to your home computer.

In Addition to the Computer and Monitor ...

Okay. You've got your camera equipment and you've now added your computer and monitor. What else do you need?

Obviously, you need editing software. I cover this in depth in Chapter 16. Your computer most likely came with a keyboard and a wired mouse. The keyboard will probably be just fine, but you may find the wired mouse to be a nuisance, with its cord always dragging and getting in the way. Lots of different options exist if you want a wireless mouse, and you probably will want to add one. Many prefer a wireless mouse with a graphics tablet. Wacom makes a wide variety of these, but for general use without taking up a lot of desk space, the Wacom Graphire tablet is the choice of many.

A Wacom tablet is a wireless mouse and graphics tablet, used for drawing by hand on the computer.

Laptops: Your Editing Environment Is Anywhere, Anytime

As portability of computers has gained popularity, video editing has become available on laptops as well. A few years ago, while teaching a directing and editing course at New York University's campus in Florence, Italy, I was so enchanted by the beautiful and inspirational surroundings that I told my students it was "prohibited" to edit inside. They were to edit outdoors by the seashore, under the palm trees, on their laptop computers. They were all happy to meet these requirements and brought back well-edited short narrative videos.

Laptop computer video editing has come a long way. The digital feature film, *Out of Balance*, which I directed in Rio and Miami and edited with my former student, Matt Kliegman, was entirely cut on a 17-inch Mac PowerBook connected to a 1 TB (terabyte) portable external hard drive. That huge drive was required to hold about 70 DVCam cassettes worth of footage.

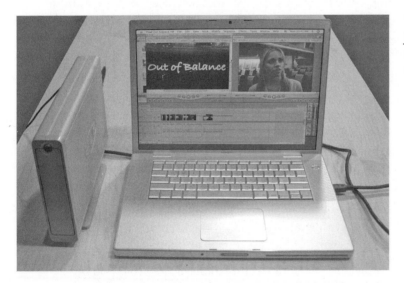

Today, you can edit an entire feature film with just a laptop computer and a 1-terabyte hard drive.

You may want to consider the portability of a laptop computer, especially if you want to use it for location recording to the hard drive with rough cutting on the spot. This method is becoming increasingly popular in professional productions. The editor's rough cut on-the-fly gives the director and the producer a rough idea of how the scene may work and also ensures that the production company does not leave the location with insufficient coverage of the scene.

Think About Your Working Space

Unless you plan to make video production a fulltime business, you will probably work in one of the rooms of your house. You don't need a vast amount of space to set up a good editing system, but you should set aside an area just for this purpose, preferably a quiet space where you will not have to deal with interruptions. Computer equipment does not get along well with high humidity, so if you intend to set up your editing space in a basement and you don't live in an arid climate, make sure you have an adequate dehumidifier.

Setting Up for Comfort

Personal comfort is very important for long hours in front of the computer monitor. Position your monitor so that the viewing distance is from about 20 to 25 inches from your eyes. If you cannot see the monitor clearly at that distance, you may want to get your eye doctor to prescribe glasses for you just for computer work. Make sure you can see fine detail clearly at the distance you choose.

You can buy a purpose-built computer desk to hold your computer, monitor, and other equipment. If you have a good table that's the right height, you can press it into service. Or you can make a "do it yourself" table to support your system by buying two of the short, two drawer, filing cabinets that are sold in office supply and discount stores. Those make the two ends of your "desk" and you buy a flat door from a building supply store and lay it across them. It may not look elegant, but it is inexpensive and very functional. Many working photographers and videographers use these home-made tables. Have the monitor at a comfortable height for viewing without making your neck sore. I find the monitor stands of most flat panel monitors place the monitor too low. You can buy gadgets for raising monitor height at office supply and computer stores, or you can make your own, or use a stack of books.

Your chair is probably the second most important purchase after your computer system. If possible, go to one of the large office supply stores and try sitting in several office chairs. Choose the one that feels best for you and provides adequate back support. The more adjustments the better.

Lighting

Use low ambient lighting so as not to distract from your monitor. Keep the room bright enough so that you can see clearly, but not as bright as normal room lighting. You need to be able to locate things on your desk and walk around the room without tripping or bumping into things.

> **Karl's Tips**
>
> Avoid fluorescent lights, because they have a flicker. You may not be able to see the flicker, but many people get headaches from it, and some studies show that it is bad for your eyes.

Choosing the Right Area

Ensuring privacy and avoiding interruptions are both very important to setting up your editing area. Editing requires concentration, and having people constantly walking through, children bouncing about, pets, and so forth will not be conducive to concentration. Also, while doing real-time editing, you certainly don't want someone bumping up against your elbow. Set up your editing area in a place where you can be sure to have privacy.

Archive Storage

Proper tape storage for your archive is a must. Tapes have a finite life, but will last much longer if stored properly. The ideal storage is a cool, dark place with low humidity. General-purpose storage cabinets from office supply or discount stores will be fine in most cases. Avoiding heat and damp are the most important things.

The Least You Need to Know

- ◆ You don't need a super-expensive computer to edit video.
- ◆ Your choice of monitors is very important, and proper tape storage is essential.
- ◆ The proper working environment—wherever it may be—will make you comfortable during long editing sessions.

Legal Stuff

In This Chapter

- Understanding copyright
- Using releases
- Incorporating

The word copyright basically defines itself. It is the right to copy a work. Copyright law restricts just who can copy a work as a protection for the copyright owner, usually the creator, or, after his death, his or her heirs or agents and distributors

Copyright Basics

Copyright is possibly the most misunderstood aspect of video creation. If you only plan to make family videos, copyright probably isn't important to you, but you may still want to have a basic understanding. However, if you intend to do any commercial video making, you really need to understand copyright law and related issues. There are many good books on this subject. See Appendix B for some suggestions.

This chapter will give you the basic information. Be aware, though, that copyright laws are subject to change. Also be aware that this book is written for an American audience; copyright laws in other countries differ in many ways.

The Truth About Copyright

Any created work is automatically copyrighted at the moment of creation, provided you claim this "right to copy" on the work. If you do not declare this right, it is difficult to prove it afterward. This applies whether the work was created for commercial purposes or not. Copyright applies to anything that can be classed as intellectual property, which is pretty much anything you create, whether on film, video, canvas, paper, word processor—anything.

It's important that you understand that ideas cannot be copyrighted, only completed works, written treatments, scripts, musical scores, and so on.

Registration

So if the work is automatically copyrighted when created, what does registration mean? Although not required, registration is always a good idea for legal protection. Unregistered works are protected, but you can only collect actual damages in cases of infringement and that may be difficult to prove. On registered works, you have a better chance of collecting damages, legal expenses, and possibly punitive damages as well.

To register a work, fill out a registration form (called Form PA or Short Form PA, depending on how much space you need) and send it to the copyright office along with copies of the work and the registration fee. Here are the requirements from the U.S. Copyright Office at the Library of Congress:

◆ Submit a copy and a description of the work being registered. The nature of the copy and description may vary, depending upon the following factors.

For all published motion pictures:

◆ A separate description of the nature and general content of the work (for example, a shooting script, a synopsis, or a pressbook) and

◆ One complete copy of the work. A copy is complete if it is undamaged and free of splices and defects that would interfere with viewing the work.

For unpublished motion pictures:

◆ Submit a separate description of the work.

◆ Include a copy of the work containing all the visual and aural elements covered by the registration.

At the time of this writing, the registration fee is $45, but verify the fee and other aspects of registration periodically on the Copyright Office's website: www.copyright. gov. You can also download and print the forms you will need from that site.

In addition to the Copyright Office of the Library of Congress, it is double protection to register your script with the Writers Guild of America, east or west. It is inexpensive, less than $20, and you can do it on the web as well. You receive a registration number with the date of submission and they place your script on file in a sealed envelope. If there ever was a dispute concerning another production that looks very similar to yours, the courts would look at the date of registration first. Then they would hire experts to examine possible contacts from the second production to your material, and whether the similarities are truly substantial.

Once you register your copyrighted work, you have better legal protection against anyone else copying your work. Many people falsely believe that this only applies to commercial use, but copying without permission is illegal even if no money is made.

You can do several things with your copyright. You can sell it to someone or transfer it to him or her without payment. Generally speaking, however, it is better to license copyright for specified uses and for a specified length of time rather than selling it outright. When you do this you retain ownership and can license it to other parties for different uses, or after the time limit on the first license has expired.

> ### Karl's Tips
>
> A simple and inexpensive method for protecting your work is called "the poor man's copyright," and it means placing your script or work with the proper copyright note and date on its front page in a sealed envelope and mailing it to yourself by registered mail. Then file it, unopened. In case of a dispute, hand it unopened to the judge in court. The postmark will confirm the date the package was originally mailed (and presumably sealed) on.

Licensing

Licenses can be exclusive, allowing only one party to use the work, or they can be nonexclusive, which allows them to be licensed to more than one party at the same time. Most people licensing your work will want exclusive license.

Who owns the copyright on a work produced by a group of people? A corporation or partnership can jointly hold copyright. But this needs to be worked out in advance to avoid legal problems later on. We've all heard stories about members of defunct rock bands suing each other over ownership of songs. Having all parties sign contracts prior to doing work on the project can prevent this.

If you bring in others to work on your videos with you, pay attention to this and have good contracts drawn up. Because contract law is governed by state laws and not national law, this is one of those times when you should not scrimp. Have a really good contract lawyer in your state draw up the contracts.

If your video production is really small and you don't have enough money, or you just don't want to spend money on an entertainment attorney, at least put together a simple "Deal Memo" in plain English that describes the ownership, the percentage points, the production schedule, and the specific responsibilities of the parties.

Public Domain

Copyrights used to belong to the author's heirs and/or to the holders (like producers, studios, publishers, and so on) for a period of 25 years following the death of the author, and then were renewable for another 25 years. After that, the copyright was no longer valid and the work went into public domain, meaning that anyone could use it any way they wanted. During President Clinton's tenure, the copyright protection was extended to 75 years following the author's death.

Fair Use Doctrine

While copyright protects you from unauthorized use of your work, there are exceptions. The Fair Use Doctrine says that others can use short excerpts from your work without permission for purposes of review.

Here is the applicable text from the Copyright Act of 1976, 17 U.S.C. § 107:

> Notwithstanding the provisions of sections 106 and 106A, the fair use of a copyrighted work, including such use by reproduction in copies or phonorecords or by any other means specified by that section, for purposes such as criticism, comment, news reporting, teaching (including multiple copies for classroom use), scholarship, or research, is not an infringement of copyright. In determining whether the use made of a work in any particular case is a fair use the factors to be considered shall include:

1. The purpose and character of the use, including whether such use is of a commercial nature or is for nonprofit educational purposes;

2. The nature of the copyrighted work;

3. The amount and substantiality of the portion used in relation to the copyrighted work as a whole; and

4. The effect of the use upon the potential market for or value of the copyrighted work.

The fact that a work is unpublished shall not itself bar a finding of fair use if such finding is made upon consideration of all the above factors.

Most of us in the media community really wish that the framers of the Copyright Act had made this less vague. As it stands, it is not always easy to tell what is and is not fair use. Obviously, using a few seconds of a film or video in a published review is clearly fair use, but how long does a clip have to be before it ceases to be fair use and becomes infringement? This book isn't the place to delve into this, but be aware of fair use and just how vaguely it is defined in the statute.

Zoom In _____

The important thing for you to understand about fair use is that you can't use other people's material in your videos and claim fair use. Most of the time, it won't be.

Music for Your Video

This leads directly to a discussion of music. You want great music for your soundtrack—we all do. If you want to license music for this purpose, you will do it through ASCAP (American Society of Composers, Authors, and Performers: www. ascap.com) or BMI (Broadcast Music, Inc.: www.bmi.com). If you go this route, you need good bookkeeping, as you will be required to pay royalties regularly.

There are two kinds of copyright you have to deal with when it comes to music: first, the sheet music of the original score and the lyrics; second, the synchronization license for the actual performance by the singers and musicians.

So, even if you hire some musician friends to play your favorite song, you still have to clear the rights for the sheet music.

Zoom In _____

"I love this song from my favorite album. Can I use it on the soundtrack of my video?"

The short answer is no. The long answer is that you could use the song if you had permission and paid the proper royalties. In practice, this means no on most low and moderate budget video projects.

A few years ago, I co-produced a low budget ($1 million) feature film for a former student of mine who was a first-time director. He wanted to use his favorite songs by leading rock artists on the soundtrack. When the music clearance attorney finished his inquiry, we were presented with a possible $400,000 bill to commercially distribute the film with those songs. That would have been roughly half of the entire budget! But purchasing the right to play these songs at a film festival only cost a mere $6,000.

What can happen at festivals? A distributor might pick up the tab if they thought the songs would help make more money in distribution. This happened to Michael Moore, who did not clear any rights for his first documentary feature, *Roger and Me*, but the distributor did. However, this did not happen to my student, and eventually we had to hire a composer and musicians to paraphrase the desired music.

Royalty-Free Music

Because of the complexity and cost of licensing, most of the time it is impractical to use music from major artists in your soundtracks. So how do you get music? One way is by purchasing royalty-free music. You pay one price for the CD and you get a license with it to use the material on the CD without paying any royalties. Royalty-free music ranges from very good to absolutely dreadful, so listen to samples prior to buying. To find current sources for royalty-free music, look at the ads in the back of video magazines like DV or do an Internet search with the keywords "royalty-free music." You will find a wide range.

Local Bands or Musicians

Another alternative is to find a good local band or musician looking for exposure. There is a lot of musical talent in most communities, and many artists would love the opportunity to compose and perform the score for a video.

Classical Music

A third alternative is to stick to classical music. Anything over 75 years old is not likely to be covered by copyright today, and can be freely used. Specific performances are protected by the artists' copyrights, however. If you have a good ear and a bit of

musical ability, you can convert free MIDI (Musical Instrument Digital Interface) files of classical music into good soundtrack music with software applications like Apple's Garage Band (part of the iLife suite).

A MIDI file is a set of instructions to your computer on how to play the music, but you can change everything to suit your needs. You can speed up or slow down the tempo, assign different virtual instruments to the tracks, cut, paste, and do almost unlimited alterations to a basic MIDI track to get the sound and mood you want.

Model/Talent Releases

Whenever a recognizable person appears in a photograph or video, you need a release from that person if the video is to be used for commercial purposes. This is true because people have a right to control commercial use of their image. But generally speaking, "editorial use" does not require releases. This is true of news reports, documentaries, and the like.

I've included a sample release in Appendix C. Feel free to adapt it for your own use, but keep in mind the details and cautions below.

What Are They?

A release is simply a formal agreement between the filmmaker and anyone who appears in the video. A release allows you to use the video you shot of that person. You should get one from everyone who appears, no matter how briefly. You will need to familiarize yourself with laws in your state, because state law governs releases, like contracts, and those laws vary considerably.

In some states, a release is not valid unless you have given payment or other "valuable consideration." And in some states you must pay the person a minimum of $25 in addition to any other considerations. Once again, you should consult with a good lawyer before writing your release form. Be sure the sample forms in Appendix C meet your local requirements before using them. Knowing the law in your locality is one of the most important things you need to do.

When Do You Need Them?

When do you need a release? The flippant answer is "always." Better safe than sorry. A release will never be to your detriment, so just make a rule now that you will always get one and you won't have to worry.

Karl's Tips

If you don't have a release with you—and it is difficult to produce a handwritten release while improvising and grabbing someone on the spot—just simply roll tape and thank the person on camera for allowing you to use him/her in your project. While this is not completely legal, the subject's nodding his/her head in approval then proceeding to cooperate with you on the tape does give you enough of an approval to go ahead.

Age Requirements

Although technically a release is not a contract, releases are governed by many of the same rules and regulations as contracts. One of the most important rules is that a person must be of legal age to sign a contract or release. So far as I have been able to determine, the legal age for entering into contracts and signing releases is 18 in every state of the United States. Does this mean you can't use someone younger than 18 in your video? Not at all, but it does introduce a bit of complexity, because the parent or legal guardian of any minor you use in your video will have to sign the release.

Also, in some states the parent or legal guardian must be present when you are shooting video of a minor. And in some places, you are required by law to have a licensed social worker present when working with a minor. I hate to repeat this so often, but you really must consult with an attorney to find out what is required in your locality.

Remember, too, that when you travel to other places to shoot scenes, you will be governed by the laws of that locality.

Property Releases

So your next-door neighbor says it is OK for you to shoot video in his backyard. Months later he sees the video and doesn't want you to use it because it shows that part of his fence was falling down and his shed needed painting. If you use the video anyway, will he sue you? Well, you can never completely protect yourself, but if you had a signed property release from him prior to the shoot, you would be on very solid ground to go ahead and use the video. A property release is just like a talent release, but applies to recognizable locations.

Generally you can shoot video in public places without a release, but check local regulations. In New York City, it is against regulations to do so without a permit. This is primarily a safety concern, because people might trip over tripod legs, cables, tackle boxes, and so on. In Washington, D.C., it is against regulations to set up tripods in many areas.

Prevent hassles during the shoot by checking with local authorities in advance. And remember that shopping malls and stores are not public places. They are private property and you can't work there without permission. It is against the law to photograph or film a U.S. Post Office without permission, and many other government buildings and facilities are strictly off limits.

As with talent releases, the best protection is just to always get property releases in advance. You will find a sample location release in Appendix C.

Other Legal Stuff

If you are shooting video for commercial purposes, you need to know what other regulations apply. In some states, for example, you will need to cover your talent and workers for Workman's Compensation. This will usually require you to fill out a bunch of paperwork and make a deposit with the state agency. Once you finish, you can file more paperwork and get most of that money back.

If you want to shoot video in state or national parks, you will run into a number of other regulations, such as indemnifying the state via an insurance policy, or a rider added to your existing business insurance. Contact park management well in advance to find out what the requirements are and to be sure you can comply with them.

Limiting Liability

This is another thing you'll have to handle through a good lawyer. Generally it is a good idea to protect yourself against personal liability by forming a corporation. This does not have to be expensive; most of the time you can form a corporation for a few hundred dollars.

A limited liability corporation (LLC) has many advantages, but also some disadvantages, and you need to explore your specific situation with a professional before acting. On major motion pictures, for example, it is standard to form a new corporation for each movie. This keeps bookkeeping and liability isolated from other movies the same people are making. For most of us working on smaller projects, this level of isolation is not necessary and one umbrella corporation for all projects will be sufficient.

This subject is rather complicated but corporations are easy to form, and they may offer you more advantages than LLCs:

◆ Your personal assets are protected in case of corporation liabilities such as bankruptcy or accidents during production.

- You can pay yourself as an employee.

- You can more easily deduct many expenses like equipment purchase, travel, production supplies, and even business meals and entertainment from your taxes.

As with anything, though, it's best to consult a lawyer to find out the details on incorporation, and whether it's right for you.

Karl's Tips

For smaller projects, the best business structure is most often the nonprofit organization (NPO), as in-kind contributions and even investments in your videos may be more acceptable for tax-deductions. It's quite complicated to form your own NPO, so try to bring your project under an existing nonprofit umbrella. For example, in New York, an organization called Film/Video Arts—in exchange for a few percentage points—offers nonprofit fiscal sponsorships for independent videomakers for the purpose of receiving tax deductible contributions. Likewise, you may be able to find NPOs that are not involved with film and video but might be willing to take you under their "umbrella" because they somehow relate to the subject matter of your project.

In addition to LLCs and corporations, you can form other business entities. However, you should avoid sole proprietorships, or DBAs ("doing business as"), because that means you and your assets are liable for anything that goes wrong.

Oh, and one last item—should you pay anyone helping you, make sure that these payments are documented for the IRS when you do your taxes.

The Least You Need to Know

- Copyright is automatic when declared, but you need to register for maximum protection.

- Releases protect you from legal problems.

- You need to know local regulations for maximum protection.

- You may want to incorporate to limit liability.

Part 2

Preproduction

Preproduction is everything you do before you actually start shooting video, gathering still images for import, recording sound, and so on. It's actually the most important stage of making a digital video, so pay close attention to the information in this section.

Preproduction: The Planning Stage

In This Chapter

◆ The importance of planning ahead

◆ Using the world around you to find great ideas

◆ Understanding what goes into the preproduction process

◆ Knowing who's who in your cast and crew

Preproduction is the stage of filmmaking before the actual shooting, when you gather all the necessary equipment and materials in preparation for the creation of your movie. Depending on your budget and the extent of your planning, this early stage of the game could determine the quality, or production value, of your film. Preproduction is the developmental stage of your movie. It is the thought before the "Action!" and the time when you look at the big picture to conceptualize and plan, as well as nail down all the details like the where, when, how, and who.

But first things first—we know your movie will be great, but what on earth will it be about? Not all movies require the standard word-by-word planning that your average Hollywood blockbuster does; as a matter of fact,

some really interesting documentaries have been shot with no real concept at all besides following someone around for a set period of time. Obviously you'll have a much tighter movie if you plan it all out ahead of time. Create a fully structured plan, complete with an finalized screenplay, storyboards, and a production schedule, or just a comprehensive idea of where you're going and what everyone will do. The more fully you prepare in this stage, the better your video will be.

Getting Ideas

If you're reading this book, you may already have an idea (or lots of ideas) that you're dying to put on screens big or small. But if you don't, don't let it stop you! Great ideas for movies are everywhere—you just need to know where to look.

Start someplace simple, like the newspaper. Pick up the morning edition, flip through it, and see if anything interests you. Was there an exciting event? A heroic act? Even an odd situation or offbeat story, no matter how simple, can spark an idea for a story-line.

What about a conversation you overheard on the train or in the elevator? Did some-one say something that caught your interest, something you could base a character on? Or how about surfing the Internet for sites such as www.overheardinnewyork.com or www.overheardintheoffice.com? Such sites are often great springboards for devel-oping ideas from fragments of conversation.

Maybe you have a family member who's had an interesting life. Why not do an inter-view or write a documentary on his or her story? This type of personal story is really fascinating if done well, and will be something your family can treasure for years.

If you're looking for something a little more creative, how about adapting a short story, play, or novella? Doing your own take on a classic tale can be fun and enter-taining, and provides a great opportunity to practice your screenwriting skills with a plotline that's already been developed. (See Chapter 7 for more information on how to write and use a script.)

If all else fails, just start out by shooting whatever's going on in your life right now. Is someone having a birthday? Birthdays are a great time to get some experience direct-ing crowds and working behind the camera, and you could supplement the event by adding in still photos of the birthday boy or girl and some cool narration in the edit-ing process. You could even just pick up a camera, grab some friends or family mem-bers, and improvise a scene or two. No matter what you do, the important thing is to use your imagination to find a story in the world around you.

Digitally Generated Ideas

Thanks to the digital age, there is no more staring at a blank screen for want of ideas. Today you can find an idea by using Internet resources. One such website is put together by the British Broadcasting Company (the BBC), aptly called the Motion Gallery of Ideas for Inspiration. You just need to enter a keyword into their "concept randomizer," and you will immediately look at hundreds of corresponding visual expressions from their archives.

It can be helpful to use stock photo archives and concept randomizers as visual inspiration for generating movie ideas. This concept randomizer is from the BBC.

For more information check out their website at www.bbcmotiongallery.com/customer/inspiration.aspx.

Most of the story processing software—which we'll discuss in Chapter 7—also contains brainstorming features that you can use for generating ideas.

Overview of the Preproduction Steps

There are several steps you should take to ensure that your movie is the best it can be, even on a limited budget. The more planning you do in the preproduction stage, the better your video will look. It may take some trial and error to get the steps down and decide which ones require more time and effort, but you should spend the bulk of your moviemaking time up front.

The Write Stuff

Now that you have the idea for your movie, the first step is to write that idea out, preferably in the form of a structured screenplay (see Chapter 7).

If you're not planning on using a screenplay, you should at least organize your ideas logically—whether in an outline of the events that will take place in your video (plot), a visual breakdown of the events in a sketchpad or notebook, or just a basic idea of what your video will consist of when finished, so that you don't forget to film an integral scene.

If you write a complete screenplay, another good step in the preproduction stage is to create a visual depiction of the major scenes of the movie in chronological order. Known as storyboarding, you can think of this visual aid as a drawn-out story, similar to the panels in a graphic novel or comic book. The storyboard puts everyone on the same "page," so to speak, both from a storyline and a visual point of view. (Chapter 8 provides a more detailed description of creating a storyboard for your movie.)

Locations: Oh, the Places You'll Go!

Sometimes you have a great idea for a place to shoot a scene in your movie, but you find it impossible to shoot once you get there, either because of crowds, a complicated setup, or the simple fact that you're not legally allowed to shoot there.

Devoting some time to deciding on locations that are available to you, and that work within your budget, can sometimes make or break your movie. Many public places require shooting permits, which are both expensive and time-consuming to obtain. It's a good idea to sit down and decide on all your locations well ahead of time, so that you can avoid potential disappointments later. (For more information on locations, see Chapter 13 on the production environment.)

Budgeting

No matter how small your production is, it always involves money. Because there may be ways you can deduct some of the money spent on your production from your taxes, it's a good idea to make an estimated budget for your production. This is especially true if you want to raise some funds and use other people's money instead of your own.

Karl's Tips
If you put your production under the "umbrella" of a nonprofit corporation, your friends, your relatives, and even your dentist may deduct from their taxes what they contribute to your digital video production! However, this is on a case-by-case basis, so check the actual situation with a local tax attorney.

Scheduling

Once you know where your movie will take place, you'll need to know when. Movies generally involve a great deal of organization because you'll have a group of people who are probably busy doing other things in their life, and you'll have to work within their availability. Your cast will need to know when they are performing a particular scene so that they can have their lines memorized, and you may need to arrange for specific equipment or props.

It's pretty common to find out that shooting a scene runs much, *much* longer than expected, so it's a good idea to build some extra time into the schedule from the beginning. And if you finish early, great! Use the time to hang out with your cast and get to know each other better over a pizza.

Presentation for Possible Grants and Investors

If you decided to go under a nonprofit umbrella, you may also want to try to apply for grant money. Go to the website of the Foundation Center: foundationcenter.org.

The Foundation Center is headquartered in New York City with branches in Atlanta, Cleveland, San Francisco, and Washington, D.C. In addition there are cooperating collections in every state, many of them able to provide access to the Foundation Directory Online.

You'll be surprised to find that there are hundreds of sources covering every idea and subject matter on earth where you can apply for funds for your video project. For a mere $9.95 a month you can conduct an online search at its website for the requirements on the forms of presentations and deadlines that you must consider. The Foundation Center has a separate directory for film and video grants as well.

Traditionally foundations prefer to give grants to nonprofit corporations and organizations, but as your online search will show, individuals still have a good shot at getting funded, provided you can come up with projects that meet the expectations and requirements.

Larger nonprofit corporations employ grant proposal writers, professionals well versed in putting together the prospectus that perfectly fits the given foundation's guidelines. Whether you are seeking a nonprofit grant or trying to pitch to commercial investors you need to develop a package proposal with pretty much similar ingredients.

1. A well thought-out project title.

2. An exciting short pitch of your idea on the first page.

3. A synopsis or short treatment not longer than 1-3 pages describing the project in more detail, especially your visual approach, that justifies why you're treating this topic in video and not as a written essay or newspaper article.

4. Access is the key to any project, especially documentaries. Show in your proposal that you have access to the people and resources that are crucial for the making of your project. These include locations, actors, and experts if you are making a documentary or a promotional video. Also list any key personnel who can open the doors for you or whose participation would attract attention. Include plenty of visuals of these components as they make your prospectus or proposal more attractive.

5. Demonstrate that you've done your research. Filmmakers are temporary experts. They need to know as much about the subject of their current project as humanly possible. They need to know what has been done on their topic before in films, videos, and books.

6. Provide a budget. Grant givers and investors alike need to know the costs of the project. Don't forget to include a salary or at least a living stipend for yourself for the duration of the project. Larger documentaries, on average, take about a year to make.

7. Give your schedule: a realistic project flow from writing and research through shooting and editing to final presentation is always required and should demonstrate that you can complete the project within the budget and according to a feasible timeline.

8. Explain how you plan to distribute your completed project, to what audiences and by what distribution strategies: cable TV, DVD, Internet, company screenings, and so on.

9. Give an income projection. This is not necessary for grants as they are not for profit, but essential for investors in a commercial venture. Even if these projections are pipe dreams, you still need to approximate an ideal scenario.

Always print out your package proposal and present it in a handsome binder. Digital audiovisual presentations for investors and clients to get money for projects at the planning stage have become quite popular. That is why the storyboard software programs always include an option to present your material as a slide-show as well.

Computers again come to the rescue. There are built in proposal templates in the Microsoft Office applications that actually guide you through the process in an interactive manner. Microsoft's PowerPoint is a powerful program that can help you to put together and present your project proposals. Apple has just come out with an impressive project proposal making and presentation software called Keynote.

Once you get the funds for your project, you can move on to setting up the specific paper flow that is essential to plan and run video productions.

Several programs provide for fully integrated planning for your video. One is the free, web-based program Celtx (www.celtx.com); another is the inexpensive program, Filmmaker's Software (filmmakerssoftware.com), which generates all the forms and takes care of all the paperwork that you need to prepare whenever you make any kind of production. Gorilla is another great, all-inclusive program that generates everything from storyboards and shotlists to your scheduling information.

Storyboard & Shotlist
Import storyboards from your favorite drawing program and build shot lists for each scene. Plus, attach cast and equipment to each shot on your list.

Locations
Link location info, including pictures and maps, directly to breakdown sheets and print out driving directions for cast and crew.

Contacts
Store all of your contacts - cast, crew, vendors - and auto-email anyone directly from Gorilla. Use this info in scheduling, budgeting, accounting, and more.

Calendar
Track your shooting schedule, rehearsals, meetings, post-production facilities, location scouts and more.

Gorilla software can be used to plan all stages, from logline and synopsis to film festival application and profit distribution.

For more information, check out Gorilla at www.junglesoftware.com/home.

Assembling Your Cast

And speaking of your cast, who are they? Cast simply refers to the actors, whether they are stars, supporting characters, or extras in your video. (See Chapter 10 for more information on casting.) The cast may consist of friends and family who contribute their time to participate in your project, or can consist of trained actors who audition for the roles.

If your budget is tight, you may need to find actors who really believe in your script or the project itself in order to enlist them. A good place to search for actors who may be willing to work with your budgetary constraints is www.craigslist.org, where you can create a post that lists the types of characters you are casting for. You can also look for talent on www.backstage.com and other acting websites. Another good idea is to post flyers for your auditions around high schools or college campuses. Actors just starting out may be more willing to take a chance on a new director.

Holding Auditions

Even if you've never directed before, you probably have a good idea of who you're looking for to fill certain roles in your movie. Once you find some actors who are good potential candidates, the audition process is a good time to get a feel for both their acting ability and their personalities. You will work with these people for the duration of your moviemaking process, so it's always a good idea to find actors you can work well with and who get along with each other. Of course, they may be donating their time and talent to your film, so you may end up having to revise your ideas of certain characters to fit the actors who are actually available—or affordable. Go with your instincts—you may wind up with an even more interesting result if you put someone in a role who goes against "type" or otherwise avoid *typecasting*.

def•i•ni•tion

Typecasting refers to casting someone repeatedly in similar kinds of roles. Think of the cheesy car salesman, Larry, on *Three's Company* or the nosy neighbor, Gladys, on *Bewitched*. These are examples of typecast characters—and wouldn't it be more interesting to see people who don't embody the typical idea of these characters, such as Vito, the homosexual mobster whose plotline made up a good chunk of Season 6 of *The Sopranos*?

Rehearsing

Rehearsals are an essential part of the moviemaking process, even if they just consist of having your actors show up for a run-through an hour or two before you're scheduled to shoot. Your actors will need to know how to interact with each other, where to stand, and how you, the director, envision them playing the scene. The more rehearsal time you can build into the schedule, the better. (For more on rehearsing, see Chapter 12.)

Who's in the Crew?

Of course, there's a lot more you can do to prepare for the big shoot, but it's easier to envision such an involved project if you have the input of at least a few others you can trust. These people, if you're lucky, will make up your crew: all those hard-working people who assist behind the scenes to make your movie. The more people you can enlist to help out on the set, the better your movie will be.

Your crew can consist of a thousand people or just one: you. Of course your production will suffer if you do everything yourself: no matter how good you are (or think you are), no one can be everywhere all the time.

There is an interesting example of how a single person crew could still strike it big. Robert Rodriguez made his first ultra-low-budget feature, *El Mariachi*, single-handedly over several weekends, writing, producing, directing, and shooting it all by himself. The rest is history, but he is still the exception rather than the rule.

If you are looking for some more experienced help, try seeking crew members on websites such as www.mandy.com, which have sections for low- and no-budget positions.

For a low- or no-budget video, you'll wear a lot of hats: those of a production coordinator, director, and writer, at least. But if you can recruit some others to help you, here are some jobs you can delegate to improve the quality of your video—and help save your sanity.

Producer/Executive Producer

If you're doing a low- or no-budget video, you probably won't have a producer or executive producer. But if you're lucky enough to have someone who's willing to donate—or raise—money for your movie, make sure you credit that person as a producer or executive producer.

Production Coordinator/Manager/Line Producer

The production coordinator is typically in charge of renting equipment, booking locations, and booking the cast. For a smaller production, the director often acts as the production coordinator, because he or she already has ideas for locations and cast in mind.

Director

The director is the center of the moviemaking process. He or she primarily works with actors to get the expected performance out of them, and is the last word in the creative process of the movie, from the flow of the content to the visual presentation. The director also controls technical aspects such as setting up shots, positioning actors, what the soundtrack will include, and much more.

Karl's Tips

In Hollywood or on larger productions, the producer(s) have much of the control on a project. On a smaller scale, you, as the director, are the one with the control. Take pride in the fact that the project is yours alone, and enjoy being at the helm of your movie!

Assistant Director (AD)

The assistant director does just what you'd imagine: he or she assists the director with ensuring that the movie is made according to the director's vision while staying on schedule and on budget. The AD may help the director manage the day-to-day activity, acts as the liaison between the director and the line producer and ensures that the script is followed and larger scenes are managed properly. In other words, the AD manages the details, and the director handles the big-picture issues.

Director of Photography (DP)

From lighting design to camera angles to camera movement, the DP is in charge of the composition of each frame and is the person who executes the all-around vision of the director. In a low-budget movie, the DP may also act as a close assistant to the director—or in extreme cases, the director may do the filming him- or herself. This person may also receive credit as the cinematographer if the DP also acts as the cameraperson, doing the camera work on the video.

Surprisingly, on large-scale, "union pictures," the DP does not operate the camera. He or she must use a camera operator, a focus puller, and an assistant cameraman.

Sound Engineer

This person's job is to monitor all the sound of the production. Nothing is worse than shooting a scene all day, only to find that the sound has been compromised in some way, either because of incorrect settings on the channels of the sound equipment, or blocked microphones, or because background noise created interference. Sound is one of the only things that cannot be fixed properly in post-production (dubbing is typically the only solution in these cases), so having a good sound mixer is essential to a good quality movie.

> **Karl's Tips**
>
> Always record the sound on a separate inexpensive DV camcorder or on a small tape recorder, as well. In case something goes wrong with your sound on video, you can use that additional recording as a back-up.

Production Designer

The production designer is responsible for creating and overseeing the visual appearance of the film, from the sets to the props to the costumes and makeup. The production designer works closely with the director to achieve the proper look for the movie; in a low- or no-budget film, he or she may also act as art director, set designer, and set decorator to create all the background visuals and props for the movie.

Makeup Artist and Hairdresser

These terms are pretty self-explanatory. If it's possible financially (or if you have a beautician friend who'll do you a favor), it's always great to have someone on the set to do the makeup and hair of your actors, and to ensure *continuity* in the way the actors look from cut to cut and scene to scene. If you don't have the resources, though, it's a good idea to have someone, either you or an assistant, review the way your actors look before each take to make sure that they don't appear noticeably different.

Script Supervisor

This person is in charge of checking whether everything has been shot as planned and there are no *continuity* errors. For example the actors dress, move and speak exactly

the same way as—let's say, before the lunch break, when they continue working on the same scene. If an actor takes a drink with his right hand during the shooting of a long shot, he cannot repeat the action in the close shot with his left hand because the two shots cannot be edited together. This is called a continuity break.

The cheapest and easiest way to avoid lapses in continuity, from costume, props, and hair to looking directions and repeating lines of dialogue, is to play back your digital video recording to the scene or shot in question. Obviously, using some kind of visual slating (even on a piece of paper) will make it easier to locate your scenes and takes, especially if you want to continue several hours, days, or weeks later.

def•i•ni•tion

An essential aspect of filmmaking, **continuity** refers to the process of ensuring consistency within the movie. All the visual aspects of a movie, from the way the actors look to the scenery to the sound, must remain the same from one take to the next, so the audience doesn't notice cuts or edits, but can follow along in a seamless, uninterrupted flow.

Costume Designer

The costume designer is responsible for the clothing—wardrobe—worn by the actors in a movie. On a low- or no-budget film, it's often best to just give your actors an idea of the way they should look and ask them to come dressed in the appropriate attire.

Grip and Gaffer

One of the two terms everyone's heard but doesn't really understand, the grip is generally the lighting and electrical technician on a movie. The grip works with the DP to set up the correct lighting and equipment for a scene.

Another function of a grip is to help operate the camera support equipment, especially the dolly. The grip pushes the entire camera assembly wheeling on a dolly. Grips often also help with some carpentry and set construction, and, on low-budget productions, they even help in set decoration.

Basically, the gaffer is in charge of setting up and maintaining the lighting, and is sometimes known as the chief lighting technician. For a smaller movie, the grip and gaffer are often the same person, just as the DP and director may be the same person.

Music Composer

Music establishes the mood for your movie, and I know you cannot wait to mix your favorite music with your digital video to show it to your family and friends. Well, most of the time that is all you are allowed to do; without purchasing the rights for that piece of music, you are prohibited from playing it to the outside world.

The solution is to get someone to compose music for you. Using music software (such as SoundTrack or Garage Band), some local musician friends can provide you with music that you can legally use anywhere.

Digital Video Editor

The last member of a basic crew, the editor assembles or "cuts" together the finished movie. He or she will often work in conjunction with—or act as—the director to guarantee the cinematic integrity of the director's vision, and to ensure that the story is told in a coherent and understandable way.

So now that you've gotten your ideas, and learned the basics of preparing for your movie, it's time to jump into the first step—writing a great script, or even just a great outline. The next chapter will show you just how to do that.

Summary and overview of the entire digital video process.

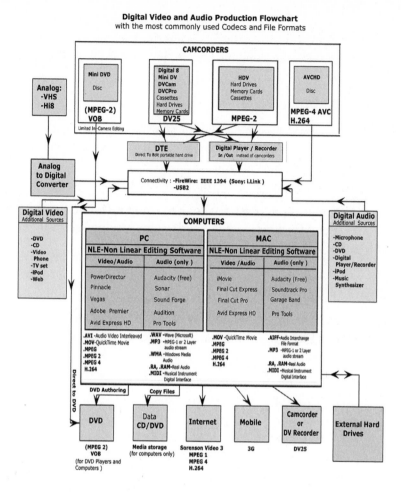

The Least You Need to Know

◆ You can never spend too much time planning. The quality of your movie is often directly related to how much time you spent on it up front—so don't rush in without putting some thought into it.

◆ The Internet is a good place to go to recruit help—whether it's in front of the camera or behind.

◆ Even if you think you can do it all by yourself, it's a good idea to have at least a few others to help out as your crew.

Writing, Rewriting, and Going Scriptless

In This Chapter

- ◆ The various screenplay structures

- ◆ Basics of screenplay content, plots, and subplots

- ◆ The importance of working with a good script

- ◆ Knowing when to rewrite and when it's not necessary to use a script at all

It has been said that you can make a mediocre movie from a great script, but you can never make a great movie from a mediocre script.

It's all well and good to add cool special effects, even better if you can cast great actors, but without a good story, it's next to impossible to make a good movie. Of course, if your objective is just to use this book to improve on your home movies or improvise short videos that you're looking to post on YouTube, a screenplay may not be essential. But a minimal written plan—even just an outline—certainly couldn't hurt.

Lessons on script-writing paradigms could fill a whole book (and if you're interested in exploring screenwriting further, check out *The Complete Idiot's Guide to Screenwriting* by Skip Press).

Here, our main concern is the newly emerging field of digital scriptwriting which, believe it or not, might even lead to writing without writing.

Well, sort of.

Digital "Writing"

Digital writing means computer-assisted writing. In this day and age, it's easier for some to just talk through their ideas and stories into a digital audio recorder, then download that in to their computers via some speech recognition software (such as Dragon for Windows and iListen for Macs). These programs can transcribe spoken sentences into written form inside your computer. Or you can talk directly into your computer via USB microphones.

Programs available for both PCs and Macs work with varying degrees of success in training computers to recognize your voice. Successful transcription also depends on possible dialects, accents, and other individual speech patterns.

Examples of some of the most common voice recognition software available today: Apple's iListen, Dragon's Naturally Speaking, and IBM's ViaVoice.

Although computer speech recognition is still in its infancy, it may very well be the wave of the future, considering that all the complicated software programs around us require the memorization of thousands of keystrokes described in thousands of pages of manuals. Voice commanded computers capable of translating simple oral instructions will only increase in the future.

But even if these programs do not work well enough yet for you to write with, you can still use one of the many small digital audio-recorders to dictate ideas, then download the recordings to your computer as audio files for transcription. The moment your ideas are stored in any written form in the computer, you can use the reverse

process of speech recognition (called the text-to-speech [TTS] function), which makes your computer read back what you have just written to you in a synthesized voice. This is a very helpful feature for writing, as scriptwriters need to hear how, for instance, a dialog scene works. This digital feature allows you to actually "cast" different male and female synthesized voices to read aloud the scenes when no live actors are available. Many computers come with a cast of voices built-in, and you can change these voices by altering the frequency, pitch, timber, and so on.

These two opposite technologies, speech recognition and text-to-speech (TTS), are aimed at not only helping you to write but also to manage your communication with computers and even your own business endeavors. Microsoft has just installed sophisticated speech recognition in Windows Vista and is determined to further develop speech software in the future. (For more information, check out www.microsoft.com/enable/products/windowsvista/speech.aspx.) As writing technology evolves it definitely will involve computers that listen, talk, understand, and even respond to the writer.

The Basics

Whether you choose to work digitally, by hand, or even from a script, you do need to know some of the basics of scriptwriting. And one of the first things you need to know is how to create a *logline*. If you can describe your video in 25 words or less in an exciting way, you're well on your way to having a tight idea for a storyline you can follow with or without a script.

def•i•ni•tion

A **logline** is a summary of your plot in one sentence (typically in 25 words or less). A strong logline usually focuses on the concept and does not give away the ending. For example, Yahoo Movies lists the logline for the film *Almost Famous* this way: "Loosely autobiographical story of a young high school journalist who's presented with the opportunity to follow a rock band in order to get a story."

Writing a Screenplay

If you've never seen a properly formatted script before, you should really examine some to get an idea of the correct look and feel of a screenplay.

Generally, with standard spacing, font, and point size, one page of screenplay is equivalent to one minute of screen time. This includes action, dialogue, and description.

It's not always an exact measurement, but it's a good rule of thumb to plan out your schedule. This is why every professional screenplay is formatted in the same way—so that the director, actors, and producers know how much time they will need to film a particular scene.

Spacing and Formatting

To get an idea of how your screenplay should be formatted, take a look online at free screenplay databases such as Drew's Script-O-Rama (www.script-o-rama.com/oldindex.shtml), Simply Scripts (www.simplyscripts.com), or any number of other sites that provide free screenplays for educational use. Print out screenplays from some of your favorite movies, and study the way they are written. Screenplays have a very particular lingo and writing style, and the only way to really come to understand how to write them is to read scripts.

Quiet on the Set!

Make sure that the scripts you're reading are screenplays, not shooting scripts. Shooting scripts are the version of the screenplay that the director uses to shoot the movie—and they're typically full of information that you shouldn't put in if you're writing your own screenplay. For example, a shooting script will often be numbered in the margin and contain specific shots, along with camera movement and angles. If you see this information in the script you're reading, find another version to study.

Length

The length of your screenplay may vary depending on whether you're shooting a full-length digital film or a short film, but you should follow some basic guidelines. In Hollywood, the standard length of a feature film is between 90 and 120 pages. A typical screenplay of this length will result in a movie that's between an hour and a half and two hours long. Keep in mind the rule that one page of script equals approximately one minute of screen time, and you should be able to easily gauge how long your video will be based on the length of the script you're shooting from.

Screenwriting Software

Once you've read a few screenplays and have a basic idea for the structure and terminology, it's time to put your ideas down on paper. An easy way to make sure you have the correct structure is to use screenwriting software, which automatically formats your script. The most popular screenwriting software programs currently on the market are Final Draft, which is available at www.finaldraft.com, and Movie Magic, which is available at www.screenplay.com. Other programs are out there, as well—make sure to also check out Sophocles (www.sophocles.net) and Script Buddy (www.scriptbuddy.com). But because these programs can be expensive, it's a good idea to download the trial version first to see which one you're most comfortable with.

And don't forget to check out the free screenwriting software program Celtx, available at www.cltx.com; this program is remarkable not only because it's free, but also because it offers you a chance to display and discuss your script with an online community of writers. Another great advantage of Celtx is that you can import your script into Celtx's storyboarding as part of your previsualization (see Chapter 8).

Battle of the Stars: Final Draft and Movie Magic

Currently, Final Draft and Movie Magic Screenwriter rule the screenwriting software market. Both contain full versions of screenplay formatting programs and are capable of reading back the scenes to you with a virtual "cast" of voices. While both programs are great, Movie Magic has always been more "production friendly"—which means that changes made in the script automatically ripple through the Movie Magic scheduling and Budgeting software, as well.

Movie Magic Screenwriter was released before Final Draft, but recently Final Draft has been catching up with features that used to give Movie Magic an advantage, especially in the area of preparing a script for production. For example, Final Draft 7 has just introduced "Tagger"—a *script breakdown* feature that has been available for Movie Magic users for a long time.

def•i•ni•tion

Script breakdown is a report that lists all the elements of a scene—cast, crew, wardrobe, props, equipment, and so on—on a template for the purpose of production organization.

An example of a script break-down sheet, which compiles all the essential information for a scene into a one-page quick reference.

SCRIPT BREAKDOWN SHEET	
Title	Prod No.
Director	Page No.
Location	
Script Page Numbers	

Day	Night	Season	Period

Scene Numbers and Synopsis	Cast and Costumes
	Bits
Props	Extras
	Miscellaneous

To cut down on expenses and simplify the process for beginners, Movie Magic Screenwriter has released a consumer version of its formatting software called The Hollywood Screenwriter, which is available as of this writing for $59.95.

Organizing Your Ideas in a Screenwriting Program

Whether you want to write a screenplay or just shoot something without a script, you need to come up with some sort of preconception and organization of your ideas and intentions. This requires some kind of outlining and various programs are available to help either in formatting or actually developing these basic elements.

Both Final Draft and Movie Magic Screenwriter allow you to read, organize, and print out your writing on index cards with the most basic information, such as the scene heading (location and time of the day), and the description of main action of the characters. These cards make it very easy to think through your structuring.

Karl's Tips

The easiest way to conceptualize an outline is to list your locations and who will do what on index cards. Try to put them in story or event order and you'll get what is called the "step outline," which forms the spine of your video. This is exactly what we did to develop our screenplay for the World War II full-length feature film, *Forced March*, with producer/co-writer Richard Atkins.

A fairly new program, Movie Outline, has been designed to assist you in this most essential task. It is available on both PC and Macintosh platforms.

Screenwriting programs make it possible to concentrate on your concept without having to worry about formatting. Of course, you can just learn basic formatting (12-point Courier font) and spacing and type your screenplay up yourself on any word processing program, but screenwriting programs really are worth the investment if you want to make digital videos on a regular basis, as they automatically set up the proper margins and spacing for the essential screenplay elements such as the scene headings, transitions, character names, dialogue, action, shots, and parenthetical elements—leaving you to focus on the content. And for time savings and a professional look and feel within the script, screenwriting software really can't be beat.

An example of a properly formatted script. The program used here is The Hollywood Screenwriter, but any good formatting program will produce a script that is set up correctly.

Conceptualizing

One of the best sources for conceptualizing the basic elements of a story is a tiny book, *36 Dramatic Situations*, by a nineteenth century European professor, George Polti. Quoting Carlo Gozzi, the writer of such plays as *The Love of Three Oranges* and the opera *Turandot*, Gozzi and later Polti stipulated that there have always been—and cannot ever be more than—36 dramatic situations. Polti organized this theory into a detailed study complete with examples and explanations.

> **Zoom In** _____
>
> The great playwrights Goethe and Schiller corresponded about Gozzi's original assertions and decided to try to prove him wrong. But in testing Gozzi's theory, Schiller had to admit that he could not come up even with 36 basic dramatic situations!

To find simplified versions of Polti's 36 dramatic situations, check out the website www.gamedev.net/reference/articles/article255.asp

The bad news is that "there is nothing new under the sun"; the good news is that it is relatively easy to figure out the basic dramatic situation (conflict) of your story, and what and who are the main ingredients and characters necessary to form the core of your story.

The simplest way to construct or retell any story is to define the main characters (protagonists); their goals, dilemmas, or predicaments; and the enemies or obstacles (antagonists) in their way.

Defining Characters

Characters can be defined in many ways, but here's an example using the program Character Pro, which bases its development on a psychological personality-typing system (the theory of the Enneagram) to develop well-rounded characters. Character Pro took the theory of the Enneagram as its starting point. The word itself and the figure of the Enneagram go back to the ancient Greek, meaning and being a nine-pointed diagram (see following figure). (To learn more about the enneagram, check out *The Complete Idiot's Guide to the Power of the Enneagram* by Herb Pearce, M.Ed., with Karen K. Brees, Ph.D.)

> **Karl's Tips**
>
> Another digital writing tool called Character Pro can help you define and develop these leading and supporting or opposing characters.

Specialists have adopted the theory of the Enneagram to reduce human personalities to nine basic types with two additional sub-types for each. In Character Pro, these personality types and a carefully designed series of questions help the screenwriter develop characters, and prevent them from overlooking any significant aspects of creating characters. It is a

playful yet quite useful way of helping with characterization and alleviating writer's block. For more information, check out www.characterpro.com/characterpro/ CP5tour.htm.

The Peacemaker

This enneagram illustration outlines different personality types that your character may fit.

And now that you have a basic idea of your story's outline and how to develop your characters, it's time to move on to …

Simple Structure

The structure of a screenplay usually refers to the accepted way of writing the average feature-length screenplay. No matter which structure you use, remember that it is just a guideline and is not meant to limit you; however, anyone starting out in screenplay writing would do well to at least understand the structures and their place in the world of screenwriting.

Traditionally, movies follow a standard three-act structure (which consists of a clear and defined beginning, middle, and end). This probably seems obvious, and it's likely that you're already familiar with this structure just from casually watching movies. But here's something you may not know—this structure was first analyzed, broken down, and put into book form *in 350 B.C.E.!* The Greek philosopher Aristotle goes into great detail about the three-act structure in his seminal work, *Poetics*, which can be used to examine and evaluate most movies today.

Aristotle's *Poetics*

The structure discussed in *Poetics* was obviously not formulated for movies. Aristotle studied the most successful plays of his day to break down what made them so popular. His findings still hold true today, and *Poetics* is worth reading to understand how to make your video more universally appealing.

In Aristotle's structure, the three acts work like this:

- Act I: the setup (this happens during the first 30 pages of a standard full-length screenplay)

- Act II: the main conflict (this occurs for the middle 60 pages of a standard screenplay)

- Act III: the resolution (this is the last 30 pages of a standard screenplay)

Each of Aristotle's three acts is a complete part of the overall story; this means that within each act, there exists its own beginning, middle, and end. These parts all fall within the parameters of the story's overall beginning, middle, and end. For more complete information, you can find the content of *Poetics* not just in book form, but on many websites online, as well. One online place to find Aristotle's *Poetics*, in its entirety, is at the website for MIT's Internet Classics Archive: classics.mit.edu/Aristotle/poetics.html.

Of course, largely due to the digital age, many films and videos today entertain non-linear structures, wherein Aristotle's three-act structure is presented out of order. This brings to mind the famous French director Jean-Luc Godard's premonition, which preceded digital media quite a few years: "Every film has a beginning, a middle, and an end, but not necessarily in that order."

Another interesting aspect of Aristotle's aesthetics is that he gives priority of *plot* over character.

def•i•ni•tion

Plot is a series of events in which a story unfolds.

By emphasizing plot over characters, Aristotle advocated action-oriented stories over character-driven ones. This, of course, was derived from Greek mythology, where human characters were subjugated to the gods, and humans' fates were predetermined by the gods. Because characters in most action films are secondary to plot, we might say that Aristotle was the first Hollywood executive!

On the other hand, character-driven stories basically believe that the fate of humans can be shaped by their free will. Considering that Aristotle's theories are at the heart of all storytelling, he is part of all present and future digital writing software.

Joseph Campbell's Monomyth

Some variations of content structure are also equally popular in the filmmaking world, such as Joseph Campbell's monomyth theory, also known as the Hero's Journey.

Joseph Campbell devoted much of his career to analyzing myths, legends, and all the "great" stories of the world to discover what made them so universally appealing to culturally diverse audiences in their different permutations and incarnations across the globe. He studied the structures of these stories and discovered that they all had something in common. In brief, Campbell realized that each and every "great" story consisted of a hero who goes on a journey of some kind to obtain an "elixir," something that is of vital importance to the hero or the hero's community, then returns home changed for the better by the journey itself.

This type of storytelling structure is detailed in Campbell's 1949 book, *The Hero with a Thousand Faces*, and is most famously presented in the (original) *Star Wars* trilogy. In Campbell's monomyth, the hero starts in what is known as the "ordinary world." He or she then receives a "call to action"—the chance to go on an adventure that will ultimately change him or her for the better—a call which he or she typically refuses at first. But the hero just can't resist and one way or another winds up on the adventure—in the realm of the "special world."

Once inside the "special world," the hero will face tests, trials, and challenges on the journey. He or she will meet adversaries and maybe a mentor or two. Eventually, the hero will find the thing he or she is seeking on the journey—the "elixir"—and must decide whether or not to leave the special world a changed person and return home with the knowledge gained from the adventure.

Although not every successful movie fits this paradigm exactly, most include many, if not all, of the "steps" Campbell outlines along the way. For an unparalleled education in the structure so many screenwriters and filmmakers closely follow, invest some time in reading *The Hero with a Thousand Faces*.

Zoom In

Two highly respected Hollywood story analysts, Michael Hauge and Christopher Vogler, have come up with a digital adaptation of Campbell's theories in a collection of DVDs: *The Hero's 2 Journeys*. In the third part of their DVDs, they apply their Hero's outer and inner journey to the heroine of the popular film, *Erin Brockovich*. For more information, check out the website: www.writersstore.com/product.php?products_id=1977&cPath=131_177&affiliate=ZAFFIL596.

Syd Field's Paradigm

Another important screenwriting structure is presented in screenwriting guru Syd Field's well-known book *Screenplay*. Simply called the Paradigm, this structure is a variation on Aristotle's three-act structure that breaks the middle act into two smaller acts. Field's structure is notated as Act I, Act IIa, Act IIb, and Act III, and also focuses on the idea of plot points or "turning points" in which goals that must be achieved are presented (more on these below).

According to Field, the successful Hollywood screenplay consists of the following:

♦ Thirty pages of "setup," which introduces the main characters, the world in which they live, and the conflict(s) that will be addressed within the course of the story.

♦ The first plot point, which presents a goal that must be achieved or a problem that must be solved.

♦ Thirty pages of conflict in which the protagonist meets obstacles that must be overcome before coming to the midpoint, another subtle turning point which often consists of a reversal of the protagonist's fortunes.

♦ Thirty pages of the protagonist's struggle to finally achieve—or fail to achieve— the desired goal and the end result of that struggle.

The following diagram demonstrates in a simple form the Syd Field Paradigm:

This is a visual representation of Syd Field's Paradigm.

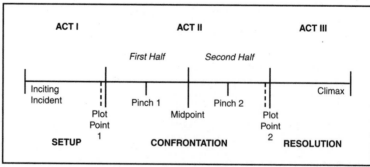

As you can see, the three acts do not follow each other in a flat line, but instead show a rising action as the story progresses, with major plot points (twists) right before the end of each act, and leading up to the climax that is the highest point of conflict—the bursting of the bubble that leads to the resolution of the story.

Syd Field's theories and writing exercises have also been issued in digital form, teaming up with Final Draft. (See Final Draft 7.1.3 and Syd Field's Screenwriting Workshop DVD.).

John Truby, Robert McKee, and Ken Dancyger

John Truby rejects the three-act structure altogether and seems to replace it with Campbell's Hero's Journey. A very useful digital set developed by Truby is the 13 major *genres*, each detailed on a separate DVD.

Genres express certain expectations of the audience. When you know that a film is a Western, you know basically what to expect. (Well, great filmmakers always surprise us with some personal twist of the genre. A recent twist in the Western genre was Ang Lee's Oscar-winning *Brokeback Mountain*.) Another good example of a recent genre twist is Rian Johnson's reinterpretation of the noir film in the critically acclaimed *Brick*, which is set—surprisingly—in a high school, yet retains all the thrills and "crime speak" of a traditional noir.

def•i•ni•tion

Film **genres** are different types of movies that are characterized by common elements of subject matter, main characters, dramatic situations, and pictorial and musical styles and tones.

Genres are so basic to filmmaking that nothing, no video that you ever want to make—even without a script—would not fall into a genre or a sub-genre or a combination of them. Genres are almost impossible to escape. Go to www.truby.com to learn more.

Robert McKee's teachings center around his nuanced anti-formulaic interpretation of the "story" that is also the title of his book and the basis for his always sold-out international traveling seminars. Read his book or go to www.mckeestory.com/outline.html to find out more details.

The East Coast's most influential screenwriting theorist, Ken Dancyger, has examined both the Hollywood formula and alternative ways of going beyond it, especially in *Alternative Screenwriting*, which he co-wrote with Jeff Rush. The alternative examples for two-act structures like Stanley Kubrick's *Full Metal Jacket* or alternative structures like Spike Lee's breakthrough work *She's Gotta Have It* are very convincing. What's different here is that this new approach was done without the rejection of the Hollywood three-act formula; instead, Dancyger and Rush open up additional opportunities for "writing beyond the rules."

The "10-Page" Rule

And speaking of rules, also worth mentioning here is the "10-page" rule. It is often said that the first 10 pages of a screenplay are the most important. They have to grab the audience's attention by introducing the main character(s) and setting up what the story is about. The dramatic situation is usually defined by page five—so keep that in mind when moving your story along.

All this can sound pretty complicated and confusing if you haven't studied these very specific writings. Yet Aristotle's, Joseph Campbell's, and Syd Field's theories are all structures you really should be familiar with—if only to break from them—if you're serious about screenwriting. But if you're a director working with someone else's script, all you really need to understand is the basic components that you'll find in almost every great movie, which you'll find in the next section.

Content Basics

Obviously, the main aspects of a screenplay are action and dialogue. Action is what we see happening on the screen; dialogue is what the characters say. In addition to these two halves of a screenplay, a few major elements occur in almost every movie that follows an accepted structure. They are:

♦ **Establishment of character:** It is often said that "action is character"—in other words, your characters' motives in a movie often reveal who they are. Which is all well and good if *you* know who they are first! Creating strong, identifiable characters who know what they want is the first step; once you have that you can start to decide how they'll go about getting what they want. (See "Defining Characters," earlier in this chapter, for some ideas about personalities.)

♦ **Inciting incident:** This is the event that propels the story forward to the first plot point. Sometimes called the "catalyst," this is the point in the story when the hero encounters the problem that will change his or her life.

♦ **Plot points:** Plot points are important structural functions that happen in approximately the same place in most successful movies. The plot point happens when an event spins the action around in another direction. Plot point I usually occurs around page 30 and plot point II comes in around page 60 in a full-length screenplay.

♦ **Climax:** This is the most exciting point in the movie, which occurs after the second plot point in a full-length screenplay.

♦ **Resolution:** This is the place in the screenplay where conflict comes to an end, all the loose ends are tied up, and the *central dramatic question* is resolved.

def•i•ni•tion

The **central dramatic question** is the line of action that drives the movie. In *Rainman*, the central dramatic question is "Will Charlie Babbitt come to terms with his father?"; in *The Wizard of Oz*, it's "Will Dorothy make it back home to Kansas?" The central dramatic question can be directly related to the hero's external goals but is often also related to his or her internal goals, as well.

But I'm getting a little ahead of myself here. It goes without saying that you need a story to write a screenplay, and to write that story you need a main character, a conflict, and a resolution. After you've identified those main components, you can move on to consider the specific obstacles you want your main character to confront on his or her road from the beginning of your story to its resolution. Depending on the complexity of your screenplay and what you will be working from, it may not be necessary at this point to figure out everything explicitly—it may be enough to pinpoint the main points of your character's struggle. But once you've done that, you've identified all the content basics of your main plot as just listed. Congratulations!

Now you're ready to move on to something a bit more advanced—the sub-plots. Sub-plots contain all the same elements as the main plot—character, conflict, and resolution. Sub-plots advance and run parallel to the main story, and exist to add interest and texture to your movie. They often involve secondary characters who interact with your main characters and have direct effects on the main plot without overshadowing it.

Sticking to the Structure

Efficient structuring of a screenplay is essential to avoid digressions and to get as much information and texture into each scene in as little time as possible, while keeping the pace and retaining the audience's interest. So whether you're writing a five-minute short or full-length movie, you must consider each scene carefully, for effectiveness in and of itself and its place within the story's larger picture. The larger picture is known as the *through line* of the story.

def•i•ni•tion

The dramatic **through line** of a script encompasses not only the premise of the story, but also all the obstacles the protagonist will face along the way.

It's important to remember that scenes should exist to serve the greater purpose of the story. In the course of story development, you may consider many different paths for your characters to take to achieve their goals, but keep in mind that the conclusion is only satisfying to your audience if it's the only reasonable conclusion possible. This is why it's so important to stick to the structure—to keep on track with your through line and come to the only conclusion possible for a satisfying ending.

Story Development in the Digital Age

The most significant change that has influenced screenwriting in the digital age is the emergence of "story development processors." These are software programs that go beyond merely formatting the pages of the screenplay; these programs are involved in writing the content of the scripts.

The Collaborator and Dramatica

The Collaborator and Dramatica have been pioneers in the field of story development software going back to the late eighties and early nineties.

The Collaborator used the three-act formulaic structure and a Socratic method of asking a series of questions, while Dramatica developed drama theories that were so complicated at first that they had to be simplified over time. Nevertheless, Dramatica is still one of the leading story processors in use today. It is a comprehensive software that helps you from the brainstorming of ideas through story and character development to scene construction during the entire process of screenwriting.

Dramatica Pro is the more complicated, more expensive professional version of this remarkable story processor. There is also a simpler and less expensive ($59.00, as of this writing) consumer version available for beginners, called The Writers Dreamkit. For more information, go to www.screenplay.com/products/wdk/features.htm.

But whether you develop your story alone or with digital story developers, you still need to have a strong idea of what works best on the screen. This means you need an understanding of visual storytelling.

Visual Storytelling

The adage "show, don't tell" is often repeated in different types of creative writing. What it basically means in digital video is that visible behavior is more effective than other forms of *exposition*, such as monologue.

In screenplays, exposition can be expressed through dialogue or physical actions. And although it can be difficult to resist simply giving the audience the information you want them to know through outright dialogue, showing them the same information through an action they can analyze for themselves can make for a much more interesting and involving screenplay.

def•i•ni•tion

Exposition is the revelation of background information about the characters and their circumstances. It also explains the conflict between the characters and the story's theme.

For example, if your main character is upset about a fight he just had with his wife in the last scene, you could have him recount the fight to a bartender in the next scene, then verbally come to a decision about the action he will take next. This would work, but it wouldn't be as interesting a scene as if you just showed him sitting at the bar, contemplating his situation while nursing his drink, then suddenly standing up with a determined look on his face and rushing out the door. Your audience would get the same information from the character without having to sit through a repeat of the altercation they just witnessed in the scene prior.

Action and Directions

You can quickly and efficiently convey the time, place, and overall mood of a scene to the audience through visuals that are described in the actions and directions within the screenplay. These directions are written descriptively with action verbs, and appear in present tense within the screenplay.

These directions set the characters in the environment of the screenplay with descriptive passages that indicate where and when the scene takes place. Pay close attention to specific visual details that provide the audience with information that is essential to the premise of the movie.

Karl's Tips
There's much to writing screenplays. It can take years of study, practice, and trial and error to even begin to really "get" how to write well in this genre. But let's face it: you're eager to get working on your digital video. So let me just leave you with this advice— it's great to read all you can about screenwriting basics and study your favorite films to learn how they were written, but the best way to learn is to jump in and begin to write. And rewrite. And write some more.

A new software program, Story View, actually visualizes your screenplay in a timeline format that is very similar to the timeline used in editing (see Chapter 16 on editing.) The program is very helpful to track the structural development of your script that you can later use even in the editing process.

Story View software helps arrange your story visually by displaying it on a timeline.

Using—and Not Using—a Script

Well, I've devoted much of this chapter to properly writing a script, so it must be apparent where I stand on the importance of the script. You wouldn't set out to build a house without a blueprint, and the same goes for making your video.

Not only does a script tell you exactly how long each scene is and allow you to plan your shooting schedule, it also helps your actors be on the same page. It's a lot easier to direct your actors properly if you're all following the same set of "guidelines" for the story.

Of course, even with the best script, sometimes you need to make some changes while you're shooting. Maybe a location you wanted to use fell through; maybe it rains and you need to incorporate the change of weather; maybe an actor you were counting on couldn't commit to your shoot. Or maybe something happens that simply changes your idea of the movie, and you think of a better idea. In any of these cases, it's helpful for you to know how to rewrite on the set to stick with your schedule, stay on budget, not waste anyone's time, and finish with a result that you're happy with.

Rewriting as You Shoot

If you find yourself in a situation where you want to change the script, sometimes it helps to sit down with the actor and "role-play" your way into a revision. Your actors may have a very specific idea of the way their characters act and feel, and may have even constructed a background for them that allows them to decide how they will behave within the confines of the movie.

Quiet on the Set!

To help keep your story clear and in focus, it might help to make a list of your screenplay's plot points and act. This outline will be the framework on which all your details are built. This way if, during production, you decide that certain changes will make your story even better, you can implement them without fear of deviating too far from the overall story. As long as you stay within the parameters of this framework, your story will retain its focus even with the changes you've made.

Is a Script Always Necessary?

More often than not the script is an important factor in making a great video. But many instances exist in which a script is not desirable, or even possible. In these cases, you need to know how to work without one.

Let's say you're planning to make a documentary, or shoot a wedding video. There's no real way to make a formally structured script work for a project like this, so one way to approach shooting in this case would be to work solely off a detailed, fairly complete outline of the important events that you absolutely must capture to make the video a success.

In the case of a wedding, your outline might consist of everything from the bride's entrance and walk down the aisle to the throwing of the bouquet and the cutting of the cake. You may include a list of essential "interviews" from everyone from the

father of the bride to the flower girl. And of course it would be great to end with a shot of the happy couple riding off toward their new future—but of course you can only do that if you remember to shoot that scene in the first place. The same goes for shooting a documentary or any other type of video in which you're essentially flying by the seat of your pants.

Whatever form your digital video takes, though, it's important to recognize the role the screenplay will play in its creation. Once you determine how much or how little your creative team will rely on a script, you can then figure out how much time you'll need to devote to its creation, editing, and rewrite.

The Least You Need to Know

♦ Learning to write a good screenplay can take years to master, but a good place to start is by understanding the main screenplay paradigms the professionals use.

♦ Have a detailed outline or list of major plot points and events that your story will follow, to ensure that the through line stays intact even if you make changes resulting from on the spot rewrites.

♦ Some forms of digital video won't require a screenplay to be effective. Almost all forms benefit from following an outline, however, no matter how informal it may be.

Previsualization

In This Chapter

◆ Visualizing your project

◆ Storyboarding your project

◆ Getting the most of storyboarding software

Even if you're about to shoot an unscripted project, or you're simply uncertain about how to shoot your project, rendering your shots and scenes before the actual photography will help you get there.

Presumably you have a pretty good idea of what your video will be about. The next step is to figure out exactly what the scenes and the shots will each look like. That's where *previsualization* comes in.

Thinking Through the Scenes

Sit down with a pad and a pencil or pen and make a rough outline of your project. This will help you firm up your visualization and give you a good idea of how many scenes you need to tell your story. I recommend picking a relatively simple story for your first project so that you won't get bogged down in a complicated storyline. You can always make your future projects more complex as you learn how things are done.

You may prefer to just have your handwritten notes and the visuals in your mind for a simple project, but you will profit more from the experience if you follow a more formal procedure. Usually this involves having a more or less complete script and then developing a set of storyboards from that.

def•i•ni•tion

Previsualization is not a proper word in the English language. *Visualization* means forming a mental image of something. It also means "making it visible": to realize on film or tape what preexisted in the script or the imagination.

Even in nonscripted projects that use no storyboards, it is still essential for visualization to make a shot-list and an overhead layout based on location scouting and an understanding of what are the essential elements to cover in a scene and with what kind of shots: wide angle (master shot) and closer shots (medium shots and close-ups).

Storyboarding

If you're a fan of comic strips, comic books, or graphic novels, you're already familiar with how storyboarding works. Each panel in the comic represents a brief segment of time, and they combine to tell the story. You can consider your storyboards as your comics, telling your story by each shot or scene in your video.

Storyboards visualize shots in script order; however, due to production considerations like lighting angles, availability of actors, performers, sunrise/sunset, or simply moving the camera from one spot to another (called set-ups), single-camera productions are almost never shot in script order. The order of shots depends on your different camera positions. Because moving the camera set-up takes time and effort, especially if you have to reposition the lights as well, the way to execute your storyboarded shots is to get as many shots as you can from as few different set-ups as possible. Once you position the camera, you shoot all the shots you want from that angle before moving to another set-up.

Therefore, in preparation for shooting you must assign the shots from your storyboard to the different camera set-ups. This calls for the use of overhead layouts, shooting scripts, and shot-lists. This is the only way to "make the day," or get all your planned shots within a day's schedule.

Professionals rarely storyboard an entire project, only scenes that require shot-by-shot preplanning, like stunts, explosions, and the like, but a basic requirement on every production is a shot-list written by the director for every day. The shotlist is prepared from the shooting script, which is the final draft of the script with the actors' and the cameras' movements written in all caps. Called "blocking," these movements and shots are decided during rehearsals.

Together with extreme close-ups of details (like a cigarette butt still burning in an ashtray), called insert shots, all the shots you plan to provide as ample material for editing is what we call the *coverage* of a scene. The more experienced you are, the easier it is to plan your coverage for your shoot.

Zoom In _____

A scene-by-scene shot-list has two main goals: to record the shots that are absolutely necessary to cover the scene (called "coverage") and, if time permits, shoot beautiful shots that visually enhance the scene (called "beauty shots").

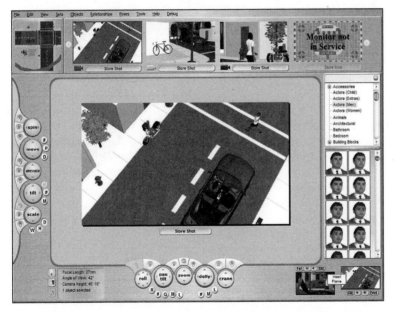

Using storyboarding software such as Frameforge 3D Studio 2, you can "preshoot" your scene in 3D using a large library of characters and locations.

But how detailed you make your storyboards or how short the time segments you break your story into is a matter of personal preference. Some prefer a storyboard that shows every camera shot, even working out the length of each shot in advance, while others prefer a more general treatment. You may take several projects before you know what works best for you and the people you work with.

Storyboards help to better convey what words can only approximate. The Hollywood industry in the 40s used storyboarding of the movies extensively. Among today's filmmakers, the Coen brothers are famous for storyboarding practically every single shot.

Expensive or difficult, "one-take" scenes of explosions, stunts, accidents require storyboarding in order to save money by the visual planning.

You can also use storyboarding software on the set to help your actors and crew visualize exactly what you want from a scene.

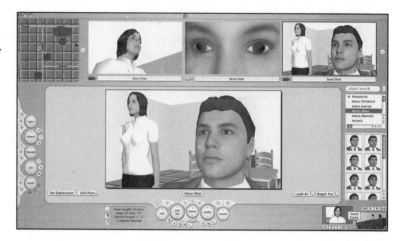

Zoom In

In spite of utmost secrecy, the 19-page storyboard of one of the most expensive explosion scenes in the James Bond movie *Casino Royale* was lost. As it turned out, it was left behind after some boozing in a London pub, luckily it was returned to the filmmakers without getting publicized on the web before the movie's release.

Animatics

In advertising, it is general practice to shoot the storyboarded concept with sound and music before actually spending money on the shooting of the expensive commercial. This process creates *animatics*. It has become a good fundraising tool for less-established filmmakers to use storyboard animatics to augment their screenplays as an integral part of their presentations for prospective investors.

def•i•ni•tion

Animatics are filmed or taped versions of storyboard drawings, rough animated versions of what a final video will look like.

Due to their complex visuals, many music videos use storyboards and animatics extensively in planning. The shots of the storyboard are edited to the master mix of the song.

Storyboarding by Hand

You don't need real artistic ability to create storyboards by hand. Some storyboards just use stick figures to show what's going on in a scene. Beautifully drawn storyboards look much nicer, but don't necessarily work any better.

Storyboard artists are still hired by productions with larger budgets, however, and storyboarding is still a way for people with good illustration skills to break into the field. In fact, some storyboards are so attractive that they have been published in book form, and many are included in DVD special features.

You may find free templates for hand-drawn storyboards on the web at www.pdfpad. com/storyboards.

You can print free blank storyboards in different aspect ratios (4:3 for television frames, 16:9 for widescreen HD/HDTV and Super 16mm film frames, and 1.85:1 movie frame aspect ratios) from this PDF storyboard generator: incompetech.com/ beta/linedGraphPaper/storyboard.html

Still Photographs

If you have no artistic ability and want a more polished-looking storyboard, consider putting your storyboards together from still photographs. The easiest way to do this is to use a digital still camera and import your images into photo editing software like Adobe Photoshop or Photoshop Elements. Use the software to resize the images and combine several onto one page. You can draw on the images, add text notes, and modify the images in any way you wish.

With Software

If you want storyboards that look really professional, consider working with storyboard software. These programs range in price from very inexpensive shareware up to moderately expensive but very powerful software applications. We tried the best-known ones in preparation for this book, but new products are introduced all the time, so do an Internet search on "storyboard software" to see what's available before you decide.

Celtx is a web based comprehensive preproduction software bundle that includes a storyboarding feature free of charge. It allows you to import shots from a digital camera as well. Check out their digital video tour at: www.celtx.com.

Some dedicated storyboarding applications include:

Storyboard Tools

Storyboard Tools is a shareware download for Windows (www.freefilmsoftware. co.uk, $20) designed as an organizational tool for storyboard artists and filmmakers. Storyboard Tools uses a simple and straightforward interface to allow you to create effective storyboards. You don't need artistic ability; it allows you to import images from various sources to build a storyboard you can show as a "slide-show" with editing effects or print for use on the set. Storyboard Tools lets you store a caption and any amount of text with each image. Once you complete a storyboard, you can use the stored text to automatically generate tables and checklists to use on the set to know exactly what you need and what you're shooting next.

Using Storyboard Tools, you can import drawings and images to create a storyboard for your video.

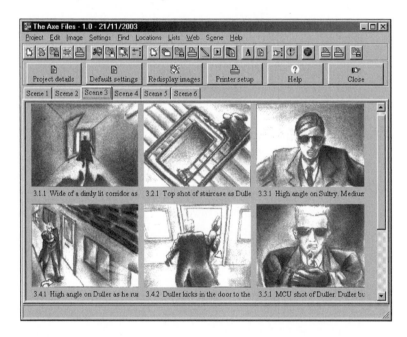

You can also create a webpage from the storyboard with the click of a button, so that cast and crew can see the storyboard from anywhere prior to production. Storyboard Tools has drawing tools with features just for storyboarding. A "visualizer" feature lets you view images in sequence and experiment with editing effects, including fades and dissolves. (See Chapter 17 on editing effects for more information.)

In brief, the features of Storyboard Tools include specialized drawing tools; the ability to store any amount of text with each image; the ability to store an entire storyboard as

a single file; the ability to swap, cut, copy, and paste images; the ability to swap, renumber, and delete whole scenes; and the ability to print the storyboard in portable form.

Springboard

Springboard (6 Mile Creek Systems, 6sys.com/Springboard) is shareware for Windows computers. Springboard is free and useful for a variety of projects. The free version places watermarks on images, has some printing and export limitations, and expires four months after the release date. But you are not blocked from downloading a new free version when one expires. If you decide you like it, you can register it for $35 and get rid of the watermark.

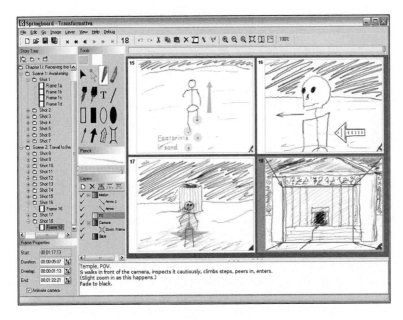

Springboard is a storyboarding software program for Windows.

The wide variety of drawing tools and options in Springboard allow you to make the most of your drawing ability, no matter how minimal it may be. Here's how it works in brief:

◆ Select one of the drawing tools from the palette on the left.

◆ Draw in the white frame box in the main window.

◆ Type the text that goes with the frame in the text box at the bottom of the main window.

◆ Use Edit, Add New Frame to move to the next frame.

Springboard is designed to help you organize and plan your story visually. Springboard preserves the simplicity of creating storyboards with pencil and paper, but adds the flexibility and power of digital media. It allows easy erasing, cut-and-paste, easy backups, overlays, and exporting directly to video and the Internet. The simple, straightforward, professional interface helps you focus on what you're doing. And lots more features are planned for future releases.

Springboard is excellent for home video projects, animated shorts, feature films, multimedia presentations, and set design. It supports WinTab-compatible pens, including pressure-sensitivity and eraser mode.

StoryBoard Quick

StoryBoard Quick (PowerProduction Software, www.storyboardartist.com, $299) StoryBoard Quick is available for both Mac OS and Windows and has lots of powerful, easy-to-use features and a large library of high quality artwork. It allows you to choose from a broad selection of characters and backgrounds you can customize in almost infinite ways. You can directly import your script, import digital photos and backgrounds, add text to frames, draw on frames, overlap frames, and print the finished storyboard in several ways.

StoryBoard Quick comes with many integrated predrawn image libraries. This includes a wide variety of characters that you can customize, both specific and generic locations, and a large selection of common props. You can change all character clothing, lips, hair, and skin color, and once you have your character exactly the way you want, you can save him or her for use in future projects.

You can put your characters into the locations supplied with StoryBoard Quick or take digital photos of your actual locations and import them as backgrounds. No matter whether you write your script in a word processor like Microsoft Word or use one of the specialized scriptwriting applications such as Final Draft or Screenwriter, you can easily import your finished script into Storyboard Quick. You can also add captions to each frame of your storyboard where you can put scene notes, dialogue, or any other useful text you want to quickly access.

Selections of 3D Director Icons allow you to indicate camera or actor movement in your storyboard. A drawing tool allows you to draw anything that you cannot find ready-made in Storyboard Quick's selections. You can view and work on multiple scenes using the Overview window, where you can also rearrange scenes.

When you are ready to print your storyboards, you have a variety of formats to choose from. You can add headers, footers, captions, and frame numbers, or print the captions to generate a shot list. Storyboard Quick also allows you to export your finished storyboards in HTML and place them on the Internet for easy sharing with your cast and crew. You can also select aspect ratio to match the actual project: TV, Feature, European, HDTV, or Widescreen.

Much like in digital cameras, Storyboard Quick by PowerProductions is targeted at the consumer level. Storyboard Artist is a higher, prosumer level software, and the highest one, Storyboard Artist Studio, is used by large budget professional productions. Of course, there are price differences as well!

FrameForge 3D Studio 2

FrameForge 3D Studio 2 (FrameForge 3D Studio, frameforge3d.com, $399) is available for Windows or Mac OS. It is the most expensive storyboarding application reviewed here on the prosumer level, but perhaps the most versatile as well. It goes beyond other storyboard software to offer full 3D visualization. It lets you create optically correct perspective based on the lens used for a scene, either by entering a desired focal length, or by zooming until you see the look you want.

FrameForge calls each of their frames a *previz*, short for "previsualization." These previz frames contain more than an optically correct image and script text. Each stored shot contains a full complement of technical camera setup data with a blueprint of props and actors so cast and crew can see exactly what you want from the scene.

FrameForge 3D Studio 2 can provide much more than just printed color storyboards for production meetings. It can also provide navigation-ready HTML pages for long-distance conferencing or Macromedia Flash animation for a real-time, shot-by-shot presentation. It allows you to create a virtual 3D set in your computer with the freedom to place any number of virtual cameras in any position. Each camera features full pan/tilt, dolly, zoom, roll, and crane control, as well as focal length, angle of view, f-stop, depth of field, and camera height to depict exactly what your camera will see. All of these features offer you familiar controls to work with for the very best shots to capture each scene.

FrameForge 3D Studio comes with over 800 actors and objects in its comprehensive library. You can search by name in over 100 different categories, including 32 fully positionable actors in four ethnicities (all of whom you can age from 20 to 60 years

old), and all the bits and pieces you will need to build exteriors, homes, offices, or just about anything else you could want in a scene. You can even change the digital actors' facial expressions from sad to happy or anything in between.

If you need a complex shot, such as one that starts with a crane shot from 20 feet up, cranes down to a school bus dropping off kids, and ends with a push-in tight on a doorway, you can build it with FrameForge 3D Studio 2. You can literally shoot all that just as if you were on location. You can also add in location/equipment limitations. If you know that the room you'll shoot in has an eight-foot ceiling, or you only have access to a 35-200mm zoom lens, you can enter those limitations for that set and FrameForge 3D Studio won't let you plan anything you can't actually do.

With FrameForge 3D Studio you can print your storyboards in grayscale or color in any of four rendering styles (normal, normal with outlines, cartoon, and sketch). You can also view your shots as a slide show within the shot manager and adjust the duration of each shot down to a fraction of a second. You can export this slide show as a Macromedia Flash or QuickTime video viewable in any web browser or burn it onto a CD. You can also post the storyboard on the web or an intranet for your production staff, or export just the graphics to Final Cut Pro, Keynote, or PowerPoint for presentation.

Want to have even more fun? For a few dollars more, the attachable Director's Pad makes working with Frameforge like playing a video game: www.filmwareproducts. com/Innoventive/dirpad.html.

No matter what program—if any—you use, you really shouldn't begin shooting without first planning out how the scenes will appear visually. Take a look at the following sample page of script, and the corresponding visual layout, and you will see how much easier it is to plan out your movements if you visualize the scene first.

Basically, whether you choose to storyboard by hand or with photography, use a sophisticated program, or just use a list, it's essential to visualize your story in some way before you begin to shoot.

```
Scene 4   Int. Bank Vault - Miami- day

Running the cash through a machine, MARTIN, the Bank Manager
is finishing up counting the money in AUGUSTINO's teller
drawer. MARTIN's face darkens. He removes his glasses and
lifts up the phone.

                        MARTIN
              Get the agents in here, right away.

The phone is answered by the GUARD standing just outside the
door.

                        GUARD
              Right away, Sir...

Back in the Vault Room MARTIN slams down his fist on the desk
and jumping to his feet turns to Supervisor, LETICIA who is
standing next to AUGUSTINO.

                        MARTIN
              Fifty thousand dollars missing from
              these drawers...I was right to
              contact the FBI...
              Why did Natalie sell him this much
              cash from the vault?

                        LETICIA
              I don't know...

MARTIN grabs AUGUSTINO by the collar and pushes him across
the vault to a pillar, CAMERA PANS with them.

                        MARTIN
              How did you smuggle fifty thousand
              dollars out of MY BANK?

From outside the door two FBI AGENTS and the GUARD are
approaching. Upon entering, CAMERA PANS with them as they
encircle and arrest AUGUSTINO. CLOSE ON AGENT#2 handcuffing
AUGUSTINO.

                        AGENT #1
              Mr. Abner, you're under arrest. You
              have the right to remain silent...

They lead AUGUSTINO outside of he vaults.

CAMERA DOLLIES IN FRONT OF THEM.

DOLLY ON Fellow BANK TELLERS as they shake their heads in
disbelief.

AS DOLLY STOPS AUGUSTINO looks into the LENS in a CLOSE UP.
```

These are sample pages of the shooting script and the overhead layout of camera setups from the digital feature film Out of Balance, *which I directed from a screenplay by Arnon Louiv*

4.10 MLS: MARTIN grabs AUGUSTINO by the collar

4.10 CAMERA PANS

4.11 LS 3-SHOT to MLS: From outside the door, the GUARD leads 2 FBI AGENTS

4.12 MLS: FBI AGENTS enter

4.12 MS: FBI AGENT encircles AUGUSTINO

4.13 MCU: FBI AGENT handcuffs AUGUSTINO

4.14 LS: Door opens, AUGUSTINO is being escorted away,

4.15 MS: CAMERA DOLLIES past shocked FEMALE TELLER

4.16 MLS: DOLLY CONTINUES on AUGUSTINO

4.17 MS: CAMERA DOLLIES past two other TELLERS watching

4.18 MLS: MARTIN and LATISHA look on

4.19 MCU to CU: DOLLY CONTINUES backward, ending on AUGUSTINO

The Least You Need to Know

- Visualizing is all-important to a successful video project.

- Storyboards are important to getting your video from concept to reality.

- You can hand-draw storyboards with even minimal artistic talent.

- Software is available to automate storyboarding and expand its capabilities.

Budgeting

In This Chapter

- ◆ Understanding the basics of moviemaking budgets
- ◆ Finding budgeting software
- ◆ Simple cost-cutting suggestions

It may not be the most fun, but budgeting may actually be the most important aspect of making a digital video.

Whether you're planning to shoot a wedding or a feature, one of the most important steps in preparing to make any movie is to get a basic idea of what it will cost. Because unexpected costs can—and do—come up during production, the initial budget you prepare will likely just be an *estimate*. A final budget will be prepared once the project gets the go ahead ("green lighted") with a schedule attached.

Budget Breakdown

You may find that, in order for your project to be feasible, you have to let go of some of the less essential costs. In order to do this, you need to identify the items on a budget you can eliminate to save money. These items can come from the above-the-line costs or the below-the-line costs.

def•i•ni•tion

Budget estimate, preliminary budget, and estimated budget are industry terms used interchangeably to mean the same thing: the need to approximate the costs of a production practically at the moment of completing the script.

One of the most significant costs in any movie is the cost of the creative talent: the writer, director, the producers, the music director and—of course—the leading actors. These are your above-the-line costs. This can be the easiest place to begin to cut costs, if these participants are willing to donate or at least defer until distribution their time and creativity to the project. Another way to look at above-the-line budgetary items is that they are contractual, based on negotiations with the artists' agents, unless they are willing to work for minimum scale set by their guilds.

Deferment deals are often based on guild minimums plus additional payments and/or percentage points from the distribution income.

Below-the-line costs are for the technical elements directly related to production, post-production, and distribution. The production costs include salaries for the crew, supporting role actors, extras, the art department, the equipment, props, sets, wardrobe, makeup, hair, and so on. This also contains the post-production costs, such as editing, sound, visual effects, music rights, and the like. Some of the finishing and distribution costs may also be included. Below-the–line costs are based on union labor rates, which are stellar for low budget productions. But for proper calculations even low budget productions use the union minimum wages and go down from there, negotiating with the producer to arrive at a mutually agreeable figure.

Similar to the consumer, prosumer, and professional categories in equipment, the same divisions apply to budgets as well: Consumer video budgets may range from a few dollars for transportation, food, and tape to a couple of hundred for additional accessories like filters, an extra light, a battery, and so on.

Prosumer budgets can go as high as thousands for semi-professional shooting: for a wedding's decent videotaping the family should be prepared to pay anywhere from $1,500 to $6,000, especially for a two-camera coverage. Professional budgets range from a few thousand to many millions, of course. In addition to the above and below-the-line items, a budget may include:

- Location fees
- Legal fees
- Insurance
- Completion bond
- Contingency

Unless you can shoot free of charge at your uncle's barbecue party, you better be prepared to pay some location fees. Even my students are often asked by the owners to pay a couple of hundred dollars for the use of an apartment, a swimming pool, or a bar for their school projects.

There are fees for an attorney taking care of the contracts, clearing music rights, incorporation, basically any and all legal aspects of the production. These fees usually take between 1.5 to 3 percent of the budget depending of course on the size of the budget and the complexity of the production.

Insurance: You are not supposed to run a production without insurance. The least you need to carry is a basic general liability insurance for a low budget video production that would protect you in case you cause damage to others.

You may want to obtain equipment and rental insurance, and larger ventures certainly need Errors and Omissions insurance as well to cover legal protection against libel, copyright infringement, suits for errors in music rights and the like, if your video gets wider distribution.

Even if you shoot and edit in your living room, it is not a bad idea to add a rider to your home insurance to protect your equipment from a leak in the pipes above the place or any other unexpected calamity like fire, flood, and so on.

You've invested upward of $6,000 in your camera, computer and accessories, so you might as well insure them. However, often insurance will not pay you back the cost of a new unit when your loss occurs a year later, only the comparable market value at that point.

For quotes and more details on insurance check the web. Here are some websites:

- www.productioninsurance.com/
- www.filmemporium.com/newweb/insurance/index.htm

In case you can get more substantial investment in your video feature, the bank or the investors' group most likely wants you make a completion bond part of the budget. This would guarantee them that no matter what happens the project will be completed on time and under budget. So this is not insurance for you but for your investors. Completion bonds take on the average about 5 to 6 percent of your budget, but normally return about 2 percent if your production is completed properly. That is actually an incentive for producers and directors to watch their budgets and schedules more carefully to get back that money and create a good track record for their next projects.

In absence of a track record, it is more likely for a beginner director to get hired for his first feature length production if he is approved for a completion bond. Completion bonds are also needed to cover unexpected disasters. When the comedian John Candy died during a film's production, the completion bond was activated, with multi-million dollar coverage.

A contingency is a safety cushion for unforeseen expenses. You want to re-shoot a scene that had to be postponed due to bad weather, and that adds additional costs to your originally planned budget. Contingency will cover that. As a rule of thumb contingency is the last item on your budget added as about 10 percent to 15 percent of the total.

A budgeting top sheet, which is basically a summary of the entire budget. This one was printed using BoilerPlate software.

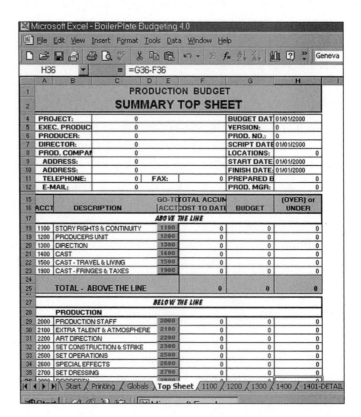

Budgeting Software

Of course, as with everything else in this book, there's a way to go digital with your finances. Video and film budgeting programs are available to suit nearly any purpose, and to fit any budget. Here are some programs to check out.

Available both for Windows and Mac computers and for $15 to download or $25 for the CD by mail, Filmmaker software (www.filmmakersoftware.com) is a well designed and beautifully color coded software that can generate for you all the budgeting and scheduling forms you may need for your production.

In terms of breaking down the script this software does not use the standard breakdown sheets used in the industry but allows you to enter the elements: cast, crew, costumes, props, equipment, etc., right inside the program.

Filmmaker software covers the entire budgeting and scheduling process and in addition, it also offers an excellent overview in its tutorial of all the elements that make up the work and paper flow of filmmaking.

Instead of a specific standalone spreadsheet program, BoilerPlate (www.boilerplate. net) runs on Microsoft Excel both on Mac and Windows. It provides templates for all categories of budgeting at a very affordable price, currently $99.

Easy Budget (www.easy-budget.com) costs almost double as much as Boilerplate at $189.95 plus shipping, but it has some elements that justify the difference. A registered user can check in to EB's website to gain access to the Labor Rates Database. This is the Bible of below-the-line budgeting that puts at your fingertips the current rates set by the unions. Obviously, this is most important for larger budget feature productions. EB's former budgeting software for commercials has been adapted for video production. The program is on CD and comes to you through mail.

Gorilla Film Budgeting (www.junglesoftware.com/home/) is not only a budgeting but a comprehensive production management software. Not only does it connect budgeting to its logical counterpart, scheduling, but Gorilla actually nurtures the project from the moment the synopsis and the script are written all the way to distribution. It comes in three production categories that are different only in budgeting levels and the number of shooting days.

The student level productions in Gorilla have a $50,000 budgetary ceiling and also are limited to 14 shooting days. This certainly corresponds well to our prosumer level productions. It's currently available for $199.

It is upgradeable to the standard level with maximum 48 shooting days and a budgetary limit of $625,000. This is obviously aimed at the independent feature market. Gorilla has over 3,000 labor rates including the ones for low budget productions and these are available either in modules like for L.A.-only or Canada-only for $11.99 each or you can buy all labor rates together for $49.

Or you can upgrade to Gorilla Pro for another $100, which provides assistance for unlimited shooting days on an unlimited budget. This is, of course, for large Hollywood studio productions. Most amazingly, Gorilla allows you to download a free trial to your computer. I encourage you to do so.

At a discounted price of $499, EP Budgeting 6 (www. writersstore.com/product.php?products_id=1780) is pretty expensive. It is used by professionals for Hollywood productions. EP budgeting and scheduling software together are available at this site for a discounted price of $799, and these two together are the workhorses of Hollywood's larger professional productions.

Financing Your Video

Once your budget is in good shape, you need to find a way to cover your expenses. There are several ways to do this. One is to get others to donate their time and talent to your project, either for fun or experience, or because you agree to pay them after the fact if the movie makes money. Another is to look for investors with enough faith in your project to finance it up front, looking to make a return on their investment on the backend.

But if you don't have any wealthy relatives willing to bankroll your project and your investment connections have run dry, don't despair. You can look to other sources, such as grants, for help.

Grants

Many programs exist to subsidize the cost of producing digital videos. They offer grants, which are not expected to produce financial returns and do not need to be paid back. Some are government-run and others are private; a few moments spent on Google or another search engine will likely turn up several programs that might be worth investigating depending on your specific needs.

Just a few of the many grant programs for digital video projects can be found at:

- The Environmental Media Fund (www.environmentalmediafund.org)
- The FilmArts Foundation (www.filmarts.org/services.php?function=grants)

- From the Heart Productions (www.fromtheheartproductions.com)
- The Fund for Women Artists (www.womenarts.org/fund)

Cultural institutions, museums, and schools or universities may also provide these programs, and are worth looking into, as well.

Tax Deductions

Depending on the state in which your video is being made, you may be eligible for tax deductions that help with the cost of the movie. Check the Internet for specific information on the state(s) in which you are shooting.

Using Credits and Points

The moviemaking process can be a pretty exciting thing. After all, who doesn't dream of being up on the big screen with their name in lights?

Because movies are so attractive, you may find that many people are willing to contribute necessary items to your project if you offer to put them in the credits. Maybe a local deli will donate some food for your cast and crew, or a mom-and-pop store will let you shoot a scene there after hours. Maybe your friends will act as extras or help out on the set by holding the boom microphone. Ask around, and you may find that you can "finance" much of your video with donations.

And if that doesn't work, you can always offer to pay *points*!

def•i•ni•tion

Points are a percentage of the profit a movie makes. A movie has 100 points that can be allocated, making up 100 percent of the profits.

Selling the Rights

Selling the right to distribute a video before it's been made is one of the main ways film financing is obtained for big-budget projects. This is one reason why Hollywood movies tend to include big-name stars—their presence in a movie often guarantees an audience of their fans, which means that the movie is more likely to make money.

The same principle applies to a low- or no-budget movie; if you can find someone willing to distribute your movie, you've a better chance to obtain financing. In order to do this, you need to "attach" someone important to it. So if your father's cousin's best friend is a noted actor, this might be the time to slip him your screenplay and see if he thinks it's a worthwhile project!

Quite a few well-known stars accept a cut in pay or even SAG minimum scale when they like the script or the filmmaker. Ethan Hawke's low budget adaptation of Shakespeare's *Hamlet* could not afford stars like Bill Murray, but he did it for next to nothing because he wanted to work with Ethan Hawke on his full feature directing debut. I had the time of my life directing my thesis film at the American Film Institute with the greatest cinematographer in the world, Academy Award winner Vilmos Zsigmond, instructing cinematography fellows on my film featuring Oscar-nominated actress Lynn Carlin. Their participation in this short feature paid off as the film was selected among the Best American Shorts of the Year, represented the United States at the Melbourne International Film Festival, and was picked up by Warner Brothers Village Roadshow for distribution. So keep trying, you just never know!

Cost-Cutting Suggestions

So now that you know where your costs will come from, you can begin to investigate some places to save money. Here's a short list of suggestions that will help keep costs down.

- Motivate students or volunteer actors to work for the experience instead of paying professionals.

- Shoot scenes in nearby locations and/or ones that don't require permits.

- Barter with your crew—in exchange for work they do on your video, offer to work for free on the movies your crew members are involved with. Engage a good camera operator who owns perhaps a better camera than yours so you can concentrate on directing only.

- Shoot outdoor scenes early in the morning to take advantage of the light while avoiding interruptions from passers-by. Get friends and relatives to hang around your shoot, to help and also be extras. Who else would stay with you for hours just to walk by in the background for a shot?

- Find another creative outlet: cooking. Prepare the food for rehearsals and shooting days yourself—or ask your boy or girlfriend, or your mom—instead of having catered food brought in for the cast and crew. Another option: scoop up the

leftovers from local restaurants in exchange for screen credit, perhaps for tax-deductible in-kind service. This way you might be able to serve filet mignon to your cast and crew instead of pizza.

And now that you know how much you can (or can't) spend, it's time to go out and get yourself some actors. Let's move on to the next chapter: Talent.

The Least You Need to Know

- Preparing a budget gives you a good idea of how much you can expect your movie to cost, and where you can save money.

- Everyone wants to contribute to the moviemaking process. Ask around to see what donations you can find to help out with the costs.

- Following some simple cost-cutting suggestions can make a seemingly impossible movie a reality.

Chapter 10

Talent

In This Chapter

- ◆ Who is talent?
- ◆ Computer casting
- ◆ Finding other talent
- ◆ SAG: what it is and what it can do for you
- ◆ Animated and virtual characters in the digital age

Anyone who moves in front of the camera for recording is some kind of talent. Talent can be thespians (male and female actors), models, performers, "real" people, animals, TV personalities, animated or virtual characters … the list goes on.

No matter how you regard actors, one thing is certain. You will need them for just about any serious video production. So how do you go about finding actors? Well, as with most other things in the digital age, you start online.

Casting

If you have a large budget, you may want to have a casting consultant find your actors for you. Look under Casting in the Yellow Pages or do an Internet search. You will only find casting directors physically located in a few major metropolitan areas, but the Internet is worldwide, and Casting Society of America (CSA, you've seen it after casting director's names in movie credits) has a service through their website to find casting directors almost anywhere. Their site is www.castingsociety.com.

If you can't find a casting professional on your own, check to see if the state you are working in has a state film board or state film commission. Many states have them, and they can generally provide you with a list of resources. Check on the Internet using one of the major search engines such as Google or Ask.com.

Zoom In

Today you will find that the Internet is your greatest ally in finding people for your projects. Websites for all aspects of cinema and video have proliferated, and finding actors and other talent has been made much easier than in the past. When searching for resources, many of us hardly use the telephone anymore. Take the time to use some of the major search engines and see what's out there to help you in every aspect of your video projects.

In Major Cities

If you live near Los Angeles, New York City, or a handful of other major U.S. cities, you will have no problem in finding actors. You can use a casting service, go through an agency, or you can locate available actors on your own. The choice is up to you, but you may save some money dealing directly with actors because that bypasses additional fees. A number of websites accept free casting listings from filmmakers. Examples are:

- www.lacasting.com
- www.prettyfacenotneeded.com
- www.talent6.com
- www.nycasting.com

The oldest and most respected listing service is the Academy Players Directory, which also includes contact information for the agents of the stars. At a minimum, actors

who are members of at least one professional union can request listing there, and they are offered two choices: "book listing" in the printed directory that is updated twice a year, and/or "online listing" on the Academy Players' website. For more information, go to www.playersdirectory.com/actor.cfm.

So many actors live in New York City and Los Angeles, that a casting ad in a paper like *Back Stage* (or on www.backstage.com) fetches an average of 200 headshots even for a nonpaying student film. Another one of the best places to find actors is Breakdown Services (www.breakdownexpress.com). It costs $10 as of this writing, but they send out your casting notice to agencies, and prescreen actors for the roles you have in mind, unlike in open casting calls where practically anyone can show up.

Some model sites also include actors in their listings. The oldest and best known of these is One Model Place, www.onemodelplace.com. You can use One Model Place to search for actors or models anywhere in the world, and the service is free. You can also join and, once you are a member, you can post casting calls there, which invariably get responses.

Outside of Major Cities

How can you get actors outside of NYC, L.A., or other large cities? You might visit or contact regional theaters and even dinner theatres or restaurants with musical performances, as well as the talent at your local television and radio stations. Their performers are more likely to suit your needs than your own friends. Check your local high school and college acting programs and theatres, as well.

Depending on your budget, however, you may wish to cast some "real" actors, at least for the lead roles in your movie. It is important to know exactly what you are looking for before you contact any agencies or talent, so you do not waste time—yours or anyone else's. Try to have a good solid idea of just what each actor in your production needs to look like, and how skilled they should be. When you work with professional actors they will most likely be members of the Screen Actor's Guild (SAG). A detailed section on SAG is included later in this chapter.

Casting Ads and Virtual Auditions

So what goes into the casting ad? The more specific you can be, the better the likelihood of finding the perfect actors. Have actors e-mail their headshots and resumes to you, so you can sort through and choose the ones you like best to ask to the audition.

And in the digital age, you can cast your video on the Internet without spending money on traveling to the major cities or flying in actors to audition. Using the digital technologies of online live video chats, it is quite easy today to conduct your casting sessions and auditions using common webcams.

We have often done this for my students' films via Yahoo! Messenger, iChat, or on Skype by asking the actors to place themselves in front of their computers or to go to an Internet café and act out short scenes from our movie in front of a webcam. Of course, they could also see us on our webcam, so this always has been a two-way live Internet casting.

There are two ways to do this:

◆ Person-to-person, two-way live video chat

◆ Two-way, live group communications

Both are new and inexpensive versions of the pricey teleconferencing operations of yesteryear. Today we call these technologies peer-to-peer (P2P) Internet telephony, and all three of the current leading services in the field, iChat by Apple, Yahoo! Messenger, and Skype, offer these options.

Technical requirements are minimal: any digital video camera can be hooked up to your computer to act as a webcam, or you may purchase a cheap little webcam just for this purpose. Apple is so confident that everybody will want to use their iChat that they built a tiny webcam into all their new laptop and desktop computers.

The operation is simple: you log in using a password and screen ID, and contact the actors either one by one or in a group. You can see both yourself and the other party on your computer's split screen. Through the Internet you may reach anyone around the world who has the same basic equipment and can accept your call, so you can audition virtually anyone, anywhere. And best of all, the video call is free of charge.

In addition, Skype now offers Skypecasting, which is basically a live connection among up to 100 people led by a moderator who turns the microphones on and off during these sessions.

> ### Karl's Tips
>
> Many years ago, thanks to producer Renee St. Jean, I was fortunate enough to direct the world's very first three-camera live streaming webcasting experiment for Microsoft. It was a series of live backstage interviews with the stars at the Tony Awards. What I learned there is still valid today: use close-ups and medium shots and avoid fast pans and busy backgrounds, as live webcams still do not like fast motion and tend to blur.

Working with Nonprofessionals

You can cast your whole project with nonprofessional actors, of course. But as Red Adair once said, "If you think hiring a professional is expensive, wait till you hire an amateur." There is a lot to be said for that piece of wisdom. If you hire professional actors, you will spend a lot less time getting just what you want in your video.

But if you have a significant amount of time and not much money, you can make it work with amateur talent. Just be prepared for lots of takes to get a scene right. And remember that the number of takes you'll need to get a scene just right multiplies every time you add another person.

Karl's Tips

Nonprofessional talent cannot help you keep continuity. They will talk, move, and act different from take to take and that's not possible to edit into a coherent scene. Use an inexpensive MiniDV camcorder for play back to remind the actor how dialog and action should be repeated so it's exactly the same way over and over again for continuity editing.

Whenever you have to use amateurs in fictional roles, try to cast someone to do something they are used to doing in their daily lives. For example, a medical professional would have little difficulty pulling off a scene of a medical doctor talking to a patient about a diagnosis.

The list is long of films and filmmakers who have worked with either a totally non-professional cast or have mixed them with some professional actors. In fact, most docu-dramas work that way. All documentaries use real people and, as you're probably aware, one of the most popular genres on television, reality TV, uses real people as the main subjects.

Working with Professionals

If you're around actors enough, you will certainly hear someone mention their "SAG card." That's their membership card in the Screen Actors Guild. SAG is a labor union for professional actors who work in film/video and television. If you want to use SAG members in your production, you must first sign a contract with SAG. This contract is called the SAG Codified Basic Agreement. This agreement will specify the minimum payments to actors, the hours you can make them work, your contributions to the SAG pension and healthcare plans, how overtime is handled, working conditions, and other aspects of the overall production.

Once you sign an agreement with SAG, you cannot make any other agreements directly with actors that violate any of its provisions. You can find more information at www.sagindie.com, and can download the necessary paperwork from there. SAG has a variety of contracts, including:

◆ **Student Film Agreement:** Only for students of accredited film schools, your total film budget must be $35,000 or less to obtain an actor under this contract. The actor's salaries and some other payments may be deferred until you make a distribution agreement or directly release the video.

◆ **Short Film Agreement:** To sign an actor under this agreement, the film's budget must be less than $50,000 and must be 35 minutes or less in length. Salaries are deferred as above, and you are not obligated to consecutive employment except on overnight location shoots. You pay no premiums, and you can use both professional and nonprofessional actors.

◆ **Ultra-Low Budget Agreement:** To qualify for this agreement, the film's budget must be less than $200,000. Actors must be paid a minimum of $100 per day. You are not obligated for consecutive employment except on overnight location shoots. You pay no premiums, and you can use both professional and nonprofessional actors.

◆ **Modified Low Budget Agreement:** To qualify to use this agreement, the film's budget must be less than $625,000. Actors must be paid a minimum of $268 per day, or a weekly rate of $933. You are not obligated for consecutive employment except on overnight location shoots.

◆ **Low Budget Agreement:** The film's budget must be less than $2,500,000. Actors must be paid a minimum of $504 per day, or a weekly rate of $1,752. You are not obligated for consecutive employment except on overnight location shoots. Six day work week with no premiums, and reduced overtime rate allowed.

These agreements include other details and some limitations on exhibitions, as well. For complete details, check out the SAG website.

Announcers and Voice-Over Talent

Maybe your video is a documentary and you don't need any actors at all, but you do need an announcer with perfect diction and a great voice to give your documentary that special touch. You can find announcers or voice-over (VO) talent the same way you find actors, but don't overlook an easier way.

You probably listen to radio at least now and then. Chances are that the mellow voice you hear on your morning drive may be available for your video—often for less money than you might suppose. Radio announcers typically are not paid very much, and many of them love to pick up some money on the side for announcing and VO work. If you hear a great voice, make a note of his or her name and make contact through the radio station. The same applies to television announcers for local stations. Many have great voices and love doing a bit of moonlighting on other projects.

Singers often have great speaking voices, as well, and that singer fronting your favorite local band might be just the voice you need for your project. Remember that it never hurts to ask. The worst that can happen is that you'll be told "no."

Suppose you need a special voice (for example, the voice of a small child) for your voice-over. You may be surprised to learn that when the child is not seen, adult women usually do children's voices—and they take direction much better than actual children do.

Or you may want a comic voice, something like Donald Duck or Porky Pig. Again, don't overlook radio announcers! Many of them like to play around with cartoon voices or accents. And everyone knows the trick of producing a high-pitched voice by inhaling helium.

Virtual Talent

One of the most interesting developments in the area of talent is the emergence of virtual actors, or virtual characters acting in both real and in virtual spaces.

In television news, the pioneer of virtual human characters was a British Internet News service that used to feature a "female TV announcer" named Ananova.

Later relatives of Ananova already populate the libraries of the storyboarding software used in the film industry where virtual characters are used in previsualizing the scenes. Synthesized voices read back your scripts in screenwriting software and in your computers, not to mention most of the answering machines and voice mail in use today.

"Talkies" no longer mean only the first sound movies in history but also new industrial applications of interactive talking heads for corporate communications, like the phone company Sprint's never-sleeping virtual human representative, Claire.

This computer-generated character, Ananova, was the first digitally created anchorwoman on a 24-hour news program, also called Ananova.

Talkie is a company that creates digital characters, such as this one, for interactive customer service.

And in movies such as *Final Fantasy*, digital human characters replace live actors.

Today, we can still tell the difference between humans and virtual talent, but imagine the possibilities if it becomes more and more difficult to do that in the future. SAG actors have already complained about the growing number of virtual actors who of course need no health and pension benefits. It has been said that Tom Hanks was one of the complainers until he himself ended up playing multiple roles in a totally digital environment in *Polar Express*.

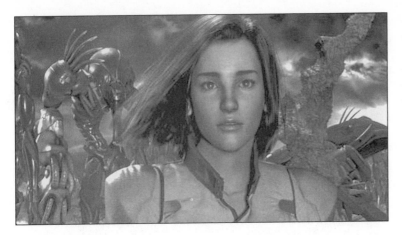

Dr. Aki Ross, a character from the movie Final Fantasy, *was also created digitally. Digital characters are becoming more lifelike—and more widespread.*

Virtual humans may become an extension of our lives in the digital age. There are already rapidly growing virtual communities with millions of virtual humans on the Internet where you can have your very own virtual character living a "second life." The future implications of this may turn out deeply philosophical and beyond just being an interactive videogame.

Welcome to Second Life. We look forward to seeing you in-world.

With digital technology today, you can create an avatar of yourself, and start a "second life" here on Earth!

Digital Extras

There is an important practical reason for using digital extras (crowd members) in films. Put simply, it's money. It is far less expensive to digitally multiply a crowd than to pay thousands of people to stand around in crowd scenes.

A good, but perhaps a tad too recognizable, application of a computer-generated crowd can be seen in the great Hollywood spectacle *Gladiator*; simpler versions on home computers might be used for simulated crowd scenes in your own very low budget digital videos, as well.

Rotoscoping

Another method of turning real-life characters and actors into great-looking animated figures is by *rotoscoping* live action digital video. This technique goes back all the way to the silent film period, where they had to draw outlines of each projected live action frame. Digital rotoscoping was successfully used first by one of the gurus of American independent cinema, Richard Linklater, in his digital film, *Waking Life*. He then repeated the same technique in *A Scanner Darkly*.

Actors Julie Delpy and Ethan Hawke were shot on video and turned into animated characters through rotoscoping for the movie Waking Life.

def•i•ni•tion

Rotoscoping is an animation technique in which individual images are manipulated by tracing or painting over them, either automatically or manually.

An animated version of actor Keanu Reeves stars in A Scanner Darkly *through the same process of rotoscoping.*

Sound too complicated for your needs? Well, a prosumer-level digital camera (the Canon XL-1) was used to shoot the live action video for *Waking Life*, and a group of animation artists rotoscoped the footage on consumer-level Mac computers. Digital rotoscoping has become even easier and more available to the average moviemaker by utilizing the auto-trace tool of Adobe After Effects. These days, almost nothing is impossible if you have the creativity and the time to put into it!

The Least You Need to Know

◆ Actors are now easier to find than ever on the Internet.

◆ Computer casting is based on two-way live webchats, and allows directors and actors to interact in an audition environment even if they're miles apart geographically.

◆ The Screen Actors Guild can be your ally in serious productions.

◆ Virtual humans—the wave of the future—can be created on your own computers, as well.

Lighting

In This Chapter

- Types of light
- Light modifiers
- Color temperature and white balance
- Light meters
- Lighting accessories

The real complete idiot is the camera. Unlike humans, cameras cannot make mental adjustments (for example, when looking at a book under yellowish reading light, humans can mentally adjust to perceive it like white paper). Adjustments of color are based on our cumulative experience (in this example, we know that books are usually printed on white paper). The camera, however, has no mind, and is unable to make mental adjustments. Therefore, we need to force the camera to reproduce images the way we want them. One of the most important ways to do that is to control how the camera reacts to light and lighting.

Without light, there can be no video image. Learning about lighting will allow you to create a video with exactly the look and visual mood you envision.

Types of Light

In addition to natural sunlight, most videographers will also work with one or more types of artificial lights, both in the studio and outdoors on the set.

Tungsten-Halogen

The bulbs most of us are familiar with for household use are called tungsten lamps or incandescent lamps. They use a thin piece of tungsten wire to produce light. Tungsten has the useful characteristic that it gets very hot when a current is passed through it, and it withstands many heating and cooling cycles before it fails. But tungsten lights are very inefficient types of lights, because the tungsten wire, the filament, produces far more heat than light. About 80 percent of the electrical energy put into a tungsten lamp is wasted as unwanted heat.

In ordinary household tungsten lamps, most of the air is sucked out of the glass bulbs during manufacture and the tungsten filament operates in a near vacuum. Another type of tungsten lamp is far better suited to our needs in video, the tungsten-halogen lamp. In ordinary household bulbs, a certain amount of the tungsten is vaporized as it heats and is deposited on the inside of the glass bulb. Over time this thins the filament and is what causes failure.

In tungsten-halogen lamps, the air is removed and replaced with a pressurized mix of halogen vapors. Chlorine, bromine, astatine, fluorine, and iodine are the halogens. They have the unique ability to hold the tungsten that evaporates from the filament and deposit it back onto the filament when the lamp cools down after use. This results in much longer lamp life. Because they typically run hotter, tungsten-halogen lamps (also sometimes called quartz-iodine lamps) produce more light at a higher color temperature than ordinary tungsten lamps. Typically tungsten lamps are about 3000°Kelvin (K), while most tungsten-halogen lamps are around 3400°K (we'll talk more about color temperature and white balance shortly). They will produce very good color fidelity so long as you remember to set the white balance on your camera accordingly.

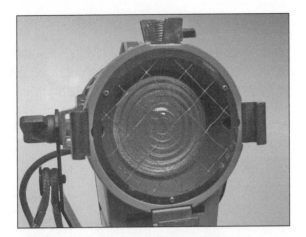

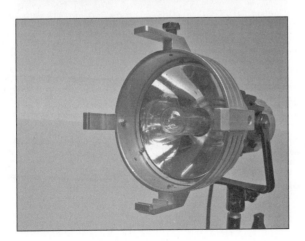

Examples of incandescent (Fresnel), tungsten-halogen, and HMI lamps.

HMI

HMIs are the princes of lights, until recently only available to people with Hollywood budgets. HMI stands for hydrargium medium-arc iodide, hydrargium being the Latin name for mercury. Now some less expensive HMI lights are available, but that still doesn't mean cheap. The lamps still cost several hundred dollars and must be driven by relatively expensive ballast units. The advantage of HMI is that the light is very close to noon daylight in color temperature, about 4500 to 5000°K.

HMI lamps operate somewhat similarly to tungsten-halogen, but instead of heating a filament, they use an electrical arc between two electrodes to produce the light. The mix of metal vapors in the lamp corrects the color temperature and prevents tungsten from condensing on the inside of the quartz lamp and darkening it. HMI lamps have a lifespan rating in hours and should not be run much beyond that due to the possibility of recrystallization of the quartz envelope and possible explosion.

Digital Lighting

A new type of light has been emerging for the digital age based on light-emitting diode (LED) that is a semiconductor device, therefore it is dubbed SSL (solid state lighting). On-camera LED lights are already available and not very expensive. Similar to incandescent on-camera lights, these can be battery operated. Many of them may be connected to dimmers and unlike the incandescent lights these LEDs do not change their color temperature by dimming.

Example of a LED camera light.

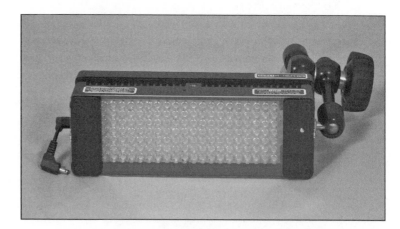

Another kind of digital lighting is emerging: a whole cluster of digital projectors can be placed on overhead railings throwing white light on the subjects below. Not only can they be remotely operated together but their color, light levels, and color temperatures can be changed by remote digital lighting control. Even traditional lights on lighting grids have been tilted and panned by digital lighting boards for quite some time.

Another use of the term digital lighting goes beyond the use of digital light meters and dimmers and deals with virtual lighting created on computers in digital effects editing.

Quiet on the Set!

All the lights used in video work get very hot during use. Tungsten-halogen gets hotter than ordinary tungsten, and HMI gets hotter still. These lamps can produce serious burns if you touch them. Always exercise great care when working around hot lamps. Be sure to let the lamps cool down completely before moving them to avoid burns and to prevent the filaments in tungsten-halogen lamps from being damaged. They are much more fragile when hot. Be extra careful when working with any liquids on the set, because water or other liquid splashed onto a light can cause it to explode.

Also be careful handling the bulbs even after they cool down. The quartz lights should not be touched with bare hands as the oily deposit from your fingers can make the bulb explode or burn out when heating up.

Light Modifiers

We can all see that light from a bare bulb source or a lamp in a silvered dish reflector is harsh and not the light of choice for most of our video work. It can be used for some purposes, particularly to produce or enhance a dramatic mood, but most of the time we want something less harsh. This is where knowledge of light modifiers will stand you in good stead. Light is your friend if you understand it, and understand the tools to tame and direct it.

The most important rule of thumb to understand about light is simple. The hardness or softness of a light source is governed solely by its apparent size at the subject's position. The hardest type of light is a point source with no diffusion, like direct sun in the desert. The softest possible light comes from an overcast sky at noon. Everything else is somewhere in between.

Softboxes

Most of the time you want to soften the quality of the light to make it more flattering to your subjects. The easiest way to do this is by mounting your lights in softboxes of some sort. A large variety of softboxes are on the market in all sizes and shapes. Just make sure that the ones you plan to use are made of flameproof material designed for use with hot lights. Many are made for studio flash, which does not get nearly as hot as video lights. The last thing you want during a shoot is for one of your lights to catch fire. Personal experience favors Photoflex softboxes. Most room-sized sets can be lit with two or three 36-inch softboxes. If you have room for them, you can use larger ones and produce even softer light.

Reflectors

Sometimes you need to throw a bit of light into a shadow, and you may be able to do this with a reflector rather than another light. Using too many lights is one of the marks of a beginner. You can buy reflectors from photographic and video suppliers in a wide variety of sizes and surfaces. Most of these fold or disassemble to a very small size for transport and storage.

If you have the time and a bit of ingenuity, you can make reflectors and other things you will need for your video shooting. Commercial reflectors can be expensive, and if you're on a tight budget you can make your own from sheets of styrofoam. If you want more reflectivity, you can glue aluminum foil to one side. White poster board also works well. You can stretch white bed sheets over frames made from PVC plumbing pipe for larger sizes.

Spotlights

There may be times when you want a focused, tight area of light on a particular part of your subject or set. For this you will need a spotlight. Several types exist, but the main ones are the *snoot*, a tubular metal cone that fits over a light and restricts it to a narrow beam, and the *Fresnel* (pronounced fray-nel), which uses a plastic or glass Fresnel lens to focus the light. Snoots are much cheaper and can be homemade, but Fresnels are much more versatile because the beam can be adjusted.

def•i•ni•tion

Also known as a "top hat," a **snoot** is a light shield that is used to direct a concentrated beam of light onto a scene. Named after its designer, A. J. Fresnel who used it first in 19th century lighthouses, **Fresnel** lenses are made up of concentric circles on a flat frontal surface to help focus the light. Fresnel lights can spot or diffuse the light beam by moving the bulb closer or further inside the light from the back of the Fresnel lens.

Color Temperature and White Balance

Color temperature is important because it will determine the proper white balance setting for your camera. If the white balance on the camera is set correctly for the light on your subject, it will render whites as white, grays as neutral, and all other colors without unwanted color casts. If the white balance is set incorrectly, whites will have a colorcast, as will grays and all colors. For the best possible color in your videos, it is important to ensure that all lights you use on your set have the same color temperature.

Here are some common light sources and their color temperatures:

1500°K	Candle
2680°K	40 W tungsten lamp
3000°K	200 W tungsten lamp
3200°K	Sunrise/sunset
3400°K	Tungsten-halogen lamp
3400°K	1 hour from dusk/dawn
4500–5000°K	HMI lamp
5500°K	Sunny daylight around noon
5500–5600°K	Electronic flash
6500–7500°K	Overcast sky
9000–12000°K	Blue sky

Automatic White Balance

Just about any video camera you are likely to encounter will have an automatic white balance feature. This means that the camera will analyze the image from a sensor and adjust the white balance based on algorithms derived from analysis of a wide variety of subjects. Most of the time, automatic white balance will work just fine and most consumer cameras only offer that option.

Karl's Tips
With the color-correction tools of your computer-editing software you can correct some errors that occur during shooting, including white balance and color temperature.

Manual White Balance

There is a problem, however, with automatic white balance. You may have seen home videos in which the color looks absolutely perfect and then, when the camera zooms in on someone's face for a tight shot, the color balance shifts toward blue. This happens because automatic white balance works great when it is presented with a mix of subjects as you would generally see in a wide shot, but when zoomed in tight on a face there is too much red and green and not much blue. So the system adds blue in an attempt to correct the colors.

The way around this is to use manual white balance settings, if your camera has them. This will hold the color balance constant as you zoom in and out or pan to different subjects. Some cameras present you with white balance options based on the light and may have settings for bright sun, overcast sun, and others. Some actually give you a choice of color temperatures for the light. This sort of setting system is adequate for many uses, but a better system is one that lets you set white balance from a sample target.

A good general white balance reference to carry in your camera bag is the Kodak Gray Card. This is a very carefully made piece of cardboard which is white on one side and neutral gray (18 percent reflectivity) on the other side. Check your camera's instruction manual for details on how to set a manual white balance. In most cases, you will put the Gray Card in a position where it is illuminated by the same light as your subjects. You will then zoom in until the full frame is filled by the card and push one or more buttons on your camera to lock in a white balance from the card. This is the best way to set white balance, if your camera allows you to do it this way.

Of course, you may not always want a completely neutral white balance. You may want a warmer or cooler look in your video to enhance a mood. You can accomplish this with manual white balance settings by setting the camera "incorrectly" for neutral rendering. Or you can carry a set of WarmCards (www.warmcards.com) with you and use them to lock in the desired white balance. You could also make your own.

Dealing with Mixed Lighting

Shooting under mixed lighting and getting good color is a real challenge. Generally it is best to avoid mixed lighting situations when possible. If you can't avoid it, you can try setting white balance manually with the white side of your Gray Card, but this only works if the mixed light is constant over the whole area where you will be shooting your video. Often the problem is not constant across the area.

A good example would be an area that you are going to light with tungsten-halogen lights, but with big windows on one side admitting daylight. In this situation, you should block out the daylight. But if that isn't possible, you can adjust the color balance of your lights to match the daylight. Rosco and Lee both make a wide variety of gels for color correction. Gels are tinted sheets of thin plastic. You can raise the color temperature of lights with blue gels or lower the color temperature with amber gels.

In the example mentioned, you could do either of two things. You could gel all of your lights to match the daylight, or you could gel the windows to match your tungsten-halogen lights. Either will work, but remember that gels absorb some of the light and will make that light source less bright. This sort of light matching is much easier if you have access to a color temperature meter. A color temperature meter is a specialized light meter that measures the color temperature of light rather than its brightness. Color temperature meters are quite expensive, but you can rent them by the day.

Another common example of mixed lighting is when daylight coming through the windows is mixed with the light of fluorescent fixtures on the ceiling. The problem with fluorescent lights is that they are unstable, flicker, and have a greenish tinge that makes the skin-tone look unhealthy. This is a very typical situation in offices, schools, hospitals, etc., and the best way to handle it is to turn off the fluorescent lights and light with tungsten lights. If that is not possible, then use magenta gels on the lights or filters on the lens. Magenta decreases the green in the picture.

A few years ago, Kino Flo, a new lighting fixture, was introduced to address these issues. These fixtures have banks of stable nonflickering florescent lights available in changeable color temperatures, and they give shadow free even lighting. Therefore, they are excellent for Green Screen effect photography as well. The simplest way to counter the sickly greenish tinge caused by fluorescent lights is to "fool" your camera by white balancing it on minus-green cards. As I told you, the camera is a fool and we can mislead it to our benefit. (See www.warmcards.com.)

Lighting Ratios

The *lighting ratio* of a scene is the difference between the main light, the light that primarily illuminates and defines the subject, and the fill light, the light used to keep shadows from going too dark. Lighting ratios are often referred to as short or long, meaning a small difference between the two sources or a large difference. Lighting ratios are generally written in this form, 2:1, in this case meaning that the main light is twice as bright as the fill light. This would be a relatively short ratio. A long ratio might be something like 16:1, where the main light is sixteen times as bright as the fill.

def•i•ni•tion

Typically about 3:1, the **lighting ratio** is the brightness of the light that is directed on the subject from the key light, the fill, and the back lights.

You need to know this so you can match the lighting ratio to the dynamic range of your camera's sensor. If you exceed the dynamic range, you will block-up shadows with no detail, blow-out highlights with no detail, or even both. Sometimes you can exceed the camera's dynamic range for creative effects, but most of the time it just looks amateurish.

The Basic Lighting Pattern

Although the three-point lighting as the basic lighting pattern has been discussed in detail in both *The Complete Idiot's Guide to Independent Filmmaking* and in *The Complete Idiot's Guide to Digital Photography* (both of which are great resources for this type of information), let's review the main points as they are essential in placing any artificial lights for your subjects.

The Key Light

This is the main source of light that, by casting deep shadows on the subject from about a 45° angle, defines the subject. It has a "sculpting" effect. This light is often a spot light hitting the subject with a narrow beam.

The Fill Light

This light softens the shadows cast by the key and ideally is placed at a 30° angle in order to get into the lower shadowy areas as well. This is a soft (broad) light with about half the intensity of the key light. The key and fill are placed at some distance on opposite (either right or left) sides of the camera aimed at the subject.

The Back Light

This light completes the triangle by throwing light on the subject from behind. It is best placed above the subject at a less than 90° angle aimed at the back of the head and shoulders. The back light's function is to separate the subject from the background. If it is 90° or more, however, the light is no longer at the back but is directly above or even ahead of the subject, lighting up the forehead creating deep shadows in the eye sockets instead of separating the head and shoulders from the background. The ratio of this back light is 1.5 to 2 times higher than the key light to counteract the combined intensity of the key and the fill lights.

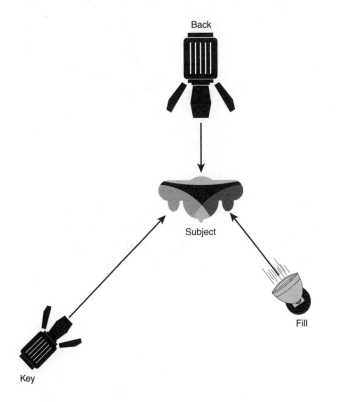

Back

Subject

Fill

Key

Diagram of the basic three-point lighting method.

In addition to this basic (key, fill, back) triangle of lights, you may need to aim lights at the background behind the subject and to increase dramatic effect. You may also use a side light called a kicker to illuminate the subject from the side.

The main reason for this lighting pattern is not simply to provide enough light to photograph, but to sculpt the subject through the interaction of lights and shadows, because in transferring 3D, real-life subjects onto a 2D screen, we must compensate for the lost 3rd dimension. This what good lighting can do.

Measuring the Light

You can't control the look and feel of your video without some understanding of light, and how to measure it.

Example of a standard light meter.

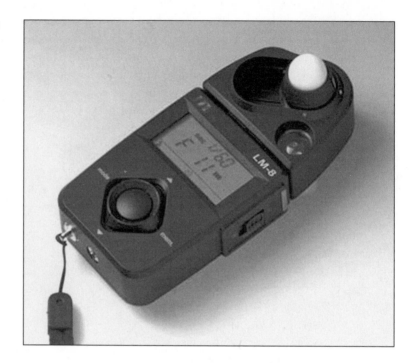

ISO Sensitivity

The sensitivity of camera sensors to light is measured in ISO units. The ISO (International Standards Organization) sets standards for a vast number of things to ensure consistency. The ISO system for measuring sensitivity to light goes back to the days of film and has been carried over to digital photography and video. It is a simple system to understand. If your camera's sensor has an ISO sensitivity of 100 (written ISO 100) it will require twice as much light for proper exposure as one rated at ISO 200. Most video cameras have variable ISO, meaning that you can set them differently depending on the lighting conditions. Increasing the ISO, however, generally produces sensor noise, which looks like film grain.

Incident Meters

You can do lots of videos without ever needing a light meter, but there may come a time when you find that you do need one to assist in setting up your shoots.

Basically, light meters can be one of two types. The *incident meter* measures the light falling on the meter as aimed at the light source and is the best type for general use. It has a hemispherical dome on it, which acts as a surrogate three-dimensional subject so it can measure light falling on it from all directions at the same time. Most also have an accessory flat diffuser which can replace the dome when metering prior to shooting flat subjects. Some people find the flat diffuser easier to use when determining lighting ratios because it can be pointed to each light source in turn. For example, if you have two lights illuminating your subject, you can go to the subject's position and measure each light by putting the flat face toward the light. As an example, let's say that one light gives you a reading of f/8 and the other gives you a reading of f/11. This is a one-stop difference, so the second light is twice as bright as the first. This would be a short 2:1 lighting ratio, ideal for video.

In addition to determining lighting ratio, you can use the incident meter with its dome to measure relative illumination across the scene. If you want even illumination, this will let you know if you have it prior to shooting any video. If you want parts of the site darker, you can use the meter to set them to the degree of darkness you want.

def•i•ni•tion

An **incident meter** is a handheld meter aimed at a light source to measure the intensity of light on the subject.

Reflective Meters

The second type of light meter is the *reflective meter*. This type of meter measures the light reflected from the subject. This is useful for some types of measuring, but is subject to giving incorrect readings of subjects that are light or dark in color. You have to mentally compensate for the subject reflectivity when using this sort of meter, and it is rarely used for professional video and film work as a result.

def•i•ni•tion

A **reflective meter** measures the intensity of reflected light bouncing off the subject.

The exception is the spot meter, a reflective meter that measures a very narrow angle of view. These are useful when it is impossible to go to the subject position, such as when shooting the top of a tall building or a distant mountain.

In-Camera Metering

All modern video cameras have built in light metering. This is always of the reflective sort, reading through the camera's lens. Most of the time this works just fine, just like auto white balance works fine most of the time. But it is just as easily fooled, such as when shooting the proverbial black cat in a coal bin, or conversely, shooting someone on a ski slope in a white outfit. The camera meter assumes a medium subject reflectance of about 12.5 percent, and will expose incorrectly if the subject reflects a lot more or a lot less than this. Luckily for us, most subjects do reflect about this amount of light, but when working with those that don't, you will have to manually compensate. That's when a hand-held light meter can be invaluable, although you can also determine correct exposure by shooting some test video.

The digital camera's auto-iris that functions as a reflective light meter over a larger area, also functions as a spot-meter when you zoom in to a small area of the subject. This is most helpful when you are faced with a high contrast problem. (You'll read about this shortly in "Lighting Techniques for Digital Video.")

Digital Light Meters

The intensity of light is measured in units of footcandles (in films in the United States) or in lux (in films in Europe and in digital video everywhere).

A footcandle is derived from the amount of light a candle radiates from the distance of 1 foot, while a lux is the amount of light illuminating 1 meter. Their ratio is 10:1 meaning that 10 lux equal 1 ft-c.

On the specs of digital cameras, you can always look up how many lux are needed as the minimum illumination to produce an image. Many digital cameras can shoot in daytime mode at 1 lux with the aperture set at f/1.6 while in night mode their minimum illumination is satisfied at an unbelievably low 0.01 lux. These are, of course, the levels to capture an image at a low quality level, better images require higher levels of light.

Because most digital cameras, even the consumer ones, do have factory built-in, through-the-lens (TTL) light meters that serve the purpose of most video shoots for consumers, prosumers may already find that the additional information about the

source of light by the incident light meter is necessary for more precise exposure control. Digital incident, reflected, footcandles, and lux light meters are all available, and they provide more accurate and easier readouts and conversions than the traditional lightmeters.

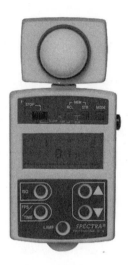

Spectra Professional 4-A digital light meter with special features for cinematographers.

Other Useful Lighting Gadgets

You want to modify the light on your set to get the look you want in your video. Many accessories will extend your capabilities and give you more versatility in light control.

Reflectors

When you need more light on part of your set or one of your subjects/actors, you can always pull out another light and set it up. But additional lights require power cords and power, and too many lights on a circuit will trip a circuit breaker or blow a fuse. Reflectors are another way to put more light where you want it, both indoors and outdoors.

You can buy reflectors in a variety of sizes and types from most photographic and video suppliers. Some of the commercial ones are ingeniously made to fold into a very small size for transport and storage. You want to outfit yourself with a selection of reflectors so you can simply pull out the right one when needed.

♦ Silver or white reflectors will reflect the light without altering its color balance. You want this most of the time. Silver is more efficient and specular, white less efficient and more diffuse.

- Gold reflectors are good when you want to warm part of the subject, and are often used to throw light onto a face or upper body.

- Zebra reflectors are striped with gold and silver for a more subtle warming effect.

- Black reflectors are really not reflectors at all, but can be used like reflectors to subtract rather than add light. You can also buy double-sided reflectors with one type of surface on one side and another on the opposite side.

You can position a reflector where needed and angle it as desired by having an assistant hold the reflector and aim it for you. This is particularly good when you are tracking a moving subject. You have to rehearse the tracking a few times to get it right during the actual shoot. With static subjects, you can mount the reflector on a light stand.

Karl's Tips
If your budget is tight, you can make your own reflectors. You can find white foam core board at many art supply stores. A stronger and more rigid version is sold under the brand name Gatorfoam. It is a bit harder to find, but it holds up better, which makes up for its higher cost. You can glue aluminum foil to the board if you want a silver reflector. The shiny side will be more specular and the dull side a bit more diffuse.

Example of a commercially made reflector.

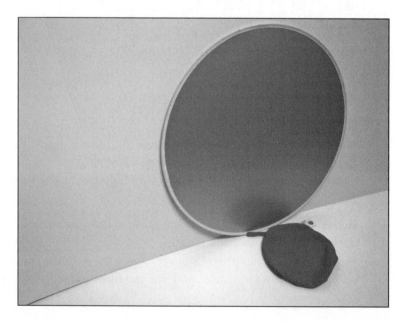

Gobos

Gobos are somewhat like reflectors, and often mounted on similar stands or held up by assistants. Gobo is short for "go between," and is anything that goes between camera and subject or between camera and light.

Gobos are used to block light from falling on a part of your scene or subject. Gobos can be fabric on frames, or black sheets of wood, cardboard, foam board, or any other suitable material. If you plan to use a gobo close to a hot light, make sure it isn't flammable.

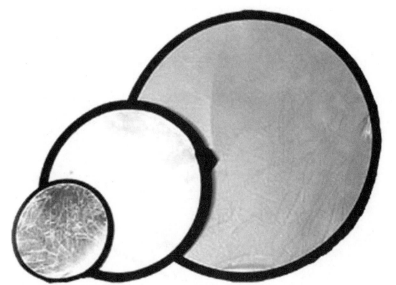

Here are some examples of gobos.

Scrims

Scrims are translucent fabric or plastic on frames placed between a light and subject to soften and diffuse the light. Sometimes you also shoot through a scrim if you want a very soft, dreamlike look. Scrims come in all sizes, and you can purchase them or make your own from fabric and plastic plumbing pipe frames. Very large scrims are sometimes used outdoors over top of a set to soften the sunlight.

As with gobos, if you plan to put a scrim very close to a hot light make sure it won't catch fire. Spun glass fabrics are available that are ideal for this sort of use.

Butterflies

Butterflies are special oval scrims used outdoors to soften the light falling on people's faces. As with general scrims, you can buy them ready made or put them together yourself using fabric and homemade frames.

Pattern Projectors

Pattern projectors are like slide projectors with very bright light sources. They accept metal or glass patterns and have a lens on the front that can be focused. This allows you to project a pattern onto your set, or part of your set. By adjusting the focus you can make the pattern sharp or soft. Pattern projectors are often used to project the light from a nonexistent window onto part of a set, create Venetian blind effects, or a wide variety of other lighting effects.

A pattern projector.

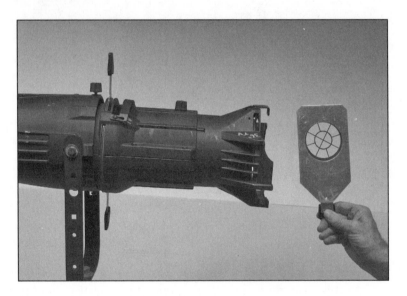

Cucoloris, a.k.a. Cookie

A Cucoloris, more commonly called a "cookie" is a piece of wood, plastic, or other material cut into a pattern. It is used somewhat like a pattern projector but its focus is controlled by how close it is held to the light. Dappled light coming through the leaves in a forest is often simulated this way. And wind blowing the leaves can be simulated by having an assistant hold and move the cookie. This can be combined with a high power fan or wind machine to effectively simulate a wind storm.

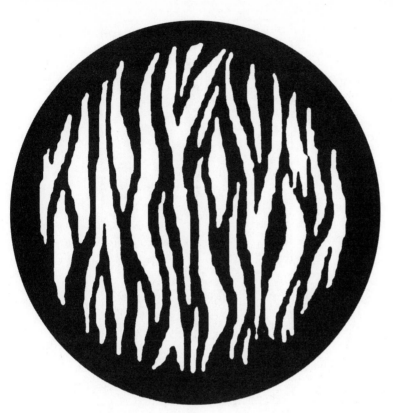

Visible Means of Support Light Stands

Lights won't just hover in the air on your set, at least not yet, so you will need some way to hold them at the height and angle you want.

The Ubiquitous C-Stand

One of the most versatile types of light stands is the C-stand. Matthews is the originator and best known source of C-stands, but over the years they have been copied by many other companies. A collection of C-stands is a very good start to a complete lighting system; just be sure the stands you use are rated for the weight of the lights you intend to put on them.

If C-stands are used in an area where people are walking about, it is a good idea to put some sandbags or weight bags on the legs to protect them from being tipped over.

C-stands are the most common light stands on professional video shoots.

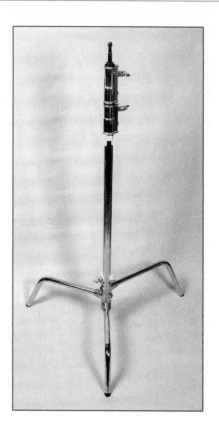

Other Types of Light Stands

Today many companies make portable light stands in a variety of designs. Make sure that the stands you are considering will handle your weight requirements and that they are durable enough to hold up to your use. Some of you can get by just fine with cheap stands, while others will need more substantial professional stands. As with many other things in life, you often do get what you pay for, and the cheapest stands may not really be such a bargain.

Overhead Rail Systems

If you are considering setting up a permanent studio for professional video, you may want to look into overhead rail systems to support your lights. Most television studios use such systems, because they prevent the dangers of people tripping over or knocking over light stands, and they get all of the lighting cables up off the floor.

Although initially more expensive than light stands, overhead rail systems are a good long term investment and offer great flexibility and ease of use.

Gaffer Equipment

As we learned in Chapter 6, the gaffer is the chief electrician and lighting technician on a movie crew, and works with the DP and lighting director to light the set. The name is English slang for "grandfather" and goes back to the days when the head of a work crew was called the grandfather.

Lots of us who work in very small crews double as our own gaffers, and handle all of the electrical and lighting stuff ourselves. For us, the term gaffer has more of a jack-of-all-trades meaning, because we really can't restrict ourselves to just dealing with one aspect of the shoot.

Technically, the reflectors, gobos, scrims, stands, and so on just discussed are gaffer equipment. But the gaffer's tool kit has a lot more things in it. A good gaffer has a wide selection of clamps for mounting things to stands, clipping wires out of the way, connecting reflectors together, and an almost endless array of jobs that come up spontaneously on a video set.

Gaffer's Tape

Many people today think of gaffer's tape, duct tape, Duck tape, and similar tapes to all be the same thing. They are not. Gaffer's tape is a very specific tape. It is fabric-based, very strong against pulling but easily torn across, and has a special adhesive that can be pulled off almost any surface without harming it or leaving behind a sticky residue. It is just plain essential on the set, and if you don't keep several rolls around, you will certainly wish you did. Don't skimp on this—get the real thing.

Real gaffer's tape is worth the higher price.

Professional Grip Suppliers

The term grip comes from the big toolbags they used to carry, which were called "grips." Today a grip will also need tools, but on a small shoot the jobs of gaffers and grips will often be rolled into one.

If you are in a major city, you can just walk into a commercial supply shop and look at gaffer and grip equipment and tools. In smaller markets, you have to be content with dealing with mail order suppliers. You will find a list of mail order suppliers in Appendix B.

Grip from Your Local Hardware Store

Often the specialized grip and gaffer equipment is just ordinary hardware. Sometimes it is modified for photo/video use, but often it is not. You will find a wide array of clamps and other items suited to use on your sets in any well-stocked neighborhood hardware store. Always check there before paying more from a specialty supplier. Many hardware items are easily modified to meet your needs, such as having a stud for mounting lights welded onto a pair of vise-grip pliers.

Lighting Techniques for Digital Video

Though based on centuries of experience in fine arts, lighting techniques were mostly developed in photography and motion pictures, and the basic methods have been applied to analog and now digital video.

The most important aspect of working with light and lighting is to consider the relationship between light and shadow. Some experts opine that lighting actually means controlling the shadows. The convention that has emerged throughout the centuries is that light conveys something energetic, more positive, and brighter, while shadow creates mysterious uncertainty, drama, and even fear.

The more shadows you have the more drama you have. This, of course, applies only to skillfully controlled shadows and not to unwanted multiple shadows, or the boom shadow that the inexperienced videographer cannot get rid of while shooting a scene.

Some methods of controlling shadows when using lights include:

◆ Move the subjects away from the background at least four to six feet, so lights aimed at them from above at a 45° angle will throw the shadows on the floor and out of your frame.

- When using a boom mic to record sound, make sure the boom does not cross in front of a light placed above it. Find alternative mic placement in between the lights.

- Because the majority of lighting fixtures are attached to the ceiling, they cast shadows from above at a 90° angle on the faces and create deep shadows in the eye sockets.

As expressions and emotions are best seen in the eyes, we need to eliminate and soften these shadows and bring out the eyes from the shadows. By using an eye light from the top of your camera, most of these are eliminated. If this camera light is too bright, however, it may burn out the face altogether and also it may create an unnatural circle of light around the subject with a fast fall-off of sharp shadows. To avoid this problem, some lighting companies have created a small circle shaped camera light that fits right around the digital camera's lens.

Karl's Tips

If you don't want to pay for camera lights, the poor man's soft facial light, a bulb placed inside a Chinese lantern, a favorite of many cinematographers, will do just fine.

Example of a Chinese lantern.

If you're using an old fashioned small tungsten spotlight that fits into the camera shoe right above the lens, you better put it into flood position to spread light around and thereby decrease the circle of burnout and fast falloff of shadows. Even then you may not be able to direct the light straight into the face of your subject; you may need to tilt the light slightly above the subject's head to avoid burnout. This is also called clipping, meaning that you lose all details in an overexposed area. Definitely set your *zebra pattern* in your viewfinder that shows overexposure (hot spots) by too much light below the clipping level.

def•i•ni•tion

A **zebra pattern** appears in the viewfinder of better prosumer cameras to indicate areas of the shot where the image could potentially be overexposed.

Another typical problem with shadows is caused by high contrast between the brightest spot (white) versus the darkest spot (black). Video cannot handle this as well as film; if you're shooting with auto-iris and you have your subject sitting in front of a window with bright sunlight coming through, your subject's face will be almost completely dark (underexposed), because the auto-iris will try to average the high contrast between sunlight and dark interior.

Solution: pull down the shades. If that is not enough and you wish to see the outside as well as the face inside, you must light up the figure inside to bring up the light levels closer to the one outside. In fact, by lighting you decrease the contrast between sunlight and darker interior. Obviously it is faster and easier to put blue gels on your lights to convert their color temperature to daylight (5600°K) than gelling the windows with amber sheets to convert sunlight to tungsten (3200°K).

When faced with the same issue in exterior shooting against the sun you need to use the Neutral Density (ND) filter built in every digital camera to cut down on the overall light and use reflectors aimed at the face of the subject for the same result.

Shooting inside a car traveling under bright sunlight you may use small reflectors or sun-guns, which are small handheld lights with blue filters covering the face of the bulb and powered by batteries.

Lighting for digital video has an added advantage over film: due to the higher light sensitivity of the imaging device, you hardly need any lights when shooting on locations even under dim lights. Using your auto-iris you should be fine in most instances.

That is why the Danish Dogme movement, based on this property of digital video, prohibited the use of any lighting in their digital movies. The only lighting they permitted was the use of some practicals. These more powerful light-bulbs replace the household bulbs in chandeliers and reading lights, thereby increasing the overall light levels.

The Least You Need to Know

◆ Light controls the look and color of your video.

◆ You need a basic understanding of color temperature and white balance.

◆ You may want a light meter to give you maximum control of the light on your set.

◆ A wide variety of light modifiers is available to you for your video.

Part 3

Production

This is the fun part—the part where you say "Action!" and work with your cast and crew to take your idea and convert it into raw footage and audio.

Chapter 12

Directing

In This Chapter

♦ The basics of camera shots and when to use them

♦ How to establish and maintain working relationships with your cast and crew

♦ The importance of scheduling sufficient rehearsal time

♦ Knowing when to "let go" and trust your cast and crew

The director is the central life force of any movie. He or she is the person whose vision will ultimately be brought to the screen, and who has final say on every working component that contributes to the production of the movie.

But what exactly does directing consist of? Directing means the supervising of the transferring of all the elements planned during preproduction into shots on video. The director is responsible for executing the plans as much as possible, but keep in mind that a good director is always ready to come up with some alternatives in case the original plan does not work. He or she also needs to be open to some improvisation of new ideas as they emerge from the location, the actors and other collaborators, and especially the director of photography.

Directing Basics

When making a digital video on any level, it's a good idea to familiarize yourself with the basics of directing, even if you think your video is just an off-the-cuff or improvised production. Ultimately, the more you know about how to direct, the better your movie will be.

The director has several priorities, all of which will be discussed in this chapter. But for a quick frame of reference, the main concerns of the director are:

- Executing the previsualized plan

- Sticking to the schedule and keeping the film on budget

- Knowing the shots and how to achieve them

- Working with the actors to bring the characters and their story to life

Executing the Previsualized Plan

Executing the previsualized plan means getting on video all the shots of the storyboard and/or the shot-list (both derived from the shooting script) in the order of the shooting schedules. It is basically shooting for the edit by providing as much useable coverage of the scenes as possible.

Of course, it's rare to obtain a perfect shot on the first take. You may have a boom shadow passing over the actor's face, a mistaken sentence in the dialogue, or any number of issues. This is why you need to repeat your take as often as necessary—which can be many, many times—to get it perfect. Well, as perfect as you can.

Zoom In

If you want to have a good laugh at what can—and does!—go wrong during shooting, take a look at the movie *Living in Oblivion*, a satirical look at low-budget independent filmmaking.

The number of takes you need to get your shots makes up your shooting ratio. It is crucial in film to keep the *shooting ratio* low, because film is very expensive. On the other hand, digital video is cheap and there is less of an incentive to keep the shooting ratio low, except for the sake of sticking to the schedule and the overall budget … which is another of the director's main priorities.

The Shots

A good director is also concerned with proper coverage, which means that you shoot master *shots* that cover the entire location with all actors in it, and mini- or sub-masters that cover other sections of the *scene* from a different angle but still contain all the elements of the main action. For proper coverage, you also need medium and over-the-shoulder shots and close-ups. Finally you need some extreme close-ups of faces and objects, called inserts. Shots just means what you do with the camera: positioning, movement, angles, and so on. Shots in scenes that make up a sequence are like words in sentences making up a chapter. Several sequences make up the entire video, like chapters make up a book.

Here's an example: a very short exterior shot of the infamous house in Alfred Hitchcock's *Psycho* is a scene, even though it is a short single shot followed by several shots inside the house that make up the next scene. In fact, the interior shots were taken on a sound stage while the house was being built on the studio lot. Only by cutting together these two scenes was the illusion of the same location created.

Although it's often said the director of photography (DP) is responsible for the shots and the overall look of the movie, he or she is really just an extension of the director. In order to achieve the final vision of the movie, the DP will have to work closely with the director to decide how each shot will look. And whether they are planned in advance or not, the shots will influence the storyline and the overall experience the audience will have when watching the movie.

To work properly with the DP (or, if working on a low-budget video, to understand the basics of camera movement to shoot it yourself), the director should know the following basic types of shots and how they are achieved: wide shot, tight shot, pan, swish pan, zoom, tilt, dolly, pivot, and sequence shot.

Wide Shot

One type of wide shot is alternately referred to as the establishing shot. And it does just that: it establishes the environmental perimeter for an audience, allowing them to get a sense of all characters in a scene and of their surroundings. In many cases, the wide shot is used at the beginning of a new scene, so that when the camera cuts to a tighter shot (i.e., moving closer to a person's face), the audience already has a sense of their surroundings.

Karl's Tips

Sometimes you may want to hold off on showing the establishing shot until the end of the scene, so it acts as a visual surprise to the audience, who previously did not know where the action they observed had taken place. Of course, this decision happens in editing, but you still have to know to shoot the establishing shot for the ending of your scene.

Another function of the wide shot is to show unobstructed action. A director may instruct his or her DP to pull the frame back (widen the frame) to show the entire ring of a boxing match, for example, so that each punch will be captured.

Tight Shot

The opposite of a wide shot is a tight shot. Tight shots can be used to build drama or suspense, or to show detail. Suppose the director decides that he or she would like to emphasize an emotion a character is feeling. He or she may decide to bring the audience emotionally closer to the character with physical proximity (using a tight shot to show only the actor's face) so that the audience can concentrate on the words being said and the expression on the actor's face. Tightening the frame so that only a character's face is on the screen can enhance the importance or significance of what he or she is saying and feeling.

Tight shots can also highlight the significance of an action that is essential to the plot. Let's say that the director wants you to remember a moment in his movie when the murderer accidentally drops a knife on his victim's living room floor. A tight shot of the knife hitting the floor would show its importance and help the audience to

remember it, so that, later, when the police announce that they have the murderer's fingerprints, the audience will not question how they got them.

Wider and tighter shots often interplay within one scene if the camera and/or the actors are in movement. This is what we call "blocking" for both actors and cameras, and we will get into this in greater detail a bit further on in this chapter.

Pan

Panning means changing what the audience sees by moving the camera from one view to another while continuing the shot. Panning can be used to follow a subject from one place to another without cutting to a new angle, and gives the sense of continuous motion.

Panning can be to the left or to the right as you swivel the camera either on its tripod head or manually. Panning right means that the frame moves to the right; your hand actually moves the tripod's camera handle to the left.

Although this can be a useful technique, panning can be complicated by several issues that a director must be aware of. Don't use panning in an attempt to capture everything that's going on in a scene; what will usually happen is the audience will be unable to focus on anything at all.

For example, let's say you're making a movie of your 10-year-old's birthday party in the backyard. The most common mistake in a case like this is too much panning, because the director isn't thinking ahead to what the birthday video will look like when it's on screen. They move the camera around the party constantly, not wanting to miss anything, but ultimately find that because they never focused on any one moment in particular, the video is basically unwatchable.

Swish Pan

A swish pan is a fast-moving panning shot that blurs everything in between the beginning frames and where the pan ends.

In America's perfect Valentine's Day film, the evergreen *Casablanca*, there is an excellent use of the swish pan, expressing surprise, when Rick enters his dark apartment and, switching on the light, suddenly discovers Ilsa waiting for him near the window.

Karl's Tips
Do not pan quickly; the camera has to move slower than the eye as it moves around. You actually have to instruct the people whose movements you want to follow to move somewhat slower than normal to obtain a good panning shot.

Zoom

Zooming is useful, especially on a low-budget movie where you don't have the means to roll your camera on a dolly or fly it in on a crane. The zoom feature allows the camera operator to move closer to the subject at the press of a button without having to move the camera—or him- or herself—at all.

But the zoom can be your best friend or your worst enemy. As the panning technique is often abused, so is zooming. It's that power rush we as the camera operator experience, as we try to cover all the moments without missing anything, such as zooming in for a tight shot of the birthday child blowing out the candles … then simultaneously panning and zooming out at light speed to get the others splashing in the pool. (For a comparison of zooms and dolly shots, review Chapter 3 on lenses.)

So how do you achieve a good zoom? In multiple camera studios where all the cameras are on dollies (camera assemblies on wheels), a dolly in movement means rolling the camera closer; a dolly out means rolling it away from the subject.

Trucking right or left means rolling the camera on its wheels in either direction. A combination of the dolly with trucking results in a curved movement called arc. (Do not confuse trucking with tracking, as tracking means to build tracks on which the camera dolly can roll.)

A crane movement involves changing the camera angle from low or *eye angle* to *high angle* (bird's eye view), and it is performed either by large cranes or by their lighter and shorter sisters called jib arms. You can rent a simple jib arm for about $50 for a weekend shoot.

def•i•ni•tion

Eye angle is an eye-level shot that conveys neutrality. In television news, it is used for the illusion of objectivity. **High angle** means looking down on the subject(s) so the other characters, or the audience, feel superior. It may be used to create fairy tale effects by dwarfing human figures, for example, by shooting down at them from a giant's point of view.

A Word on Angles

While we're on angles, high angle diminishes the importance of the character. Low angle is quite the opposite; looking up increases the importance of a character, making him look more powerful or menacing. Oblique angles, on the other hand, create a psychological imbalance expressing an out of ordinary frame of mind.

In Bernardo Bertolucci's masterpiece, *The Conformist*, the camera is tracking with the main character in an oblique frame while he is upset about being followed by

someone. When the follower introduces himself not as a threat but as a new body-guard, providing the character with more security, the camera returns to normal angle. This technique shows the main character's return to a normal frame of mind.

Pivot

The newest trend in camera movements, pivot, combines steadycam-like movements with a jib arm moving up and down—and also around the characters. This is often performed and monitored by computers.

A fascinating, new, digitally animated in-depth study of pivot and all other camera movements, as well as actors' staging, is available at: www.hollywoodcamerawork.us/mc_chapterlist.html.

Karl's Tips

These days, digital directing often means computer-assisted directing. A director must keep track of many things while shooting: the script, the breakdown sheets, the story-boards, the overlays, the shooting schedules, the lighting plot … it's endless. Luckily, digital assistance has become available to help with the management of all these tasks. Called the Director's Notebook Pro, this software puts all of this complicated information together—simply—at the director's fingertips.

The lighter version for consumers and amateurs, called the Director's Notepad, is also available. Check out: homepage.mac.com/directors_notebook/pad.

Sequence Shot

A sequence is formed by a string of shots or by a single sequence shot lending a larger thematic context for the scenes.

Shooting an entire movie in uninterrupted takes is only possible in digital. In the movie Timecode, *Mike Figgis orchestrates four cameras simultaneously—and brilliantly.*

A sequence shot is achieved when, without cutting, the director choreographs the actors and the camera's movements for an entire scene, or, as it has become possible in digital video only, for an entire movie. Some examples of movies to study for sequence shots are Mike Figgis's *Timecode* and Aleksandr Sokurov's *Russian Ark*.

Director's Cheat Sheet

Look at these figures for a quick shot strategy guide.

Use extreme long shots (establishing shots) for describing the environment in which the action takes place. (The samples in this section were created using the previsualization software FrameForge.)

Use long shots to depict the actions and interactions of the subjects, who are not necessarily only people.(They could be penguins, too. Think of the animated cartoon Happy Feet *or the incredible documentary,* March of the Penguins.)

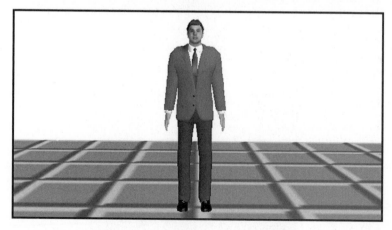

Use medium shots, including over-the-shoulder shots, for dialogue or closer interaction between the characters.

Use close-ups for emotional moments and reactions.

Use extreme close-ups for magnifying details such as the actors' faces and limbs and certain objects that are part of the action (such as the knife left behind by the murderer).

Working with Actors

Of course, understanding the shots and how they strengthen or weaken the scene is just the beginning of the director's duties. One of the director's most important jobs—and the one that can really make or break a movie—is knowing how to work with actors. Some say that working with the actors is the pivotal responsibility of any director. If your movie has actors in it, then it's true.

We've all seen movies that were … well, abysmal. On the other hand, we've also seen movies like *The Godfather*, which is generally considered to be unforgettable. And part of the reason that film is so unforgettable is the actors' performances.

In the way that a psychic medium transmits information, the director must communicate with the actors. The director must tune into the actor and vice versa for a successful performance.

It all begins with character. The director must know what to look for in an actor to satisfy the needs of the character … and must find it during the casting process (see Chapters 6 and 10 for information on casting). Once the actors have been cast, though, the director's primary objective is ensuring that the actors embody the spirit of the character to make certain that the story moves forward correctly and smoothly.

Knowing Your Characters

Have you ever walked out of a movie and said that an actor was terrible, unconvincing, or lacking in screen presence? What you're actually saying, without realizing it, is that the director of that particular movie didn't understand the characters.

Keep in mind that a director has the final say on just about everything related to the movie. If a bad actor is playing a role in that movie, it's because the director has allowed it to happen. Of course, sometimes a producer requests that a particular actor be cast in the movie; in this case, a director may not have much say about it. But he or she can work with that actor for as long as time permits to ensure that the actor accurately represents the character in his or her performance. That's why you can pretty much hold the director accountable for how the actors portray the character on the screen.

You may not be directing a movie that has producer involvement, and maybe your resources are limited to the few friends or family members you can find to devote their time to your digital video. In this case, they may not be the most skilled actors around, but they are the most available. So how do you get a good (or at least a decent) performance out of your cast in this case? One way is to devote as much time as possible to rehearsal.

The Importance of Rehearsals

Time is of the essence when the camera is rolling, so the more prepared the actors are, the less time you'll spend on the set. And that's what rehearsals are all about: preparation for the actual shooting. By the time shooting commences, the actors should be completely immersed in their characters.

The director should schedule time in advance of the first day of shooting to get together with the actors (individually or as a group, depending on the needs of the screenplay) to run through the movie as it will be shot. During rehearsal, the director can talk with the actors about each character's personality traits, quirks, flaws, and *motivation*. The director may have a particular idea of how the character should be played, but in talking with the actor he or she may discover that the actor has a very different view. It can be helpful to "talk through" these ideas in advance to determine the best way of portraying the character so that both the director and actor agree to avoid any delays during shooting.

Also during rehearsal, you should have your crew around to get a sense of what they will be doing during shooting. This is an optimal time to form and maintain the working relationships you will need to develop with your crew to make sure that your set will be a creative, constructive atmosphere and your production is the best it can be.

Talking with the actors in rehearsal also allows the director to convey the importance of certain sections of dialogue. It could be that the director needs a certain inflection of a particular word in order to make a point in the story, or it may be that understatement is key in certain situations. Details like these are vital during rehearsals, so that time is saved on the set. If you have good actors they can also help you finalize your dialog during rehearsals as they may come up with better lines than you or the writer could ever think of.

def•i•ni•tion

Motivation is the wants, needs, and beliefs behind a particular character's actions that cause them to act—or react—the way they do.

It's also essential to rehearse where the actors will stand, move, and interact with each other physically. This is known as blocking.

Blocking

When the director yells "Action!" all elements of shooting the scene should be ready to go. In most cases, the actors are the central focus of the scene, but they need to be told where to go and how to move.

Blocking is when the director instructs the actors in their precise movement and positioning for the performance. The screenplay provides minimal instructions for the actors, and it's not the actors' job to coordinate how to move through a room or how long it should take to go through motions such as uncorking wine and pouring it before lighting a cigarette. The director knows what he or she wants to see and how, so it is up to him or her to tell the actors what to do and where to stand.

The director will also have particular shots in mind for each scene and may need to have the actors stand a certain way so that the lighting is correct in the scene, or so that he or she is not in the way of something in the background that will be zoomed in on. The director will therefore need to work with the director of photography (DP), if there is one, to determine how the shots will look, and then work with the actors on the best way to block that particular scene.

The alternative could also be true—depending on the director's style or inclination, he or she may choose to block out the scene first, and then work the camera shots around it. Either way, the actors must know how to interact with their environment, and the director is their guide.

Much Needed Assistance

As the director, you may feel the need to micromanage, or keep an eye on every single aspect of the production. But not only is that not possible, it can actually be counter-productive.

No matter how low budget your digital video may be, one of your best investments can be to hire an assistant director, or find someone who can volunteer to act as one, either for the experience, the credit, or simply to do you a favor.

The assistant director, or AD, can focus on the details for you to make sure that the movie is on track. The AD makes sure that everyone sticks to the schedule and stays on set to manage the details. He or she ensures that the actors are ready when the scene is set, and in the absence of a script supervisor, makes sure that the script and storyboards are followed. In other words, the AD does the nitty-gritty and frees you, the director, up to direct the scene and manage the big picture.

Continuity Is Critical

The director also needs to ensure that proper coverage has been shot and, most importantly, that continuity and proper screen directions are not violated. (On larger budget films, this is done by the script supervisor.)

Some famous examples of continuity errors in high-budget movies are Edward's (Richard Gere's) tie in the seduction scene in *Pretty Woman*—off, then on, then off again—and Mia Wallace's (Uma Thurman's) cigarette constantly switching hands while she's having dinner with Vincent (John Travolta) at Jack Rabbit Slim's in *Pulp Fiction*.

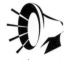

Quiet on the Set!

Unlike stage actors, experienced film actors know how to repeat their actions exactly the same way over and over again for the sake of continuity editing.

You might be surprised to learn that continuity errors are not limited to badly made, low-budget films. The actor lights up a cigarette, holding the lighter in the right hand, and then when the medium shots of the same scene are shot after lunch break, he holds the lighter in the left hand due to oversight.

An important rule to follow is the proper way of entering and exiting the frame. In order to preserve screen direction continuity, when an actor is moving from left to exit frame right in the next shot, he needs to enter from frame left to preserve the continuity of movement.

And the most important rule to observe is the 180° rule, also known as the violation of the axis. This means that, opposite to the camera, there is a virtual 180° line between the characters; most of the time you cannot cross to the other side of this semicircle without reversing the screen directions.

The 180° rule.

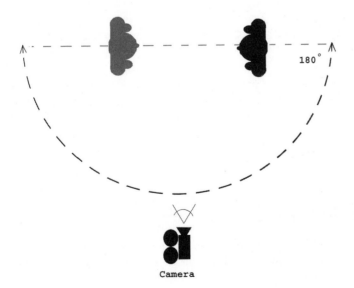

Camera

To avoid this violation and still be able to cross over to the other side for different angles, you must remember to take shots that can be inserted between two sides of the 180° line during editing. These shots—frontal close-ups or simply shots near the 180° line—help transition to a new 180° angle opposite to the camera setup. This new angle will already include the previously unacceptable other side within its semicircle. Another way to get to the other side of the original 180° is simply by moving the camera across the line while filming.

Look at the drawing of two people facing each other. There is a virtual 180° line between them. As you take a two-shot of them from one side of this axis, one character is clearly on the right side of the frame and the other one is on the left. If you would now cut to a shot taken on the other side of this 180° line, they would switch places; the one who was on the right would suddenly show up on the left side of the frame, thereby reversing screen directions. This is called a violation of the axis or the 180° rule.

Another simple example is a car moving left to right in one shot on the road. If you'd cut to a shot taken from the other side of the road that would show the car suddenly going the other direction, right to left. This jumping to the other side and thereby reversing the screen direction is a confusing violation of the axis or the 180° rule. A frontal shot of the car inserted between the two-shot taken from opposite sides would resolve this problem.

A close-up of the driver inserted in between would also make possible to use the two long shots taken of the moving car from opposite sides of the road without the feeling that the screen direction was reversed.

Karl's Tips

Sound complicated? The good news is that all continuity errors can be easily avoided when shooting in digital video. You can always play back the footage immediately if in doubt to eliminate these errors before you decide how to connect the shots.

In fact, the new way of shooting films is to use immediate on location digital nonlinear editing so that the company will not leave a scene without a rough cut, ensuring right there that everything has been shot correctly.

The Final Word on Directing

The best thing you can do as director is to work with your cast and crew as much as possible before filming starts to ensure that you are all on the same page and all have the same objective in mind for the production.

Then, step back. Trust in your actors and crew members to carry out your directions, because after all you are the one who asked them to be part of your video, and therefore you must have confidence in them. Treat everyone involved in your video as collaborators—although you are at the helm of your production, being too close to any one aspect of it is a good way to ensure that you overlook the big picture. And, after all, the big picture is what you as the director are after.

The Least You Need to Know

- It's a good idea to study wide shots, tight shots, panning, and zooming techniques, and to know when each would be most effective.

- The more time you can spend up front with your actors and crew, during rehearsals and preproduction meetings, the better your video will be.

- At some point, you need to step back and trust your cast and crew. The director's job is to achieve the big picture, not to get lost in the details.

The Production Environment

In This Chapter:

◆ The importance of setting the proper production mode and environment for your digital video

◆ Knowing when to shoot on location and when to use a set

◆ Using the world around you to work within your script

◆ Understanding the costs and benefits associated with permits

◆ Knowing when—and how—to use a green screen

Depending on the topic of your digital video and on your resources, you must decide what production mode and environment work best for your project. Should it be single camera or multi-camera, in a studio or on location? Will you shoot at home, in public, or on a green screen? These are all things to consider well in advance, as they play such an important role in making your finished video look the best it can.

Single vs. Multi-Camera Shoots

The single versus multi-camera decision depends on the question of control. If you shoot in single-camera, film-style mode, you can repeat the action for take after take until you get the perfect shot. Most films are shot

this way, as it gives maximum control over each shot. On the other hand, when you cannot control the event or repeat it for the camera, you need multiple cameras to follow the event and get the best possible shots. No wonder that the heart of a multiple-camera television studio is called the control room!

You might think you can only do single camera shooting, but this is not true. Cable television studios all over the country may be available to you for taping your community-based shows. There are also public access channels that provide training, equipment, and even broadcasting time for your projects. For instance, the Public Access TV in New York City offers free training, equipment, and airtime for literary hundreds of different programs. In addition to public access, you can find access to multiple camera studios at high school and college media facilities. Check out the studio information available at www.mnn.org/en/producers/studios.

Sets or On Location?

Movies can be shot in studios on a set—a constructed environment made to look like a school room, an office, or the foyer of a mansion—or on location. Movies shot on location not only tend to look more realistic, but can also be cheaper than building a set. Shooting on location has its drawbacks, however, such as a lack of control over environmental issues like sunlight, weather, and passing traffic.

Clearly, if you're planning to shoot that birthday video in your backyard, location isn't an issue. But depending on the type of video you're planning to make, choosing a location can be quite difficult. Because the locations will play a large part in setting the mood for your movie, you need to carefully consider each and every one.

Shooting on location is not limited to single cameras. You can, of course, shoot with multiple cameras on location as well, especially when you have to cover events, such as parades, weddings, and sports, that cannot be repeated. Professionals take a studio on wheels to the location—in big trucks with the cameras attached with long cables and/or to microwave dish antennas … but this probably won't work for your budget.

On the consumer/prosumer level, inexpensive ways exist to shoot with multiple cameras at events. For example, you may just shoot without any connection between the cameras and line them together in editing.

Karl's Tips

The most important thing when shooting with multiple, unconnected cameras is to make sure that the cameras are from the same manufacturer. Different brands reproduce color and render space differently due to their different optical and electronic systems.

Finding the Perfect Location

A daytime shot outside in a park, with kids running around laughing, will probably set an upbeat or happy mood. A car ride down a lonely street in the middle of a thunderstorm might evoke a thrilling or suspenseful mood. Shooting outside in a park or driving down that lonely road, however, will likely require a permit from the state or town in which you are shooting. And these permits depending on the location could be expensive. Wherever you decide to shoot should fall within your budgetary means, but, above all, the location should relate to the subject of the movie.

Use Whatever Is Available

So how do you do both? First things first—look around you to consider every available location. One school of thought is to build the subject of your movie around whatever locations are available to you. For instance, maybe your home is the only indoor place in which you can shoot your movie. This might lead you to write (or find a screenplay for) a movie about two people who stay inside and discover the cure for cancer because it happened to be raining outside that day.

To illustrate this point further, let's take the movie *Star Wars Episode IV* for an example. Luke Skywalker is an average, innocent nobody living in the middle of nowhere on a desolate planet. But by the end of the movie, he has gained the knowledge and personal experience to destroy the base of the evil Empire.

If you think about it, only a small percentage of the success of *Star Wars* is owed to lasers, monsters, and space ships. At the core of the movie are some very human truths to which people gravitate. Throughout the movie, Luke faces things within himself that allow him to grow, go out into the galaxy, and form lasting relationships with equally relatable characters. The fact that this film takes place in space, shot with expensive special effects and in various locations, doesn't have as much to do with its success as the core story—that of the small-town boy who makes good.

You may not realize it at first, but very similar human character growth takes place in *The Breakfast Club*. Though two of the characters are quite popular, they are still underdogs on the day the film takes place—serving detention with the others on a Saturday, at the mercy of the school disciplinarian. By the end of the film, they have—you guessed it—formed lasting relationships with equally relatable characters. But unlike *Star Wars*, the locations and special effects are not as varied in *The Breakfast Club*; almost the entire movie takes place in a high school library. A dramatically

powerful movie with great character development—all essentially taking place in one location. And not once did Molly Ringwald need to visit Tattooine to figure out that she didn't want to be the shallow prom queen of Earth.

A great example of a filmmaker using whatever location was available is Kevin Smith and his indie hit *Clerks*. Smith had access to a convenience store, but he was only allowed to shoot there at night. Therefore, he wrote a screenplay about a convenience store clerk, and added into the storyline a small issue: the main character, Dante, is unable to open the metal window guard in front of the store. Because the window guard was down at all times, the audience could not see the sky, and did not know that it was nighttime instead of day, when the story was supposed to have been taking place.

The point is, the emotional impact of a good story could potentially work in any environment. You just need to be creative and write characters (or find a screenplay) that the audience can relate to. The actual environment may not matter as much as you think.

In the history of digital video movies, the Dogme-95 movement deserves a special place. It started in Denmark in 1995, and its birth was connected to the first prosumer digital camcorder, the Sony DVX-1000. A group of young Danish filmmakers led by Lars Von Trier and Thomas Vinterberg decided that they would only shoot on location without artificial lighting, tripods, or any other camera support; they would use only handheld digital cameras, concentrating on the actors' performance.

They named their movement Dogme (dogma) because these production requirements were set in a manifesto and videomakers who wanted to join had to take a "chastity oath" promising to stick to these rules of pure, unadulterated shooting techniques.

Dogme-95 has been so successful that their videos were blown up to 35mm film and have been distributed in theatres worldwide. Many digital filmmakers have followed their example. In the United States, InDigEnt, led by Gary Winick, was one of the most prolific companies shooting full-length theatrical features on prosumer level camcorders on location. The American development of Dogme-95's aftereffect is called the "Mumblecore Movement," which came out of the South by Southwest Film Festival (SXSW) in 2005. These feature-length projects were mostly shot for a few hundred dollars and starred the filmmakers themselves, focusing on the private lives and relationships of twenty-something artists and college students. What is most important about this Mumblecore Movement is that it is not centered around New York or L.A., but these micro-budget movies are from anywhere in the United States. You can find some examples at molehillindependent.com.

Shooting at Home

Shooting a digital video in your own home is actually a pretty good idea. For one thing, your home is a completely controlled and familiar environment. And just by using your creativity, you can make your home look like several different places. You can rearrange furniture, set a particular mood by controlling the light, or shut off all the lights and just use a few candles.

Look at the spaces you have. Strolling around your home for a half hour may inspire lots of ideas for a dramatic story that could take place there. Let's face it, most amateur moviemakers are not in a position to make the next *Jurassic Park* or *Spider-man*. But right there in the spaces you have in your home, you can still develop interesting, fleshed-out characters who can tell their stories and with whom the audience can relate.

Here are some other benefits of using your home as your main location:

◆ **Cutting your costs, time, and energy:** You can instantly reduce the cost of renting studio space or obtaining permits from the city if you shoot in your home.

◆ **Scheduling:** You can shoot your movie any time you feel like, with as many takes as you wish.

◆ **Making modifications:** You can move things around however you need to, and if you make a mess, it's your mess and no one will penalize you. This is not always possible when you're shooting in a location that someone else is ultimately in charge of.

If you think about it, you'll probably come up with other locations aside from your home that wouldn't be a hassle in which to shoot. How about shooting at your uncle's warehouse on the weekend when no one is working? Or the cabin in the woods owned by one of your friends? Maybe you can combine these places to make up the landscape of your vision—make a movie about gangsters who meet in a warehouse to plan their crime, with the final scene carried out as a murder at a cabin in the woods. You can probably find plenty of resources out there—just be creative and dig for them.

Your Home Can Be Your Studio

Okay, so let's say that you're planning to shoot a scene in the bedroom of your condo, but you need it to look like the bedroom of your protagonist, who is a corrupt banker and lives in a penthouse on the Upper East Side of Manhattan. What can you do to make your tiny bedroom with no view look like the luxurious retreat it's supposed to be?

Accessorize, Accessorize, Accessorize

One way to instantly turn your apartment into that New York City penthouse is to evaluate your décor and see where small changes can lend the appearance of affluence. Keep in mind that objects can often appear different onscreen from the way they look in real life. So if you find a great, antique-looking lamp that has a crack down the side but otherwise looks expensive, simply turn the lamp so the crack doesn't show, and place it in the background. Paying attention to the *mise-en-scene* goes a long way toward creating the location you want with very little money.

def•i•ni•tion

Mise-en-scene comes from the French and its literary meaning is "putting into scene." The term's got too many other definitions and applications, including directing a scene, but for us here it is the act of layering objects of different tones and textures in the background of a scene to create depth and interest, without distracting the audience and making them focus on any object in particular in the background.

Another way to spice up your backdrop is to go to garage sales, flea markets, or even your local Target, K-mart, Wal-Mart, or other inexpensive home decorating store. Find throw pillows, blankets, pictures, knickknacks, and other decorative items with interesting shapes and angles that you can place in the background to give a different texture or appearance.

Your budget may not allow for new furniture, but one way to make a chair look different is to strategically drape some fabric over it to give it a different look. Use your imagination and you'd be surprised how quickly—and cheaply—you can turn your apartment into that penthouse. Who knows, maybe it'll look so fabulous, you'll end up leaving it that way!

Karl's Tips

To make the audience believe that the room you're shooting in is something that it's not, try to use tight shots or other types of shots that don't show everything, and let their imaginations fill in the rest. A room can often appear larger than it is in the mind of the audience if you don't use an establishing shot to show its actual size. (See Chapter 12 on directing for more information on types of shots.)

Lighting Can Make All the Difference

You can also add depth and interest to your background with dimmers for your lamps, candles, and trying other interesting placement of light and shadow. In the same way a simple garden can look very different in the moonlight than in the sun, lighting can transform your room to make it look more elegant or mysterious. Try out different forms of lighting using the information in Chapter 11 to achieve the desired look and feel in your apartment.

Making It the Real Deal

Accessories and lighting can go a long way toward making your home seem like something it's not, but you can employ other tricks, as well, to make the illusion even stronger. Suppose you have one small window in your room. Would a penthouse look like that? Probably not; so maybe you would choose to buy some inexpensive, floor-length (and opaque) draperies for that wall. Suddenly, it appears on camera that you have floor-to-ceiling windows in your "penthouse." Add an audio track in postproduction of the sound of traffic whooshing by in the background, and voila! Your New York City penthouse is complete.

The Outside World

If your own home just won't cut it, then you must get out there and scout for your desired locations. You may have some places in mind already (probably because your screenplay says so). Or you may be working without a screenplay and writing as you go. Either way, it's always good to find locations nearby, to save travel time and cost.

If your script dictates a particular location and you've budgeted for location fees, go ahead and check out great outdoor locations, such as streets, parks, woods, mountains, lakes, beaches, and so on. Is there a distinguished statue or monument on the lawn of some municipal building that you always knew would look great in a movie? Is there a courtroom or a jail scene in your movie? Would the local police allow you to shoot there for a few hours? It's possible—but you won't know until you ask.

If your heart is set on locations like these, you most likely need a permit, and that may cost money. But don't just run out there and start spending money that you don't need to spend. You'd be surprised at how many people are so drawn to movies that they might just let you shoot for free. If you like the atmosphere of a particular restaurant

in town, walk in and ask the owner if you can shoot a scene there after hours. Promise to include the owner's name and the name of the restaurant in the credits, and show the outside of the establishment in your movie. People are often intrigued by the immortality of motion pictures, and you may find that they will let you use their property for free just to be a part of your movie.

Permits

People who are shooting their videos on the fly, guerrilla style, often don't bother with permits. They typically, however, have to deal with all the inconveniences—traffic, pedestrians, interruptions in their shoot, and so on.

If you're shooting on public property or if the filmmaking will affect the "normal use" of the area, you will generally be required to obtain a permit first. You can obtain permits by calling the city, municipality, or state in which you are shooting. (Check online first; many states and even cities have movie permits available on their websites.) If you're shooting on private property, such as a university campus, contact the owners of the location directly.

Karl's Tips

Any time you shoot more than a tourist would on either private or on public property, you must have some kind of production insurance. Many amateur videomakers just "forget" about this, hoping that nothing will happen on the shoot, not realizing that they can be held liable for all accidents. That is why at the very least, liability insurance is important for your production. Small business production liability insurance may be purchased for your company for about $2,000 a year, covering multiple productions. Go to www.filmemporium.com for low-cost production insurance.

In addition, if you're planning to use weapons in your shoot, no matter how silly or "fake" they look, a special permit and the presence of police are always required to avoid the impression of a real shootout or armed robbery. You may also be required to pay for the services of an off-duty police officer to be on the set for safety. In some municipalities, such as New York City, the presence of police is available free of charge.

Oh, and one other thing is worth mentioning when it comes to permits: if you have one, you can often count on help from local authorities for crowd control and for closing off streets from traffic while you're shooting. The convenience of that assistance alone can often save you days of shooting time, so a permit may be worth the investment even if you think you can get away without one.

Any (Green) World You Choose

Let's say you have your heart set on a particular location, but it's just not feasible to shoot there, either for geographical, budgetary, or other reasons. Don't sweat it! There is an alternative to an actual location, and that is to use a *green screen*. Technically you do need a location to set up the green screen in, but you could use any decent-sized room that works for you.

def•i•ni•tion

A **green screen** is a green background set up behind your subject against the entire frame of the shot. When your actor is filmed against the green background, images can easily be replaced during postproduction, giving the appearance that the actor was actually filmed somewhere else.

A humorous example of shooting with a blue screen (the green screen's predecessor) can be seen in the movie *Wayne's World*, when Wayne and Garth are preparing to film their TV show in a studio and are "magically whisked away" to various locations while standing against the blue screen.

The reason you use a green screen instead of any other color is because people's skin tones don't have a green tint to them. Unless your actor is ill, flesh tones tend to be made up of reddish, brown, or yellow tints, but not green. When you later go into your video editing program to remove the background, the computer will isolate whatever color you choose—in this case, green. That means that anything else that's green will vanish as well, so make sure, when using a green screen, that you don't have anything else in the shot with green tints to it (for example, your actor's shirt—or, in some cases, their eyes!), or it will also "disappear" during editing.

Successful shooting with a green screen is not the easiest thing in the world to do, so it should be the last resort in your hunt for a viable location. If you're set on using the green screen to give the appearance of your perfect location, however, here's how it works.

> **Karl's Tips**
>
> If your actor has green eyes consider changing that color with contact lenses in the close ups to avoid turning them into the "eyes of Laura Mars."

Shooting with a Green Screen

If you're shooting a well-lit, bright, and solid green area, you can remove this area digitally on an editing system in postproduction (more on this in Chapter 16). And once you remove the green, you can put anything at all in its place, simply by laying an additional track of video below it.

For example, let's say that you're shooting a scene of two people having lunch in front of the Eiffel Tower. The problem is that you live in the suburbs of Indianapolis, so you're using a room in your home to shoot a green screen scene.

Karl's Tips

You can buy an actual green screen at most photo and video stores, or save a few bucks and make do with some material from your local craft store. As long as the material is bright, solid green, opaque, and stretched perfectly taut against the background with no wrinkles, it should work just fine. (Any unbalanced shadows from ripples or wrinkles in the material may not vanish as fully in postproduction as the perfectly stretched color of green of the rest of the material.) That is why many prefer to use large green photo background papers that can be rolled down from behind your actors. The green material should be the "greenest" green you can find. Too dark or too light and chroma keying will not work well in editing.

Have your two actors sit at a table in the middle of a room. On the wall behind them, you would tack up a piece of green material. The lighting needs to be relatively strong and balanced on the green area in order for your editing program to "erase" and replace it with other images of your choice. This is often difficult, and like I've said, green screen success isn't easy. But it's worth a try—especially if you don't plan on going to Paris for a while.

Once you've shot your scene and uploaded your video to your editing program, you can go to that scene and *key out* the color green. If your screen has been set up and lit properly during production, you should have no problem replacing the green background. Your subjects will then seem to be set against your selected image.

def•i•ni•tion

To **key out** a color means to select a particular color with your editing software's digital effects feature and then "remove" it from the digital image by making it transparent.

Once you removed the green area in postproduction, you can fill that blank space behind your actors with whatever image you choose. In this case, you'd replace the green with a Paris scene that includes the Eiffel Tower. And how do you do this? You can either obtain some stock footage or just insert a high-resolution still image, either of which can be purchased and downloaded for a relatively small fee.

Alternatively, there are programs available now, such Adobe Ultra CS3, part of the Adobe Premier Production CS3 package that allow you to choose from many realistic backgrounds to use when shooting against a green screen. Some of them look so real that the average audience would be unable to tell that you didn't actually shoot on that location.

Zoom In

One example of obvious green screen work is the movie *Ghost*. Throughout the film, Patrick Swayze wears a red shirt—this is likely because red is the most opposite color on the color spectrum from green, making it easy to remove backgrounds on him and have him appear more "ghost-like."

Hollywood has also embraced this technology to such an extent that more and more movies are entirely shot with the green screen process on high-definition digital video. That means that the actors have to relate to a blank green screen as if there was something real in that background that in fact would only be "keyed in" in postproduction. Gwyneth Paltrow experienced this strange kind of acting in the movie, *Sky Captain and the World of Tomorrow*.

The Final Word on Locations

Remember, don't burn bridges (or houses, or restaurants, or jail cells). Always make sure to leave the location in the condition in which you found it. Make sure that your crew removes everything you brought in, clean up any messes you made, and repair anything that may have been inadvertently damaged during shooting. (This last part is why it's often so important to obtain some kind of moviemaking insurance before shooting. Not only does it protect you and your actors from any injuries they may sustain during filming, but it protects the locations themselves from any damage that may occur.)

As moviemakers, it's important to maintain a good reputation, because if you don't you may not get much cooperation when you're scouting your next location. Always treat each location with respect while you're filming—it's the same as showing respect to those who were kind enough to allow you to shoot in their establishment.

And now that you know the basics about choosing and using locations, it's time to get out there and arrange to start shooting!

The Least You Need to Know

♦ The best locations are the ones already available—you can make just about anything work with a little creativity.

♦ Permits are not only required in some cases, but can get you the help you need when shooting a complicated scene.

♦ Green screen is not always easy to use, but can provide a great solution when getting to your preferred location is just not an option.

Sound–It's Not a Silent Movie

In This Chapter

- ◆ Recording sound while shooting video
- ◆ Recording sound while editing
- ◆ Recording sound to add later
- ◆ Getting sound from other sources
- ◆ Do you need music?

Nobody really wants to shoot video without sound, but all too often people concentrate on the video and let the sound take care of itself. This results in a very amateurish final product—or in missing half of that great toast your grandfather gave.

Recording Sound While Shooting

All digital video camcorders are capable of recording *sound* while recording images. In most cases this is great, as you will want to just record your soundtrack directly onto the tape (or other medium) in the camera. This

eliminates the problems in synchronizing the sound to the video. But it also introduces problems.

def•i•ni•tion

Sound is vibration moving through a medium. The medium we deal with in video is usually air, occasionally water. Sound vibration is measured in Hertz, usually abbreviated Hz, a unit of frequency equal to one cycle per second. Most of us can hear sound frequencies from about 15 to 18000Hz. Some people can hear higher frequencies above 18000Hz. You will also see standard metric prefixes used with Hz, such as kilo-Hertz (1000Hz), abbreviated kHz. The reason for capitalizing the "H" is in deference to Heinrich Hertz, for whom it is named.

First of all, the microphones built into most video cameras are good, but not the best possible quality. They are better at picking up sounds close to the camera and lose their effectiveness as the distance to the subject increases. Some are too sensitive and pick up the sound of the camera's motors during shooting, and some will also pick up the sound of the lens zooming. If you're outdoors and the wind is blowing, they're difficult to shield and will pick up lots of noise.

An example of a standard camera microphone.

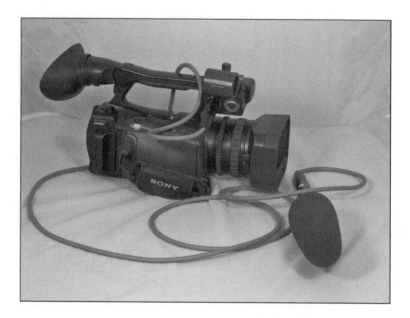

Types of Microphones

The most commonly seen microphones today are either electret or dynamic. Both pick up sound and convert it into an electrical signal, but they operate somewhat differently and each is best suited to certain applications.

Electret Microphones

Electret microphones were originated at Bell Laboratories in the 1960s. An electret microphone is a type of condenser (capacitor) microphone, and uses a dielectric material that has been charged. The electric charge in the electret is electrostatic. Electrets can be quite small, which is why most lavalier microphones are electrets. They are also used in telephones, pocket recorders, and in some digital cameras. Because of their low output, most electrets have integrated amplifiers that require power (often from a button battery).

Dynamic Microphones

Dynamic microphones are also sometimes called induction microphones. They are widely used on stage and by reporters because they produce reasonably high sound quality while at the same time being quite rugged and resistant to moisture. The two basic types of dynamic microphones are the moving coil and the ribbon.

In the moving coil type, a diaphragm made of resilient material is moved by the sound. A small induction coil is fastened to this diaphragm and is moved by the diaphragm's vibration within the field of a permanent magnet. This produces a variable electrical current in the coil through magnetic induction, thus an electrical signal whose peaks and valleys would match those of the sound wave impacting the diaphragm. A perfect induction coil system would respond in a linear manner to any sound waves, but in practice there are limits, mostly mechanical. To deal with these limitations, some higher quality microphones have more than one diaphragm and coil, each set "tuned" to a different frequency range. The composite signal produced by such a microphone encompasses a broad frequency range, ideally approximating the range of human hearing. If you know about audio speakers, you may recognize this sort of system as working just like a speaker in reverse.

In a ribbon microphone, a thin metal ribbon is suspended in a magnetic field. The ribbon vibrates directly in the magnetic field, bypassing the need for a diaphragm and

induction coil, and generating the electrical signal directly. Ribbon microphones can produce very high quality sound, but the ribbon must be suspended very loosely for good low frequency response, and this makes the microphone more fragile.

Piezoelectric Microphones

Piezoelectric microphones use the piezoelectric characteristic of some crystals. Such crystals produce an electrical current when compressed, which can be amplified to produce an audio signal. A diaphragm, as in the basic induction microphone, responds to the sound but presses on a piezoelectric crystal instead of moving a coil. A piezo transducer without a diaphragm can also be used as a microphone, and is often used as a contact microphone to pick up sound from musical instruments. Instruments that don't use metal strings cannot use magnetic pickups, but can use piezo transducers.

Choosing Your Microphone

Choosing the right microphone(s) is very important and will save you many headaches at the editing stage of your project.

Handheld or Lavalier?

The hand-held "reporter's" microphone is one option. Often you will also see "talking heads" on television with small microphones clipped to their lapels or neckties. This is called a lavalier (sometimes spelled lavaliere), a term originally used for jewelry worn as a pendent around the neck by Madame Lavaliere, a sweetheart of King Louis XIV. The lavalier (or lav or lapel mike) is a small electret or dynamic microphone that allows hands-free operation, with some sort of small clip for attaching to collars, ties, or other clothing. The cable is usually hidden under clothing and may be run down a pant leg and across the floor to the camera. Almost everyone today, however, connects the lavalier to a small, belt-mounted transmitter that sends a radio signal to a receiver connected to the camera.

Lavaliers are sometimes sold with one or more grilles that provide a boost to higher frequencies by forming a resonant cavity. A peak of around *6dB* at 6-8kHz is considered beneficial for compensating for the loss of clarity caused by chest mounting of the microphone. Boosting high frequencies in this way does not worsen noise performance, as electronic compensation would do.

An example of a lavalier microphone that clips onto the clothing of the person who is being recorded.

def•i•ni•tion

When talking about sound, you will often encounter measurements in **dB** units. This is a metric unit of measurement. A dB is a decibel. Decibels measure the loudness of a sound with reference to a standard. There is about a 120dB difference between the softest sound we can hear and the loudest we can tolerate.

If you include people in your videos, you will probably need several lavalier microphones. But you may not be able to hide the microphone and/or cable/transmitter, depending on how your people are dressed, so other types of microphones may work better.

Boom

Sometimes when you watch television, particularly with movies originally shot for theatrical release, you may notice a microphone intruding into the top of the frame above the actors. The fact that you can see the microphone is unintended, an artifact of the process used to convert the film for television screens. More of the top of the frame is included than would be seen in theatrical release. This microphone suspended over the actors is called a boom microphone.

In studio parlance, a boom is a long arm that extends into the set from a stand that is out of camera view. Booms come in all lengths and types and are often used to suspend lights. The booms used for microphones are not as burly as those used for lights because microphones don't weigh as much.

Go to www.zotzdigital.com/index.php?cid=67 to check how microphones are attached to boom poles.

A boom microphone can be much larger than a lavalier, which allows you to use a much higher quality microphone. If your actors are in motion, however, you will need a boom operator to move the microphone, following the action and keeping the microphone at a relatively constant distance from the person speaking.

Boom poles can telescope out over the head of the actors in a scene from 10 to 17 feet so you can use them in relatively long shots as well.

An alternative to the boom microphone is the directional microphone, sometimes called shotgun microphone. A directional microphone picks up sound primarily from a narrow cone. The angular coverage of this cone varies with design and is included in the microphone specifications. Short booms designed for hand holding also exist and are sometimes used with directional microphones.

Go to well-known audio manufacturers the Azden Corporation's site to check out this type of microphone, www.azdencorp.com/shop/customer/product.php?productid=93299.

Monitoring Sound Levels While Shooting

Monitoring sound levels is very important in producing a professional-looking and professional-sounding video. Some cameras have helpful sound meters on them or visible in the viewfinder/monitor. I'll talk more about "mixers" later in this chapter.

A good set of headphones, such as these, are essential for monitoring sound in the field.

Here are some common sound issues and some simple solutions. If you have sound from …

♦ The equipment you're using to shoot the scene. Isolate the equipment in a nest of sound blankets.

♦ Other equipment. Turn it off or unplug it, or wrap it in sound blankets.

♦ Talent/crew noise. Make sure that they remain still and breathe softly during shooting.

♦ Creaking floorboards/squeaking shoes. Lay down a temporary floor, hold the floor down with weights to counterbalance it, lubricate with WD-40, or treat with baby powder.

♦ Rustling clothing. Avoid fabrics such as corduroy or silk.

♦ Wind. Use zeppelins, windsocks, or windjammers over the mics.

It's all simple stuff, but stuff that the beginning filmmaker might not consider until it's too late.

> **Zoom In**
>
> You—or your audio person if someone else is "riding the levels" for you—needs a pair of good audio headphones to monitor sound while shooting. Not only do headphones make it easier to hear exactly what your recorded sound will sound like, but they will suppress external noise.

> **Zoom In**
>
> Getting great sound on location is tricky, and unfortunately there's no easy way of doing it. Short of attaching yourself to a sound professional and following him or her around on shoots for a month, the best way to learn to record sound on location is to practice with the equipment you have well in advance of any important projects, so you can isolate potential issues and work on correcting them.

Multiple Microphones and Mixers

If you only use one microphone, you can simply run the output from the microphone directly into the camera and use the camera's controls to set the sound recording level.

If you use multiple microphones, you will need a mixer. A mixer is a box with multiple microphone inputs and a single stereo output. You can control the volume of each microphone individually. Most mixers use sliding controls rather than knobs. Some incorporate digital audio recording capability, storing the audio on hard drives for output onto CD or other media.

As with other equipment, what sort of mixer to get will depend on your needs and budget.

Recording Sound to Add During Editing

Regardless of whether you record sound onto your video while shooting, you will certainly want to record other audio and add it to your video during the editing process.

A good digital sound recorder, such as this one, is an essential piece of equipment for your home studio.

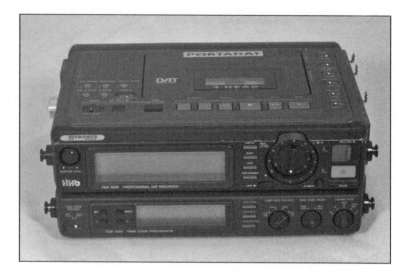

In Your Home Studio

You may want to set up an audio studio in your home for recording. Pick a room as isolated from household sounds as possible. Depending on how much background noise you have, you may or may not need to cover the walls of this room with some sort of acoustical isolating panels. The cheapest thing is just to buy sheets of foam, the kind used in upholstered furniture, and glue or staple them to the walls. If you want a more professional look, you can buy panels made just for this purpose that are very effective in sound deadening.

Once you acoustically isolate the recording area, you will want to divide the room into two areas with a wall. You need a window in this wall, made of acrylic plastic instead of glass because it transmits less sound. This will let you see what's happening in the recording area. A counter or table below the window will hold your mixer and recorder.

A simple studio doesn't have to be really big, it just needs enough room for the maximum number of people you will have in it at any one time. How many microphones and stands you need will depend entirely on what you intend to record. If you plan to record voiceover narration only, you'll only need one microphone and stand, but if you intend to record rock bands, you'll need a lot more equipment.

On Location

The simplest location recording system is a hand-held microphone and a tape recorder, which will suffice for many projects. But you will most likely want more microphones and a portable mixer to go with the recorder. We don't recommend analog tape recorders, because you'll only have to convert your recorded sounds to digital before you can edit them or add them to your video. A digital recorder will produce a digital signal that you can import directly into your NLE or audio editing application.

Digital audio recorders come in a wide variety of prices and with varying capabilities. Narrow down exactly what your needs will be before you buy. You can get a good overview of what the pros use by going to www.nagraaudio.com and navigating to their pro cinema section. You'll see that recorders using hard drives, reel-to-reel tape, and solid-state memory storage are all available. Nagra is only one brand, but their recorders have become the professional standard.

A Fostex recorder can serve both for location and home recording at an affordable price for higher end prosumers.

Location and Home Studio Audio Connectors

Microphones, mixers, and recorders are all connected to each other by cables and connectors. Whenever setting up any recording or playback, make sure that you select the proper male and female connectors that fit one another.

Consumer camcorders, mixers, and audio recorders mostly use (Sony) mini-plugs, RCA plugs, and phone jacks. Higher level prosumer equipment uses the 3-prong XLR-connectors.

For a list of these connectors and an extensive photo catalog visit the following website: www.audiogear.com/Audio-Adapters.

Royalty-Free Sound

You can buy collections of royalty-free sounds on CD to use in your videos. Royalty-free means that you pay once when you buy the CD and you don't have to pay any royalties no matter how often you use the sounds in your productions. A wide variety of sounds are available. Here are just a few sources we know of, but we also suggest checking the current ads in video magazines for new companies.

- www.partnersinrhyme.com
- www.sounddogs.com
- www.soundrangers.com
- www.royaltyfreemusic.com
- www.soundfx.com
- www.productiontrax.com

Who Was Foley and Why Did He Break That?

If you look at the end credits of any feature film, you will usually see a credit that reads Foley, with one or more names after it. What do these people do? They create sounds. They're named after Jack Donovan Foley (1891-1967) who pioneered the art of adding sound effects to movie soundtracks during his long career as head of sound effects at Universal Studios.

The Foley artist's tools include big sheets of steel that emit cracks of thunder when shaken and flexed, cellophane that sounds like fire when crumpled, half coconuts that make the clopping of horse's hooves, sheets of glass to shatter with hammers, pieces of scrap metal that can be thrown down to mimic the sounds of car crashes, and so on. Today much of this stuff is recorded in advance and used as needed, rather than created on the spot during postproduction.

You can create your own library of Foley sounds with ordinary household items. You might be surprised at the origins of some of the sounds used in feature films. For example, Bradd Burt created the sounds of the blaster pistols used in the *Star Wars* films by tapping on the guy wires of a radio tower in California. Cool sounds are everywhere around you if you just listen.

Does Your Production Need Music?

We've all become accustomed to background music in videos thanks to generations of Hollywood feature films. But adding music just for the sake of having it is a mistake if you don't have the budget or resources to do it right.

Royalty-free music works just like royalty-free sound effects and can be obtained from the same sources. Check ads in the video magazines for the latest companies offering royalty-free music. Unfortunately, a lot of royalty-free music is really dreadful, so don't buy anything if you can't listen to samples. The age of synthesizers means anyone can create music—even those who are tone deaf!

GarageBand has a great interface, and works in the same familiar timeline way as your video and sound editors.

If you're musically inclined, you may be able to produce your own background music. Just be aware that if you didn't write it, you'll still need to go through proper licensing to use it in any commercial project. If you can write your own music, so much the better, but don't forget to register your own copyright (see Chapter 5).

You can also create music on your computer. If you play keyboards, you can buy a USB keyboard and input your music into your computer. You can also use a virtual keyboard on your monitor and click the keys with your mouse, but that's less satisfactory for real-time performances. It works fine for inputting notes one at a time, though.

If you're using a Mac and have the iLife suite, you'll have a really neat application called GarageBand. GarageBand lets you build musical compositions by inputting with a keyboard, or one note at a time via virtual keyboard or mouse on the timeline.

You can also download and work with MIDI (Musical Instrument Digital Interface) files of an incredible array of music, load the MIDI file into GarageBand, and assign your own instruments, create your own arrangements, and modify the sound in ways only limited by your imagination. Just remember that the songs are owned by the composers and can't be used without royalty payments, regardless of how you work with them (see Chapter 5).

The Least You Need to Know

♦ You can record sound at any stage of production.

♦ You can get sound from a variety of sources.

♦ Music can make your video come alive.

Covering Events on Video

In This Chapter

- ◆ Shooting weddings, Bar Mitzvahs, and the like
- ◆ Family reunions, travelogues, etc.
- ◆ Sporting events and parades
- ◆ Concerts, stage plays, and similar events

This chapter covers tips and techniques for shooting video at common family and group events. Remember that when you put together a video like this, you basically are shooting a documentary. A documentary for a limited audience in many cases, to be sure, but a documentary nonetheless.

Documentary Basics

What are the most basic elements, techniques, and methods of *documentaries*?

- ◆ Original footage of real people in action, of events and surroundings
- ◆ Archival footage and/or still photographs
- ◆ Interviews with the principals
- ◆ Voice-overs
- ◆ Music

In documentaries, the interviews of the principals are called A-roll. The action footage, and the stills and archival footage, are called the B-roll. The A-roll is the "meat" and gives the main subject and the structure to your documentary, while the B-roll provides the visuals.

Most documentary subjects are a series of one-time events, and are rarely if ever re-enacted for the camera. You cannot reshoot, meaning that—unlike in fiction films—you better get it right the first time. You need complete familiarity with the subject matter and your equipment, and to be able to solve problems on the fly, so that when something goes wrong—as it almost invariably will—you can "roll with the punches" and deal with it.

It would be foolhardy, for example, to try to cover an event without a backup camera. Today's digital video cameras are well made and reliable, but like any other piece of equipment they can break down. Cameras can be dropped, lenses broken, lights shattered, so it's imperative to have backup equipment. Not to mention that certain events require multi-camera coverage anyway.

Make a list of what you need and check it over before you head for the event. It may sound silly, but include everything on your list. I am sure you've heard of people remembering every possible accessory and gadget but forgetting their camera. Don't forget to include spare lamps for your lights. And make sure you have plenty of extra blank videotape.

def•i•ni•tion

The term **documentary** was first coined by John Grierson to describe, *Moana*, Robert Flaherty's 1926 film about the daily life of a young Polynesian man. He derived it from the French documentative, used to describe travelogues. Over the years, it has come to be applied to all nonfiction films, because they document life.

Indoor Events

For indoor events, you will need lighting unless stage lights are already provided. Ideally you want to have several assistants to keep an eye on light stands to make sure someone doesn't trip over one or knock it over. If you're working alone or with only one or two others, carry sandbags for the legs of your light stands and lots of gaffer's tape to tape power cables down to the floor so no one trips over them. Remember that video lights are very hot and a falling lamp can give someone a nasty burn or even start a fire. You don't want to be known as the wedding shooter who burned the church down!

Many places may object to cables but might allow you to shoot with a built-in or attached camera light running on battery. Extra batteries are crucial in these cases. Other places won't allow any lights, period. Solution: Shoot with a wide angle extender to shorten focal length and lower the amount of light needed; open your iris as wide as possible, like an f-1.6 or whatever is the lowest f-stop of your lens, to take advantage of all existing light. In addition you may have to turn your gain up from 0dB to 3dB perhaps even to 6dB. Yes, your image will show some "video noise," but it's still better than not getting a picture at all. In these cases, try to arrange for re-enactments after the ceremonies, as that would provide the best possible image for your camera and for the parties involved.

When reenactment is not an option, they still may allow you to tape the dress-rehearsal. Because there won't be an audience, concentrate on tight close-ups that you can cheat into the crowd scenes later in editing.

With regard to editing, you need to find out in advance how elaborate an edit you are expected to deliver. Hopefully, they do not expect you to hand over a finished tape at the end of the event as that would require shooting with in-camera editing, which—while not impossible—is very difficult. You would have to perform fades, dissolves, and even some digital effects in-camera while shooting. You also can't turn off the camera; you have to keep it in "pause" for the duration of the shoot and in between scenes.

Weddings, Bar Mitzvahs, and So On

Weddings, Bar Mitzvahs, Bat Mitzvahs, baptisms, and other religious ceremonies are joyous occasions for the people involved. Your job is to document the event in the way your clients want while being as unobtrusive as possible. Remember, it is their event, not yours.

Special Requests

Before attempting to photograph any religious event, have a good talk with the people involved to see what they want. Be prepared to deal with such things as, "Now, don't get so-and-so in the picture," "Can you make Aunt Julie look less fat," and similar requests. Be honest about your abilities and what you can and can't do, and you'll save yourself from possible problems after the fact.

Talk to the rabbi, priest, minister, etc., to find out about any restrictions on shooting video in the church. Even if we've never been to a wedding, just about all of us know how they "work" from seeing so many of them on TV and in movies. Remember that

even though they're similar overall, different Christian denominations will have differences. You need to prepare yourself for all of these by asking beforehand.

Some places will not allow any photography or video during the ceremony at all, and you may have to stage a reenactment afterwards. Some will only allow you to shoot from certain positions, requiring you to reenact certain scenes after the fact and edit those clips into the appropriate places in the timeline. Make sure you understand all of this in advance, so you're best prepared for the actual ceremony.

Paying Attention to Audio

Getting good audio during the ceremony can be really tough, even with directional microphones. You may want to consider having the bride, groom, and minister wear wireless lavalier microphones if they are willing, and mix the audio from these with overall sound from a single microphone in the church, even the one mounted on the camera. When they watch your video, people will want to clearly hear the couple exchanging their vows.

Just as you needed a back-up camera, you must back up your sound recording, especially when you are working with wireless microphones, as *radio interference* may occur. Always carry a small and simple audiotape recorder as well. Although its wild recording is not in sync, it could—if necessary—be brought into acceptable sync in editing.

def•i•ni•tion

Radio interference occurs when your wireless receiver plugged into your camcorder picks up unwanted signals like a nearby radio station's music or truck drivers exchanging jokes over their CBs. Higher level wireless microphone receivers offer you a selection of channels so you can switch to a different channel for avoiding interference. Back yourself up with direct recording of important audio, just in case.

Reenactments and Close-Ups

Still photographers often stage a reenactment of some events after the wedding so they can shoot good close-ups of things like putting on rings, cutting the cake, the obligatory garter shot, and so on. You can do the same, or piggyback your close-ups with the still photographer's.

Karl's Tips
Beware of the still photographers' flashes as they will burn out a frame of your video each time. Try to arrange it with the photographers so that after they finish shooting a scene they won't flash while you are shooting the reenactment.

One or more still photographers will also cover most of these events. Unless you're working together, you should spend at least a few minutes together before the event to work out how you will be covering the occasion so that you won't get in each other's way.

Family Reunions and Travelogues

When you put together video of family events for your own family, you can be a lot less formal and organized than when someone hires you to do it for their family. In both cases, the events are rarely scripted, so you just have to roam around looking for good material. Watch the children, because they often are the most spontaneous and likely to do things no adult would have ever thought of. Just keep an eye out for their safety, no matter how interesting their actions.

Generally, you should begin with some wide establishing shots to show the location and surroundings. You could even shoot some footage of the drive to the reunion, focusing on the family members' anticipation of the event.

While you get lots of interesting material from the kids, don't neglect the elderly family members. Sadly, in many cases your video will be the last many family members see of them. Make the overall context of your video upbeat and happy. It will lift the spirits of those who were there to see it again, and it will mean a lot when copies are sent to those who couldn't attend.

Just as you begin with wide shots and zoom in during the body of your story, you may want to slowly zoom back out toward the end, and perhaps even end as you began within one of the cars as the family drives away. Family events are chances to just let your creative juices flow, so have fun and experiment.

Travelogues of family outings and vacations can also give you a chance to be creative and

Karl's Tips
One of the most important elements in family event videos is the short interviews and brief sound-bites that you can "yank out" of the participants. Nothing is more touching, when viewing these videos of the past, than our loved ones actually talking to us.

produce a diary of the event. If you make your family documentaries interesting and unique, you will find that others don't cringe and look for reasons to leave when you suggest viewing them. You'll even have people asking for invitations to come and watch them!

Tell your story, share the enthusiasm you had when planning your trip, and hit the highlights. Don't make your travelogues too long, or linger too long on scenes that have little going on visually. A good rule of thumb is that most vacations of a week can be edited into very good half-hour videos. Sometimes you can stretch really exciting ones to an hour, but any longer and you risk boring your audience.

Family Docu-Dramas

One of the most interesting areas of documentaries made by family members is the family docu-drama. Quite a few of my former students have made heart-wrenching, soul-searching documentaries of their own families that brought them awards at festivals and earned wide distribution on television or even in theatres.

The family docu-drama *Tarnation*, a compilation of old 8mm footage, stills, graphics, and current digital videos edited with simple iMovie software and transferred to 35mm film, became a surprise hit at art film theatres.

The family documentary has a huge range: from the amateur's light entertainment to the most serious dramas created by professional filmmakers. This is one unpredictable area where anyone may become a successful video artist. I have been shooting every one of my daughter's music performances in the clubs of New York since she was 16, and even Martin Scorsese crafted a beautiful documentary about his family's Italian origin.

Amateur Sporting Events and Parades

If you aspire to produce videos of amateur sports, parades, and other outdoor public events, take a cue from TV news and watch how they cover them.

First you'll see the establishing shot, a wide shot of the stadium, field, street, or wherever the event will take place. This is often followed by a slow zoom in on part of the crowd, or some players if they're already out on the edge of the field. Cheerleaders are always good for an action pan to get things moving before the game or match begins.

Once the event begins, you really need to know the sport to follow the action and know when to zoom in tight and when to go wide. Every sport is different and some are very difficult to cover well with a single camera from the stands. Just do your best.

If possible, get some friends to bring along their cameras and prearrange with them a multi-camera shoot. Just like the professionals, you will have to predetermine which camera should cover what aspect of the game.

Rudimentary directing is also possible by using walkie-talkies or even cell phones through headsets for communication among the different camerapersons shooting at the same time.

Different digital cameras will render the colors differently, so you will have to use the color correction features on your editing software to bring them closer to each other.

If you're shooting professionally and have a place just off the sidelines, you may want to use a tripod with a fluid head to smooth out your pans as you follow the action. For professionals, powerful zooms such as the steadicam and jib arms provide the best moving shots. For prosumers, the Merlin or the Fig Rig may enable them to run alongside the players and get very exciting yet smooth shots.

Don't feel bad if your coverage isn't as good as network TV when you first start out, because those folks have years of experience, large support crews, and big budgets.

Parades are somewhat unique because the action just moves past you and you don't necessarily have to move much yourself. Small pans and zooms will probably be all you need to produce interesting parade footage. Getting good audio of bands during a parade is something that not even the best have mastered, because the acoustics are horrible and lots of crowd noise often overpowers the music. But all of the noise is part of the experience, so you could just rely on your in-camera microphone and not worry too much about it. Again, you may befriend people up on the balconies to get you overhead shots of the parade.

For professionals, multi-camera coverage of the parade is required. In case of live broadcasts, both sporting events and parades require taking and setting up an entire television studio on location. That is why they are called the big remotes.

Stage Plays and Concerts

The main issue with stage events and concerts is concern over copyright infringement. It is nearly impossible to get permission to shoot video unless you work for some media organization. But if you have permission, or are filming professionally, your main challenge will be setting up your equipment somewhere with an unobstructed view of the stage. Crowds can get rowdy, and if you're in among them you risk having your tripod knocked over and your equipment damaged. A raised dais would be the ideal location. You will definitely need a good, sturdy tripod.

The second challenge for this kind of work is the lighting, which is often much dimmer than outdoor light and frequently cast through colored gels, as well. Attending a rehearsal or two should give you an opportunity to do some lighting checks, particularly if the light changes a lot during the course of the event. You can shoot some test video under each lighting change and check it to make sure your camera's light meter is dealing with it correctly. You may find that you need to switch to manual exposure (see Chapter 11) for some of the lighting changes. That is possible, of course, mostly on prosumer grade camcorders and above.

The third challenge is the audio. Ideally this is a multiple microphone situation with an audio person riding levels on a good mixer during the performance. For a stage play, unless you can outfit every performer with a wireless lavalier, you need at least a couple of assistants holding and aiming directional microphones to properly pick up the voices. For concerts, you'll ideally need a collection of microphones for vocals and microphones for the instruments. With many musicians, this can become very complex and really is a job for a professional audio engineer. You can get the cleanest audio by connecting the line-out of the stage's audio mixing console to the line-in audio connector on your camcorder. You should check these connection as part of your location scouting ahead of time. In addition use a small audio recorder aimed at the crowd and speakers to pick up ambient sound as well.

Once again, you generally begin your video of a stage performance or concert with an establishing shot, a wide shot of the whole stage, and then move in to closer shots to follow the action. If you aspire to do well at this kind of work, it is best to start out simple with stage plays that have only a few actors or concerts with bands made up of only a few musicians. As your skills and those of your crew increase, you can tackle more imposing jobs. Don't make the mistake of trying to get jobs you really aren't equipped for. If you take a job and make a royal mess of it, you'll be surprised at just how long people will remember you!

The Least You Need to Know

- All the events mentioned in this chapter (weddings, concerts, parades, travelogues, and so on) can be considered quasi-documentaries.

- Before a wedding always talk to the minister, priest, rabbi, etc., about rules, procedures, and permissions.

- Know your sport before trying to capture it on video.

- You need permission to shoot during concerts and stage plays.

Part 4

Postproduction

If you thought all the hard work ended on the final day of shooting, think again! Now you need to work on the editing, titling, special effects insertion, image enhancement, audio mixing ….

Introduction to Nonlinear Editing

In This Chapter

◆ Really good editing cannot be done in-camera

◆ Many good editing software applications exist

◆ Choosing the right NLE depends on knowing your needs

◆ It is very important to output your edited video in the right format

Rarely does anyone produce a really great looking final video using only in-camera editing. In fact, the limitations may only lead to frustration. Learning to use editing software will allow you to produce fully professional quality with your computer. But which software do you want? This chapter describes and compares many of the editing software applications on the market today.

Linear vs. Nonlinear Editing (NLE)

Video can be edited in two ways: linear and nonlinear. One example of linear editing is what may be done by in-camera recording on tape, like when you shoot an event in chronological order without further editing of the

footage. You should avoid this if possible. Even many consumer cameras, especially the disc-recording kind, come with built-in editing software. In these camcorders, the flip-out LCD screen serves as the monitor and touch-screen menu for the rudimentary editing you can perform on the camcorder.

This type of editing has been enjoying a comeback on certain video camera cell phones, where, understandably, the immediacy of a crudely edited video message is often the main consideration. In the event, however, you have some time between shooting and the delivery of the video, we highly recommend postproduction editing. Why? Simply because the main function of any kind of editing is to correct the unavoidable errors of shooting the original material and create the best possible retelling of the event or story.

Whether you shoot your video in a linear (chronological) fashion or out of sequence using a linear editing system, you have to edit all of your scenes into the exact order you want them in for the finished project. Unlike film that is made up of physical frames, the magnetic recording on videotape cannot be perfectly joined at the point of cutting a frame, therefore video editing has quickly developed into a copying process precisely to avoid physical cutting.

That is why, even in the simplest type of analog linear editing system (called cuts-only system, borrowing the term but not the actual physical action from film) there were four essential elements:

- A player, to play back your camera original tapes

- A recorder, to copy over your selected shots in a linear order

- Monitors, to view the camera footage and the recorded tape

- An editing controller unit placed in between the player and the recorder, to synchronize the in- and outpoints of your selected shots on both the player and the recorder

It was called a cuts-only system because, for dissolves and other effects between two shots, you needed another player to play back the two shots from two tapes at the same time, and you also needed an SEG (special effects generator) or switcher that could switch from one tape to the other during a transition, like a dissolve. This was called A/B roll editing, because two players were rolled together at the same time to perform a gradual transition like a dissolve on the recorder. The editing control unit synchronized the rolling and activating of all these machines at every single edit. It was a complicated, cumbersome, and expensive procedure, reserved for highly specialized, technician-like editors.

The author at an editing station.

Editing stations used to take up quite a lot of room in an editing suite, as seen here. Yet, except for in public access or cable TV stations, this is rarely the case anymore. Today, all you need for your digital editing studio is a laptop computer, some editing software, and a small, quiet space in which to use them. Sometimes, like at a band's performance in a bar, you can edit in-camera by pausing and unpausing your camcorder at the beginning and at the end of each song, but it's usually not possible to shoot all scenes in order in other films. For example, you may have an actor who appears in the opening scene, then midway through the video, and again at the end. If you are doing a shoot that lasts for several days or weeks, it makes more sense to shoot the scenes involving that actor at the same time, then plug those scenes into the video where desired.

And that's what editing is all about. Editing systems let you shoot the scenes in any order you want, save them as clips, and put them into your video in any order you wish. It allows you to jump around in time in your video, adding, subtracting, tweaking wherever you want.

The problem with the analog linear systems was that you could not change your mind after you had recorded your edited tape. You could only restart your edit from scratch or copy it to another tape, suffering "generation loss" of image quality. (It was like repeated photocopying on paper where the copy of a copy gets worse and worse in quality.)

A MiniDV player/recorder can be connected, as shown in the middle image, to edit on analog systems.

SOURCE REMOTE, EDIT MODES/FUNCTIONS, RECORD VCR REMOTE (LEFT TO RIGHT)

MINIDV PLAYER/RECORDER, EDIT CONTROL UNIT (LEFT TO RIGHT)

B&C VIDEO, VLR AUDIO, RS 232 REMOTE, POWER (LEFT TO RIGHT)

That is why linear editing always had two phases:

♦ Off-line editing, to figure out all creative decisions going from copy to copy, ruining image quality but making up an edit decision list (EDL).

♦ On-line linear editing, to go back to the original camera tapes for original image quality and with the help of a very expensive and highly technical computer-assisted studio, the technicians reassembled the off-line edit, basically repeating the edit decision list.

No wonder video editors have always been envious of film editors, because, due to their freedom in physically cutting the shots and resplicing them in any order, film has always been nonlinear.

Moviemakers who used film could do nonlinear editing, but it involved cutting and splicing the actual film and having a lab add in any effects that were needed. You would edit your original film into a minimum of two separate reels, called A and B reels, using blank leader in A where you had a scene in B, and vice versa. This allowed for a lab to do cuts, cross fades, and other effects. Just a simple cross fade from one scene to another was both labor- and time-intensive. And you wouldn't see what it looked like until you got the finished print back from the lab, which took days or weeks in most cases. If the cross fade was too quick or too long on the lab print, it meant another trip to the lab, another work print, and more expense. Your ability to visualize what the project would look like was stretched to the limit.

The history of video editing has been closely connected with the changes in recording modes and devices. Basically, they went from huge machines that took four people to move to the MiniDV cassette—and to the possible death of videotape by solid-state recording on disk.

There have been basically two kinds of video recording, analog and digital. Video recording originally was a development from broadcast television. TV producers wanted ways to archive broadcasts and the luxury of recording broadcasts in advance. The original videotape systems used reel-to-reel videotape two inches wide. Sound

and images were recorded onto this tape using a rapidly spinning head. The recording of sound and video used analog signals that varied amplitude to represent changes in loudness or brightness. In many ways, analog video made everything easier, but early video systems were as cumbersome to use as film had been, and splicing was a nightmare requiring the use of a microscope to precisely line up the tracks on the cut ends of the tape. That is why the electronic copying in linear editing quickly replaced the hopeless process of cutting videotape. But it was still very complicated having to go through the off-line and on-line phases.

Analog video survives today in VHS systems, and in BetaSP cassette recording and playback at some corporate, industrial video operations and at some UHF and cable TV Stations, but these are rapidly disappearing.

The Sony MiniDV recorder/ player shown here can be connected in various ways, depending on your equipment.

Digital video uses sequences of ones and zeros recorded onto tape or other media to represent sound and video. Because this is how computers work, digital video is compatible with computers, and this compatibility has revolutionized how we handle and edit video today. It wasn't until the advent of digital video that things began to get truly easy—and much less expensive as well.

Computerized NLEs

Today, with a modest investment in a computer and software, you can produce videos that rival those done by the pros. The greatest advantage of the computerized NLE is

that the old division between offline (creative) and online (technical) editing systems has largely disappeared. Million-dollar online studio features can be found on even laptop computers' NLEs today for a mere fraction of the former studio's price. This democratization of the once privileged procedure makes it possible for everybody to become a video editor.

For most digital videos made today, all you really need is a laptop, some editing software, and an external hard drive.

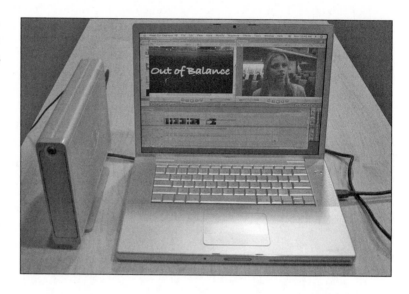

Zoom In

Many cameras can add things like fade-in and fade-out at the time of shooting, but it is very difficult to control with any precision, and trying to use more complex effects is often an exercise in frustration. It is far better to avoid the frustration and just shoot your raw footage straight, adding any needed effects on the computer.

We will go into more detail on specific features of software video editing applications when we discuss them later. For a valid comparison, we took a same simple video consisting of three clips and loaded it into all of them. For our tests, we wanted to know how these NLEs would run on a relatively basic computer system, so we used a Gateway computer running an AMT Athlon 64 Processor 3700+, nVidia GeForce 6100 GPU video card, 1024MB DDR memory, and a single 200GB hard drive partitioned into two equal drives. All the NLEs ran just fine on this system, although they would have run even faster on a dual-processor machine such as a typical Macintosh version 10.4.6 with a 2.16Ghz Intel Dual-Core processor with 1GB DDR2 SDRAM.

Basic NLE Steps

Now let's go through the basic steps in using an NLE. Although they differ in specific details, all of them function in basically the same ways.

First, obviously, you must shoot your raw video. Once your camera has recorded it onto digital videotape or another storage medium, you need to get it into your computer. This is done by connecting a Firewire (IEEE 1394) or USB cable to the jack on your camera (see your camera's user manual for the location), and plugging the other end of the cable into your computer. Now is not the time to discover that the computer you bought doesn't have a Firewire or USB port! But if you bought or inherited a computer lacking a Firewire or USB port, in most cases you can add a card to one of the expansion slots inside your computer to add a port on the back. It is much more convenient, though, if the port is on the front of your computer so that you don't have to go fumbling around in back every time you want to connect your camera.

Most manuals give the impression that it is okay to connect or disconnect the camera with the computer turned on. In practice, this may not be such a good idea. We've seen computers that got "confused" by this and began to act strangely or even locked up. Unless the instructions specifically tell you not to, it is safest to turn off both camera and computer before connecting. Generally you then need to turn your camcorder back on (in its VCR or playback mode) prior to turning the computer back on. All of the editing software applications we tried will give you a warning when started if they cannot find your camera. Should this happen, try turning everything back off and on again and it usually solves this problem. If not, it's time to make one of those dreaded calls to tech support. In some cases, you may have a newer camera and the necessary driver to work with it was not included with your editing software. You will have to download and install it from either the software or camera websites. It is always recommended that you check these websites every few months, anyway, because most post regular software updates.

Once your camera is connected to your computer and your editing application has recognized it, you will, in most cases, be able to control your camera from the computer with buttons on the application's user interface. In a few cases, particularly with older cameras, this interface control may not be fully implemented, and you will need to operate your camera manually, starting it and your software's capture at the same time.

With most programs, you can download your scenes individually as clips, or download a whole tape and cut it up into clips afterward (either by cutting after putting into the

timeline, or by adding "in" and "out" points with software buttons). Find out how your particular NLE does it and experiment to see what works best for you. We each have our own workflow preferences; those in this chapter work well for me, but you may find totally different workflows that are better for you.

Clip Storage

You should store your clips on one of your storage disks in a folder your editing application recognizes. You can name the clips any way you want, using alphabetical names, numerical names, or any combination you like. So long as you can find the clips when you need them, it doesn't matter what you call them. Your editing application will have a window (called a bin in some NLEs) where you can see and organize your clips, either by filename, a visual thumbnail, or both. Always back up your clips to a different disk once loaded onto your computer, and be sure to backup your project periodically as you work on editing it. You never know when a computer crash, power outage, or some other problem could lose hours of your work. If there is one rule for computer editing of video, it is: back up, back up, back up, and then back up again.

One or more windows serve as monitors for previewing your clips and project. Another window will be for the timeline of your project, where you get your clips in order by drag 'n' drop or by using commands from the editing menus. The sound recorded with your clip will move along with the video clip and in most NLEs it will show up in the timeline below the video clip, usually double. This is because cameras record in stereo, so one audio clip will represent the right channel and the other one below it will represent the left channel.

The Most Basic Editing Software

Some digital video camcorders come with very basic automatic editing software. For the most part, they are stripped-down versions of more complete applications for those who do not want to bother with editing of any kind. This is like auto-iris or autofocus on your camera, you allow the built in recorder of the camera to auto-edit your footage. You may find these auto-edit functions (sometimes called a "muvee") on many video camera cell phones and even on your computer.

For instance, in Mac's iMovie, it is called the Magic iMovie. These auto-editing modes require only the push of a few buttons like selecting the mood, comedy or music video, from the built-in music library and letting the computer select the shots and their order. Most auto-editing software also offers an override for those who want to perform limited editing and choosing music, transitions, and so on themselves.

Some, like MovieShaker, fill a specific need because it is designed for MiniDV cameras and is a simple way to convert the MPEG files these cameras produce into more standard DV files that NLE software can recognize and import. Although you can have fun playing with some of these very basic applications, ultimately you will find them frustrating in their limitations and will want to move on to something that gives you more flexibility and capability.

NLEs for Amateur Use

Not everyone needs all the features of the pro NLEs and not everyone wants or needs to spend as much as they typically cost. For these people, several good NLEs are available for about $100 or less.

Apple iMovie

Mac users are lucky in many ways, and one way is that Apple's iMovie HD (OS X only) is included with the computer in most cases. If you didn't get it with your Mac, it is part of the inexpensive iLife Suite that you can add to your Mac for well under $100. For the price, you might expect iMovie to be very limited and basic, but it is actually a very sophisticated and stable NLE application that integrates with iDVD (also part of the iLife Suite) to make fully professional interactive DVDs. It has one of the cleanest and most logical *GUIs* of all, and can be learned in only a couple of hours. Many professional projects have been produced in iMovie and, with the iMovie HD version, you can edit HDV footage as well. Its only real practical limitation is that it really is designed for producing videos under an hour in length.

def•i•ni•tion

GUI enough for you? The GUI (pronounced gooey) is the graphical user interface. That's the collection of windows, buttons, icons, and so on, that appear on your computer monitor when you launch a program. The best GUI would use an intuitive workflow to get things done, with icons so well designed that you wouldn't even need an instruction manual. Unfortunately, in practice the ideal GUI does not exist, yet.

Magix Movie Edit Pro 12

Magix's Movie Edit Pro 12 sells for less than $50 (Windows only, www.magix.com). For that price, it does a lot. In addition to the expected basics of NLE capability, it also offers support for videos with Dolby digital sound, can create videodiscs in

high-resolution HD-DVD video format, reads video DVDs from DVD camcorders and recorders, and can automatically generate background music for your video. It can also convert your video into Flash format for Internet use.

An interesting feature uses "magnetic" objects and decorative elements. With this feature, you can follow the movement of individually specified pixels in your videos, photos, decorative elements, or texts automatically. Your selected "magnetic" object will "stick to" and follow those pixels just like a magnet. You can decorate people, even when they're moving, with accessories (glasses, jewelry, tattoos, new haircuts), point to special picture elements with arrows, have speech bubbles follow faces, or make faces unrecognizable with black bars, just like you see on TV. You can also use this feature to create picture-in-picture effects with videos and photos.

Another unusual feature is the thematic 3D fade series. Using this you can add a thematic curve to the story in your videos and slideshows. Walk your viewers through a virtual gallery with your photographs on the walls, scatter your pictures on a table, or tack them up on a corkboard.

Magix Movie Edit Pro 12 also includes a sophisticated audio mixer with real-time automation, allowing you to adjust the volume and panorama sequence of your soundtrack simultaneously to match the course of the video. This allows you to lower passages in the background music quickly and intuitively to allow the live action sound or the recorded spoken commentary to be heard, or to give audio support to the video by letting the sound follow a visual element such as a passing car. The integrated audio DeClipper lets you remove annoying overloading and distortions if your recorded sound volume is too high.

When looking at NLE applications, don't let the low price of Magix Movie Edit Pro 12 fool you into thinking this is a bare-bones, basic program. It offers a lot of features that are rarely found on high-end NLEs.

Cyberlink PowerDirector Premium 5

Cyberlink's PowerDirector Premium 5 is another NLE that can be bought for under $100 (Windows only, www.cyberlink.com). It works with DV, HDV, MicroMV, and analog camcorders, as well as with images from digital or PC cameras. It can also capture video from DVB-T digital TV and analog TV content, and VCRs. It allows you to add a variety of effects, create CDs, and record voice or audio to add to your video. PowerDirector automatically detects and captures your DV tape's original aspect ratio. During editing, you can convert 4:3 to 16:9 and vice versa for consistency. You can also import video files recorded using the latest Windows XP Media Center Edition (DVR-MS).

PowerDirector supports most video formats, including HD MPEG-2, DVR-MS, DV-AVI, DAT, MPEG-1, MPEG-2, VOB, VRO, WMV, WMV-HD, MOV, MOD, DivX, live capture, and most audio formats including MP3, WAV, WMA, and audio CD. It also supports a variety of still image formats including JPEG, TIFF, BMP, and GIF. It can import non-CSS protected DVD-video from DVD+VR and DVD-VR discs

With PowerDirector's Smart Captions feature you can include onscreen video information such as time, date, personal comments (such as geographic location, live event, TV channel, or series). PowerDirector stores RichVideo information within your video files, ensuring that the next time you have to perform the same functions your production speed is dramatically improved. As you browse for video files you can preview previously cut scenes performed by Magic Cut. CyberLink RichVideo saves an enormous amount of production time by reusing video file information created by Magic Cut or Scene Detection functions.

A feature called DV Quickscan lets you go through your video quickly to find exactly the scene you want. You can scan an hour of digital video in 6 to 10 minutes. It also lets you capture clips in batches. And you can manually scan video you didn't shoot.

PowerDirector allows you to directly record live video, narration, or music on your computer. You just need a good quality microphone that can be connected directly to your computer.

Sony's Vegas Movie Studio+DVD Platinum Edition

Sony's Vegas Movie Studio+DVD Platinum Edition (Windows only, www.sonymediasoftware.com, free trial download available on site) costs a bit more than the NLEs we've talked about so far, at about $120 for the Platinum Edition, although the somewhat less capable regular version can be bought for about $90. The main difference is that the Platinum version has HDV support, 5.1 surround sound mixing, and encoding. It also includes NewBlue VideoFX MSP, a collection of 107 video effects and transitions, a comprehensive training DVD, advanced three-wheel color correction tools, and more than 20 DirectX audio effects.

In addition to import from digital video cameras using tape, Vegas Movie Studio also offers easy direct import from finalized DVD disks recorded with Sony DVD Handycam camcorders. Vegas Movie Studio software allows you to use up to four tracks for video and four tracks for audio for a very versatile editing and compositing environment. It also has real-time audio and video event reverse, a very nice feature that lets you reverse audio and video on the timeline in real time, without the delay of

rendering. It also lets you quickly skim through your video to find specific sections. Its native VST effect and DirectX audio plug-in support increase the range of effects you can apply to your audio tracks. Vegas Movie Studio makes video scoring and audio mixing easy with its built-in ACID loop support. ACID loops contain special metadata that allows Vegas Movie Studio software to easily match tempo and key in real time.

Pinnacle Studio Plus Titanium Edition

Pinnacle's Studio Plus Titanium Edition (www.pinnaclesys.com, about $100, free trial download available from site). Studio Plus Titanium Edition includes Pinnacle RTFX volume 1. Pinnacle RTFX volume 1 adds 20 effects to the hundreds that were included in previous versions of Studio Plus. Also now included is one-click export to Apple iPod, Sony PSP, and other DivX consumer devices.

The Studio Plus GUI uses a simple three-step process to create your video, capture, edit, and share. Pinnacle Studio Plus includes hundreds of keyframeable and format independent (SD and HD) real-time effects and transitions. With it you can create real-time multitrack editing and special effects like Chroma Key (green or blue screen) and Picture-in-Picture (PIP). The Chroma Key effect lets you star in your video and import a background of anywhere in the world while the PIP effect lets you place one video inside another in real-time.

You can preview these effects and transitions immediately in full resolution on your primary or secondary computer monitor. And if you outgrow the collection of included effects, Pinnacle offers hundreds more effects that you can add. With added keyframing, you can control the characteristics and parameters of an effect on a frame-by-frame basis.

Pinnacle's integrated CD and DVD authoring workflow allows you to easily create DVDs with motion menus and custom navigation on the fly. Other NLEs could learn a lot from Pinnacle's simplified workflow. There is no need to jump back and forth between two separate applications when you can preview your results with full DVD controls from your editing workspace. And for those times when you want to quickly archive your treasured memories on DVD, Pinnacle Studio Plus provides a quick and easy tool for instantly transferring your video tapes to DVDs without the need to first copy your files to your hard drive.

Pinnacle Studio Plus lets you retain the greatest image resolution while creating HD movies. Studio Plus allows you to take advantage of the inherent quality of your original digital images when animating them with close-ups and pans and scans in any direction with "Ken Burns" effects. You can zoom in on a face or object and keep HD

clarity. Studio Plus also includes some special tools like red eye removal so you have your best work when adding effects, transitions, titles, and music.

The Pinnacle SmartSound feature provides a library of categorized, royalty-free music to compliment your videos. Your music choice will be automatically matched to the duration of your selected video clip or movie.

Additionally, Pinnacle Studio Plus includes tools for video cleaning to restore old damaged videotapes, image stabilization for shaky and jerky footage, color correction, and noise reduction filtering to eliminate extraneous sounds such as wind and rain.

Another nice feature is that Studio Plus does rendering in the background, so you can continue to work on your video while rendering is taking place. This is something that all NLEs ought to offer. It speeds up editing and reduces aggravating delays.

Prosumer NLE Applications

If you find the above basic NLEs don't have the features you want or need, you can move up to the "mid-grade" NLEs. These offer more features at a higher price, but are still not as capable, or expensive, as the fully professional NLEs used by the full-time working editors.

Before reviewing the highest prosumer-level NLE software offered today, let's make an interesting digression into the so-called standalone systems for the sake of those who may not want to bother with computers at all or those who may want to separate their video editing from the family computer.

Standalone Systems

Standalone NLE Systems are hard-disk based computers that are designed to do only one task: editing video. Unlike other computers (Windows PCs and Macs alike) that multitask by doing e-mail, office duties, your taxes, and also editing, standalones like the Casablanca from Macrosystems or the Screenplay from Applied Magic are designed to do only video editing.

You can see how easy it is to start editing with a standalone system practically minutes after you take it out of the box. An interactive menu is also helpful in leading you through the basic steps of nonlinear computer editing.

The well-designed standalone system, Casablanca, originates from Germany. The Casablanca has many different levels from consumer to prosumer units under different names like Avio, Kron, Prestige, Solitaire, Claro, Gymnos, and Renomnee, and their

prices range from $900 for a simple unit to just under $3,000 for the more sophisticated and higher power units.

As these standalone hard disk units are not computers with multitasking, they are not subject to the common computer problems of crashes and viruses, and they will never lose your edit files. As the price of the better units equipped with DVD burners may run over $2,500, however, they are a lot more expensive than the consumer level NLE software—under $100 and often included in your computer's purchase price. That's the main reason standalones are not as popular.

These standalone systems came about during the transition from machine-to-machine linear video editing to computer software editing, when NLE editing was available for professionals only at sky-high prices. The attractive ease of laptops with editing software has affected the standalones as well. Macrosystems has just teamed up with Toshiba to create the first Casablanca Liberty, a portable laptop editor that is now switchable between editing-only or computer-only operations.

Casablanca Liberty is specifically aimed at HDV editing, but it remains to be seen how this is going to be better than installing one or two of the star software apps like Avid DV, Final Cut Pro Studio, or Adobe Premier Studio on your PC or Mac laptop.

Karl's Tips

If portability and light entertainment are important for your creativity or for easing your hectic schedule, consider editing on your laptop. Many laptops come with the basic free NLE software like iMovie HD factory installed at no extra charge, but if you want one or two of the star software apps, you'll have to purchase and install them.

The Battle of the Stars

And then there's the cream of the crop—the editing programs the pros use. Although you may not need to make the (significant) investment in these programs for your digital video needs, it's always good to know what's out there should you ever want to upgrade.

Avid Xpress Pro

Avid Xpress Pro ($2,194, www.avid.com, Windows and Mac, trial software download available on website)

Avid's claim to fame is that a large number of today's feature films and prime-time television shows are created using Avid systems. Avid makes some very high-end editing hardware systems that integrate their software, as well as offering Avid Xpress Pro as a stand-alone NLE software application.

Avid calls their timeline concept Open Timeline. It lets you trim across multiple tracks, with both sides of the trim monitor updating at once. Avid's Open Timeline also allows mixing multiple HD resolutions, and HD and SD in the same sequence—even the same clip group for mixed resolution multi-cam editing. Avid Xpress Pro is one of only a few NLE applications that can run on either Mac or Windows computers, allowing you to pick the platform you like working with most. Both versions come in the same box, so you can work on a Mac in one place and a Windows computer in another. A USB *dongle* acts as security to prevent the software from being run on more than one computer at a time. Multiple users need to buy multiple copies, each copy with its own matched dongle.

def•i•ni•tion

Dingle, dangle, dongle! What the heck is a **dongle**? A dongle is a little gadget that looks just like a USB jump drive. When a software application is protected by dongle security, the dongle must be plugged into a USB port on your computer before you launch the software. If you try to launch it without the dongle, you will just get an error message telling you to plug in the dongle. If you have a software application that requires a dongle, be sure to keep it in a secure place when it is not plugged into your computer. Remember the slogan, "Don't lose your dongle!"

Avid Xpress Pro media management tools are powered by a patented dynamic media database. This lets you share bins between projects, work with multiple versions and resolutions of a project, and move projects between computers with only the media you need.

Avid actually won an Academy Award for their Avid Film Composer. Using it you can track advanced film metadata, including KeyKode and multiple time codes, directly inside the editing interface without needing a separate database application. Color correction is easily done with tools exclusive to Avid, including Curves and one-click automatic correction. Avid Marquee offers you a very capable set of tools for 2D and 3D animated titles.

If you're working in HD, Avid claims the industry's first HD format designed for postproduction, Avid DnxHD. According to Avid this format produces the quality of uncompressed HD in the bandwidth of SD, which can lead to great savings in disk space.

Tech support is no small thing in this era of outsourcing. Avid is known in the industry for their support when things go wrong or when you just need a hand. id Xpress Pro comes with SmartSound SonicFire Pro for custom high-quality music creation; Sorenson Squeeze 4 Compression Suite for high-quality encoding to QuickTime, Flash, MPEG-1, MPEG-2, MPEG-4, RealMedia, and Windows media formats; and Sonic DVDit for DVD production (Windows only).

Apple Final Cut Studio

Apple's Final Cut Studio (about $1,200, www.apple.com/finalcutpro/)

Today, Apple's Final Cut Pro is up to version 6 and has greatly improved on the original application in response to customer comment and competition. It is still the NLE many of us favor, although it would be hard to say how much of that comes from better performance and how much just comes from familiarity. Regardless, it is unlikely you will want to do anything in your editing projects that you can't do in Final Cut Pro. Today Apple bundles Final Cut Pro 5 into the Final Cut Studio suite and no longer sells it separately.

Final Cut Pro 6 allows you to edit virtually any video format, from DV and SD to DV, DVCPRO, DVCAM, XDCAM HD, HDV, DVCPRO HD, and uncompressed high-definition video, more specifically: DV, DVCPRO, DVCAM (4:1:1 8-bit), HDV, XDCAM HD (4:2:0 8-bit), VCPRO 50, IMX 50 Mbps (4:2:2 8-bit), DVCPRO HD (4:2:2 8-bit), Uncompressed SD (4:2:2 8- and 10-bit), Uncompressed HD (4:2:2 8- and 10-bit), and Native HDV Support.

Unlike many other NLEs, Final Cut Pro 6 captures HDV media via FireWire (IEEE 1394) and keeps it in the original format, transferring it into the system without generation loss. After editing you can output via FireWire back to an HDV camera or deck, or transfer your HDV to DVD Studio Pro 5 for a complete HDV workflow.

Final Cut Pro 6 can also edit native IMX video from XDCAM and eVTR devices. Using software from Telestream (not included with Final Cut Studio), video can be acquired and converted from MXF to QuickTime, providing Final Cut Pro 6 with the necessary camera native IMX files for editing. Final Cut Pro 6 is compatible with 30Mbps, 40Mbps, and 50Mbps IMX media.

Final Cut Pro 6 has support for high-speed acquisition that lets you transfer files from Panasonic P2 devices faster than real time. And a file transfer from MXF to QuickTime provides Final Cut Pro 6 with the necessary camera-native DVCPRO, DVCPRO50, or DVCPRO HD files for editing.

Final Cut Pro 6 can also work with Sony's XDCAM HD format. It has native editing support for 1080i 50/60, 1080 24p, and VFR video from XDCAM HD devices. Capture and output of XDCAM HD video requires software from Sony that is not included with Final Cut Studio.

Final Cut Pro 6 has real-time multistream effects architecture. This provides speed for multicam editing and new Dynamic RT (real-time) effects processing that scales with your system. Final Cut Pro 6 has real-time multicamera editing tools for DV, SD, and HD. This feature lets you simultaneously play back and view shots from multiple sources and cut between them in real time.

This latest version of Final Cut Pro improves on what Apple calls the Multiclip, a new type of clip that allows you to group together multiple sources and cut between them, giving you up to 128 angles, of which 16 can be played back at one time. A synchronization window provides graphical feedback to show where clips overlap so you can accurately create Multiclips. You can add, delete, or change the order of angles in a Multiclip at any time. The Multiclip Viewer displays and plays back Multiclips in 1-, 4-, 9-, and 16-up layouts. Time code, clip name, and angle number information can also be displayed over each angle.

Also included with this version of Final Cut Pro is RT Extreme. Built on scalable software architecture, RT Extreme with Dynamic RT speeds up performance and allows more real-time effects as CPU speeds increase. Real-time effects play back both onscreen and on external video output devices at the best available quality, so you can see basic cuts and effects at the highest quality. The faster the system and disks, the more simultaneous video streams you can work with in real time.

In addition to standard keyboard shortcuts, you can create your own keyboard short-cuts and user interface buttons for over 600 tools and commands. You can also customize the browser columns and increase the font size for text, create custom window arrangements and timeline settings that suit the way you work, and save your settings and load them onto any other Final Cut Pro 6 system.

You also have a lot of audio control with Final Cut Pro 6. It can capture up to 24 channels of high-resolution 24-bit/96kHz audio in a single pass. Use the onscreen mixer with an external MCP (Mackie Control Protocol) audio control surface to edit and manipulate audio more efficiently. Or take your audio editing to the next level with Soundtrack Pro, an included component in Final Cut Studio.

The Final Cut Pro 6 Media Manager helps consolidate media and projects on your system. Options let you manage multiclips effectively and rename media files to match clip names or changes you've made in the browser. Use the "Reveal in Finder" option to quickly locate media files from your project on the hard drive. Reconnect functionality allows you to specify locations to search for media, saving time when opening projects after media has been moved.

When you finish your project, output capability is very important. With Final Cut Pro 6's 8-, 10-, and 32-bit float image processing, you can be certain that your output will retain its high quality. The scale and rotate algorithms along with advanced color correction tools give you the tools to finish your story and output it to tape, DVD, or the web.

Final Cut Pro 6 includes frame-accurate edit to tape operations. Output DV, DVCAM, DVCPRO, DVCPRO 50, DVCPRO HD uncompressed 8- and 10-bit SD, or HD to professional decks. To output to DVD, you send your project directly to DVD Studio Pro, and Final Cut Pro 6 keeps your chapter markers intact. You can use Compressor 2 to encode MPEG-2 or H.264 for SD and HD discs or send native HDV directly to DVD Studio Pro 5 for a complete HDV solution.

If you want video for Internet use, the QuickTime media layer used by Final Cut Pro 6 gives you great flexibility in outputting for the web. From the Export menu, you can output to the default Sorenson 3, H.264, or other web-friendly codecs, or you can use the built-in QuickTime Export feature or other compression tools such as Discreet Cleaner or Sorenson Squeeze. If you need to output to film, Cinema Tools can extract 24-fps film frames from your 30-fps tape and track the relationship with the original negative for an accurate film conversion.

Final Cut Pro 6 integrates with Apple's family of professional audio and video applications. You can seamlessly move content between Final Cut Pro 6, Motion 2, Soundtrack Pro, and DVD Studio Pro 4 with automatic asset updating as items change in your project. Final Cut Pro 6 also offers integration with Apple's Shake 4 for digital effects compositing.

Final Cut Pro 6 also supports XML interchange format, which describes every aspect of a program from edits and transitions to effects, color correction settings and keyframe data. By using XML interchange format, you can seamlessly share project, bin, sequence, clip, and media data generated by Final Cut Pro with any other application or system that supports XML, including other nonlinear editors, asset management databases, and custom postproduction pipelines.

Grass Valley EDIUS Pro and EDIUS 4 Broadcast

EDIUS Pro and EDIUS 4 Broadcast, from Grass Valley (formerly from Canopus) are highly capable NLE software applications. At about $450 and $1,000 respectively, these are competitively priced and offer a full range of professional features. EDIUS 4 Broadcast adds features needed by higher-end broadcast and postproduction environments, including support for newer, nontape forms of video recording and storage. EDIUS Broadcast also provides additional support for Panasonic DVCPRO 50 and DVCPRO HD, Panasonic DVCPRO P2, Panasonic VariCam, and Sony XDCAM. Real-time, mixed-format HD/SD editing, including DV, HDV, HD, MPEG-2, and uncompressed SD video. EDIUS has in/out support for DVCPRO 50, DVCPRO HD, P2, VariCam, and XDCAM cameras and decks.

EDIUS is the other NLE, along with Avid Xpress, that requires a USB dongle to operate. The flexible GUI includes unlimited video, audio, title, and graphics tracks. Other features include real-time editing and conversion of different HD/SD aspect ratios, such as 16:9 and 4:3; real-time editing; conversion of different frame rates, such as 60i, 50i, and 24p; and editing and conversion of different resolutions, such as 1440 × 1080, 1280 × 720, and 720 × 480.

Also in real-time are HD/SD effects, keyers, transitions, and titles, as well as render-free DV output directly from the timeline. You can do multicam editing of up to eight different sources simultaneously, and create nested timeline sequences.

Sony Vegas Movie Studio+DVD Production Suite

If Sony's Vegas Movie Studio+DVD Platinum Edition does so much, why would you spend over $400 more for Sony's Vegas+DVD Production Suite? (Windows only, www.sonymediasoftware.com, free trial download available on site)

Vegas+DVD Production Suite includes all of the features of Vegas Movie Studio+DVD Platinum Edition, but adds to them by combining Vegas 7, DVD Architect 4, and Dolby Digital AC-3 encoding software, producing an integrated software suite for all phases of professional video, audio, DVD, and broadcast production. This suite lets you edit and process DV, HDV, SD/HD-SDI, and all XDCAM formats in real time, edit audio with precision, and build and burn surround sound, dual-layer DVDs.

Adobe Premier Pro Studio

Adobe's Premier Pro Studio with After Effects and Photoshop CS2 (www.adobe.com, $1,699 Premium, $1,199 Standard)

Adobe Premiere Pro Studio comes in two versions. What's the difference? The Standard version includes Adobe Premiere Pro 2.0, Adobe Photoshop CS2, Adobe Dynamic Link, Adobe Bridge, and Adobe After Effects 7.0 Standard. The Premium version upgrades Adobe After Effects 7.0 to the Professional version, and adds Adobe Audition 2.0, Adobe Encore DVD 2.0, and Adobe Illustrator CS2. Which one to buy depends on your personal needs.

Adobe Premiere Pro 2.0 works with virtually any format. It supports all standard and high-definition formats, including DV, Digital Betacam, HDV, HDCAM, DVCPRO HD, and D5 HD. You can capture, edit, and deliver full-resolution SD or HD by adding the Xena HS real-time encoding card from AJA Video to your computer. You can capture and edit HDV content in its original format with no conversion or quality loss. Adobe Premiere Pro 2.0 works with most HDV-format cameras and VTRs.

This latest version of Premiere Pro allows you to play multiple video channels at full resolution and with titles, transitions, effects, and color correction, without the need for rendering or additional hardware. How many channels you can work with simultaneously will depend on your system's power.

You can import most video, audio, and graphic file formats: QuickTime, Windows Media, AVI, BWF, AIFF, JPEG, PNG, PSD, TIFF, and so on, and output to those same file formats after editing.

If you need to do it, you can capture, edit, and output 24-fps progressive content. You can also display time code for 16mm and 35mm film as standard Feet + Frames nomenclature. You can also import, edit, and output 4K image sequences with dimensions up to 4096 × 4096 pixels.

Premiere Pro lets you review widescreen footage on a 4:3 monitor or transfer to a 4:3 tape or DVD with real-time letterboxing. This will ensure that your 16:9 material looks right during playback on standard monitors or TV.

Because Premiere Pro supports most professional hardware you can choose from a wide range of capture cards and other hardware to build the HD, SD, or DV editing system that meets your needs and budget. The same versatility extends to control of video decks through RS-422 and RS-232 serial protocols or Firewire for precise batch capturing, recapturing, and insert editing. For audio, you can record and play back audio through any multichannel audio card or hardware that supports the industry-standard ASIO protocol.

Because Adobe's software components integrate so well with each other, you can easily import and animate Photoshop layers. You can edit still images from Adobe Premiere Pro 2.0 with Adobe Photoshop software, or automatically create Photoshop files to match a project's frame size and aspect ratio. This same integration of components lets you take advantage of After Effects plug-ins to expand your video effects options. Most After Effects plug-ins are compatible with Adobe Premiere Pro. High-level integration between programs lets you drag and drop or copy and paste clips or timelines between Adobe Premiere Pro and After Effects, and open complete Adobe Premiere Pro projects, including nested sequences, in After Effects. You can edit each section or sequence of a project on its own timeline, and nest each timeline section into a master timeline while maintaining full access to every edit. You can break master clips into smaller subclips for more flexible editing. Trim, apply effects, rename, and otherwise treat subclips like any other video clip.

Adobe Premiere Pro 2.0 sets itself to take full advantage of the power of your graphics card, accelerating the preview and rendering of motion, opacity, color, and image distortion effects.

Almost everything in the Premiere Pro GUI can be customized to fit your personal editing style. Here's a quick overview of some of the other features of Premiere Pro 2.0: View multiple video tracks from a multicam shoot and edit by switching between tracks in real time. Easily sync clips based on source time code. Use primary and secondary color-correction tools to match shots; change colors; correct exposure errors; and modify highlights, midtones, and shadows across clips, sequences, or entire projects. Monitor luminance and chroma levels on every line with the built-in Waveform monitor and Vectorscope. Display Waveform IRE information in standard, YCbCr Parade, RGB Parade, or combined modes. Create sophisticated text and graphics titles from scratch, from professionally designed templates, or from user-defined styles.

Adobe Premiere Pro 2 also has full support for 5.1 surround sound editing to produce true surround sound.

Once you complete your editing you can create menu-driven DVDs directly from the Adobe Premiere Pro timeline, make full-resolution, interactive DVDs for digital dailies, test discs, or final delivery.

You also have the option of encoding video and audio for Macromedia Flash projects with built-in support for Flash Video export. Or you can make your project web ready. Adobe Premiere Pro 2 includes tools for Internet-friendly file formats including Flash Video, Real Video, Windows Media, and QuickTime. You can also output to tape including standard and high definition, NTSC and PAL, interlaced and progressive, DV, Digital Betacam, HDV, HDCAM, DVCPRO HD, and D5 HD.

Saving Your Project

All these file formats can be very confusing. How do you know which one to use when you finally get your project finished and ready for saving and output? Just saving for your own archiving is easy, because you will normally just use whatever the default file format of your NLE is. Most of them have their own file formats for quickly importing back into the NLE for additional editing. So set up an archive on one of your storage hard drives and put your projects there. It is a very good idea to make a backup copy on another hard drive as well to protect you against disk failure. Hard drives do fail.

How you output your project in final form depends entirely on how you intend it to be used. If you intend to put your video on the Internet, you will need to output it in one of the web compatible formats like Flash Video, Real Video, Windows Media, and QuickTime. Because preferred formats for Internet use change all the time, check with the website you plan to submit your video to and see what they prefer. If the video is for your own or a corporate website, do a bit of Internet research to find out what works in the quality you want. You could even set up a temporary website for your own testing and upload several different saved files in different formats to see which produces the best look.

If you intend to send your video to a commercial DVD manufacturing facility for mass production, get some guidelines from that company on how they like material submitted. Most want a master DVD from you, but a few still prefer to receive material in some form of tape format. You will generally get the best results if you give things to them in their preferred form.

The same is true if you are sending your material to a film production house to produce film output for theatrical projection. Find out what the production house wants and make sure you understand how to supply it to them.

The shift to HDV has been revolutionizing the consumer and prosumer digital video market by making high definition available and affordable for mass consumption and that greatly influences your choice in editing as well. Make sure that your NLE software can handle HDV both in tape and in disk format.

The Least You Need to Know

◆ To make informed buying decisions you need to know what your editing needs will be. Consider the fact that the market is currently changing to HDV.

◆ Many nonlinear editors are available to choose from, at a wide variety of price points.

◆ Knowing the needs of the end user is all-important in producing the proper output.

Chapter 17

Editing Techniques and Intro to Sound Editing

In This Chapter:

- ◆ Different types of cuts and when to use them.
- ◆ Knowing when not to cut a scene.
- ◆ Using audio effects to your best advantage.
- ◆ Understanding the importance of leveling and volume.

Now that you've learned the basics of editing, it's time to get into the nitty gritty—the types of cuts, when to use (and not use) them, and the importance of editing sound.

Cuts

The key to successful editing is that it's unnoticed. This means the audience watching your film should never for a moment be distracted from the content of your story because of a jarring, choppy, or amateur-looking editing choice.

For this reason, it is important to understand the different types of cuts and when to use them—even if you're not planning to do the editing yourself.

Arrange the Clips

The first thing you do is lay out the clips in a rough arrangement of the sequence of the movie. Give yourself some semblance of chronology, even if it's very rough, to work from.

Then take a look at what you have and decide on the best way to move from scene to scene within the sequence to give the audience a smooth transition from moment to moment.

Cross-Dissolve

Dissolves blend one scene seamlessly into the next. They are gradual transitions from one image to another—specifically, the last image of one scene and the first image of the next. Dissolves are often used to indicate the passage of time or a transferal from one location to another—or both at the same time.

Fade In and Out

These are gradual transitions from no picture to picture (fade in) and from picture to no picture (fade out). When the end of a scene gradually darkens until it's black or lightens until it becomes a visible picture, this is known as a fade. In contrast to a cross-dissolve, a fade is often used to suggest closure and opening. As opposed to a fade to black, a fade out to white is sometimes used to indicate dying (a character "moving toward the light"), falling into a coma, or moving forward from a flashback into present time.

A fade can also be used to show a larger transferal of time than, say, a cross-dissolve. If you're showing the passage of centuries rather than days or hours, it may be more effective to use a fade than a dissolve.

L-Cut

An L-cut, also known as a split-edit, is a transition from one shot to another. It is used for a continuous flow of audio from one scene to the next. For example, when a character is talking about going to a café, and then finishes his dialogue as the audience actually sees him sitting in the café, this is an L-cut.

L-cuts can also be used to make conversations flow better; rather than cutting back and forth for the full duration of a character's speech, the editor can use an L-cut to have the audio continue while showing another actor's reaction.

L-cuts are also used to successfully "hide" transitions by using the audio as a bridge from one scene to the next.

Wipe

When one image is replaced by another coming in through some kind of geometric pattern or shape, this is called a wipe. George Lucas used wipes in the *Star Wars* movies to give them a serialized, "pulp" feel. Although not common today in most dramas or action films, a wipe may be used for comedic effect.

Different types of wipes that may be used include a clock wipe, which shows the passage of time by introducing a new image in the physical shape of the movement of a clock's hand; the invisible wipe, where a transition element like a person or wall disguises the wipe; and the matrix wipe, which is a pattern transition (in the shape of a grid) between two images.

Cut-Away

These are shots that are not part of the main action. Often used in parallel editing. During a murder scene a shot of the police receiving a phone call alerting them to the situation is a cut-away.

Insert

An insert differs from a cut-away in that it provides visual information that could go unnoticed in the scene. In the example of the killer dropping the knife, if the audience is already watching a full shot of the killer walking away dropping the knife, an insert can be used to close in on the knife dropping to ensure that this vital piece of information is conveyed.

What's distinctive about this type of cut is that the action you're zooming in on is already being shown in the wider shot.

... And When Not to Cut

Of course, some times you would choose not to cut a scene at all. It's important to understand the effect not cutting has on an audience, so you can use this choice to your advantage.

To Create Tension

One example of a scene that was famously not cut is the scene in *Pulp Fiction* in which Uma Thurman's character, Mia, is overdosing on heroin. John Travolta's character, Vince, brings her to the home of his drug dealer to try to revive her. From the moment Vince and the drug dealer, Lance (played by Eric Stoltz) bring Mia in the door, the audience sees an unbroken sequence. The characters are panicking and trying to find a medical book and syringe with which to save Mia. From that moment until the end, when she comes out of her drug-induced stupor with a syringe sticking out of her chest, the scene is completely uncut.

Why did the director, Quentin Tarantino, choose to do this? Maybe because not cutting increases tension. This scene, made more thrilling by the fact that it's filmed with a handheld camera, gives us, the audience, the feeling of being a bystander in the situation—we get no relief from the chaos through a change of perspective. Just like the other characters who are unable to help and are stuck being bystanders, so are we incapacitated as viewers, simply watching the scene unfold, unbroken, in front of us, wondering if she will die.

To Feel a Part of the Action

In Martin Scorsese's award-winning film *Goodfellas*, an uncut scene is shown from the time the character of Henry (played by Ray Liotta) gets out of the car with Karen (played by Lorraine Bracco) until they are seated in the front row of the Copacabana. They walk down the back entrance of the club and wind their way through hallways, the kitchen, and the lobby until they finally emerge through the side entrance of the club. This incredibly complicated shot helps the audience see and feel a part of Henry's world—one of the privileged few who doesn't have to wait in line, as indicated by the continuous shot.

Sound Editing

Just as choosing jarring or inappropriate cuts in transitioning your film can take the audience out of the moment while watching it, so can inexpert sound editing ruin the enjoyment of a scene. Sound quality is the one major aspect of moviemaking that is not taken into consideration as much as it should be. It's true that once the sound of your movie is brought into the timeline of your editing program, you can enhance it, cut it, add effects to it, and so on. But you should understand that you shouldn't rely

upon even the most state-of-the-art editing system to fix anything major that happens during the actual recording of the video's sound.

The simplified layout of today's video editing programs makes the process visually comprehensible for the editor. At the top of the timeline you have the video, and beneath that are the tracks that manage audio. Multiple tracks of audio can be layered, offering the capability to enrich the overall sound of your movie. (One track would be for the sound that accompanies the video, while other tracks could hold a musical score, sound effects, narration, or whatever you choose.)

Zoom In

Good sound supports and enhances the story you are telling by subconsciously drawing your audience into what they are watching. As with editing, the better job you do with your sound, the less it will be noticed.

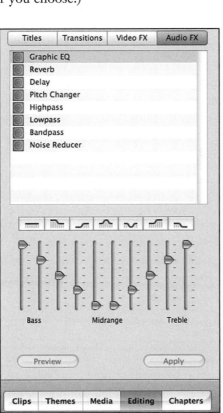

iMovie's sound editing and effects features.

On the Simpler End of Things ...

Several editing programs are specifically marketed to beginners. Apple's iMovie, for example, is a perfectly good editing system in the sense that it's understandable and easy to use. It may not have a lot of bells and whistles, but getting started editing with iMovie is a cinch, as you saw in Chapter 16.

Audio Tracks

Once your video has been captured, drag the clip into the timeline. If you're working with iMovie, there will be no separation between the video and the audio, but by selecting the Extract Audio option, you can pull the audio from the video.

That audio will then occupy one of the three available audio tracks of the timeline. You can fill the two remaining tracks with other audio (narration, music, etc.), but keep in mind that you cannot go beyond this. In comparison, a more in-depth editing system such as Apple's Final Cut Pro can handle up to 99 tracks of audio.

By divorcing the audio and the video in iMovie, both are free to move independently from one another. This could potentially cause some problems; for example, if someone in your video is speaking and you move the audio track slightly down the timeline, it will be out of sync with the speaker's mouth. You can always link any video track with any audio track, however. This is a nice feature, especially when you'd like to keep particular music with a particular section of your movie.

Some features you should be aware of with more sophisticated editing programs are different types of audio effects, such as echo and reverberation, or reverb.

More advanced programs also offer tools with which you can fine-tune your audio for a more professional sound. Final Cut, for example, provides an equalizer feature with which you can balance audio for emphasis or a more even sound. These programs also allow you to remove a hissing sound that may result from microphone usage, or many other issues that result from faulty audio capture.

Pump Up the Volume

In most editing programs, each audio clip has a continuous, rubbery band that may allow you to adjust the volume. Raising this band upward will raise the volume, pulling it down will lower the volume.

You are not, however, restricted to just this mode of volume adjustment. There may be isolated areas throughout your audio clip that need to be louder or softer than others. If this is the case, you may adjust the volume in almost every editing system, even the most basic. Clicking onto a spot on the rubber band creates a small bead. Pulling this bead up or down will adjust the volume of this moment in your audio clip. For example, if someone in your movie is screaming and it's too loud in comparison to the other sound of the scene, you can simply lower just that area.

Also along the margin of the audio track, you can select a specific track to manipulate. For example, if you have three tracks of audio (one is the dialogue, one is the music, and one is the sound effect) and you want to mute the music to focus on the way the dialogue and sound effects interact, you can do this with just about every editing system out there.

Favoritism

Make sure that all the controllable audio in your movie is part of a volume hierarchy. At specific times, specific sounds need to come forward and push all other sound into the realm of supportive ambient.

For example, let's say that two people in your movie are sitting at a table talking. Because this is the focus of the scene, the audience shouldn't have to struggle to hear them. Their voices are on the first audio track on the timeline. On the track below, you decide to lay some music, but this cannot override the voices of the characters. Having the option to lower the music so that it supports the characters' voices and not override them is ideal.

If you're filming a car chase, you might have the growling engine of the cars rumble into the audio foreground. Or bombs exploding during a war scene as soldiers run through an evaporating city of dust and fire. In all instances, it's essential to consider the importance of each audio track and how it fits into the overall hierarchy of the scene.

Quiet on the Set!

Let's say that when you play back your footage, you find that your audio is too low. In some cases this may be fixed by raising the "rubber band" a few decibels. But be careful not to raise it too much, or your audio will crack and lose its solidity. It cannot be stressed enough how important it is to make sure your audio is recorded clean and clear during shooting. If you have badly recorded audio, there is little you can do in postproduction to repair it.

Watch Your dBs

Once all your individual audio tracks are leveled properly, they must act as a whole (essentially, as one audio track) within the scene. For the best sound quality, this occurs at 12 decibels.

The best way to achieve this is to set each track individually, keeping an eye on the meter in your editing program which reads the decibel level. The dialogue is typically the focus, and should be set at 12 decibels. If you then want music playing softly in the background, you may set the music to 6 decibels. If, in your scene, you also have the crashing sound of someone dropping a tray of glasses in the background, you may set this sound at 8 decibels. The important thing to remember is that none of your sound should go over 12 decibels or you will have a cracking, splitting sound (which you may want to use as a distortion effect, but which is not ideal for the average scene).

Dealing with Background Noise

Extraneous noise is the bane of the audio engineer's existence. Wind, planes, trains, automobiles—whatever—it all gets in the way of good clean sound. Sometimes the solution is as simple as a foam windscreen slipped over the microphone. Other times there will be absolutely nothing you can do to eliminate the unwanted sounds at the time of recording. In the past, this problem was insurmountable, but today digital processing comes to our rescue.

Audio processing software like Apple's Soundtrack Pro and some others lets you sample the background noise by selecting a segment of it in the audio timeline and then digitally "subtracting" that noise from the rest of the sound timeline during editing.

You can also use such editing applications to edit your soundtrack using a timeline similar to your video editing. Or you can do your audio editing in your NLE and just export sections to a soundtrack editor when they need extra work.

Editing your movie is essentially your last chance to perfect your work. This is when you really need to make sure you've given your audience the experience you worked toward all through preproduction and production. Don't rush; carefully consider each cut, and check and recheck your audio. The end result will be worth it.

The Least You Need to Know

- Understand when to use each type of editing cut, and what its effect will be on your audience, even if you're not editing the film yourself. Cuts influence the overall experience of the movie, and should be carefully considered for each transition.

- Sometimes it may be effective not to cut, and you should understand how continuous shots will affect the viewing experience.

- Work within the confines of your editing system to perfect, enhance, and use audio effects to improve your video.

- It is of vital importance to ensure that your audio is recorded properly during production, because there is very little you can do to fix it in postproduction if it has been badly recorded.

Chapter **18**

Digital Effects and Animation

In This Chapter

- ◆ Applying and working with effects and animation within your footage
- ◆ The strengths and limitations of video effects and animation software
- ◆ Choosing the right effect to create the right mood for your movie

Sometimes moviemakers don't have the money or the resources to achieve a particular desired look or action during the actual shooting stage of their movie. Some things can only be done in postproduction.

As you now know, postproduction should not be relied upon to "clean up the mess" of actual production. You need to focus on whatever you can when you're actually capturing your information: shooting, audio capture, lighting, movement of camera, cinematography, and all the rest. Good rule of thumb: whatever can be done during the shooting stage of making your movie, should be. Whatever you absolutely cannot do during production can wait for postproduction ... if you know how.

Knowing What Can Be Done

Many programs offer cool postproduction options that can spice up your visual footage and, even better, are easy to apply. These options are known as *video effects*. With these tools, a video editor can transport an audience to

a different dimension of thought, time, or place; to a more fantastical realm; or to a vision that completely defies all orthodox laws of human perception.

def•i•ni•tion

Video effects are software applications that can be used to alter the original video footage in some way—from brightening or darkening a scene to completely changing the location in which the footage appears to have been shot (for example, with a green screen).

No matter how expensive or "cutting-edge" your software on your personal video editing system may be, you just won't be able to create any kind of advanced or complicated effect or animation to completely change your footage. In other words, you won't be able to show a space craft soaring from planet to planet, or transform a person into a Tyrannosaurus Rex. Other programs do that sort of thing, which we'll touch on a little later, but don't despair. Your editing system provides plenty of rudimentary effects to impress you and your audience.

So first, let's take a look at the basics.

Basic Effects

To have as much control as possible in the way the movie appears to the audience, you may first wish to consider working with simple effects that give you the most "bang for your buck." Here's a short list of effects you can use to quickly and easily adjust specific actions or establish and enhance the mood of your video.

Changing Speed

Having the ability to speed up and slow down the video footage is helpful in situations when you may want to emphasize something in a scene. In our example of the killer dropping the murder weapon, you may wish to slow the scene down so the audience concentrates on the knife falling to the ground.

To accomplish this, you simply change the speed percentage on your editing system. For example, the average scene speed in Final Cut Pro is set at 100 percent. If you want to slow the scene down, you can drag the percentage down (say, to 50 percent). If you want the scene to speed up (for comedic effect or to cover a lot of expository ground quickly), drag the percentage up. Again, the best way to decide what works for your movie is to experiment with this feature and see how it works within the context of your movie.

Changing Direction

In the same effect panel you'd use for adjusting the speed, you will find the "reverse" effect. Aside from the obvious uses (making your footage appear to "rewind" and run backward, then start again for comedic effect), you can accomplish something kind of interesting using reverse.

Let's say you want to shoot something that would be too dangerous to film properly in real life. For example, your script calls for your villain to wheel around and just miss your hero with a knife. You could film this backward by having the villain start with the knife close to where it "just missed" and bring his arm back, away from the hero. In postproduction, you then use the reverse effect to make it look like the attack is going in the other direction, all without potential harm to your actors. (Of course, you shouldn't be using a real knife anyway, but this type of setup works for all sorts of situations.)

If you use your imagination, you'll find other ways to make these very simple effects go a long way to improve the production level of your video. But if they're just not enough, don't worry. Your editing software doubtless has other cool image-control features that are just as easy to use as these are.

Image Control Effects

If you're looking to do some more in-depth editing to increase the impact level of your video, many other options are usually available on your editing system—and are just as easy to apply. Some simple effects that are both easy to apply and impressive looking include: color correction, blur and sharpen, distortion, keying, stylization, brightness and contrast, and desaturation—all of which fall under the heading of *image control*.

There will be times when you've loaded your footage into your editing system and then realized that what you shot is not really what you thought you were getting at the time. This could mean many different things, but let's take one at a time.

def•i•ni•tion

Think of **image control** as the paramedic of wounded footage. These options help to shape the way your footage looks, ensure continuity among several takes or scenes, and assist in providing an overall professional look to the movie.

Color Correction

How and why would you want to "correct" the color of your video footage? One very important reason for using a function such as color correction would be for continuity from one edit to another.

If an audience notices the edits in a movie, the editor has failed. Why? Because when an audience is distracted by something outside your movie world, then you've lost your audience. Noticing anything technical constitutes a failure of the moviemaker.

Color correction menu on
Final Cut Express HD.

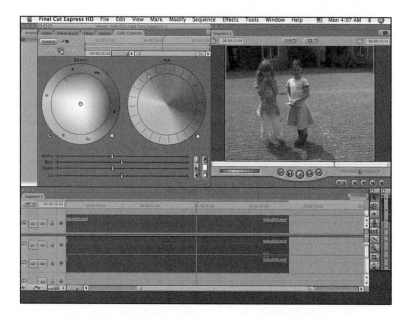

Let's say that you have a two-camera shoot, one camera for each subject conversing over a cup of coffee. When you load each camera's tape into your editing system, you realize to your horror that you forgot to white balance one of them before shooting.

Camera 1's footage has regular color, but Camera 2's footage has a slightly greenish tint to everything. This makes it impossible to cut back and forth from the actors, because they will look like they're in two differently lit rooms. The audience will be saying to themselves that it doesn't look right ... that whoever made this movie did it badly. And if they're thinking this, they've been pulled from the movie universe and are no longer listening to your characters' dialogue.

So in a case like this, what can you do? Depending on how severe the greenish tint is, it's possible that it can be fixed to match the better footage of Camera 1. In Final Cut Pro, one of the color correcting options is a color wheel. This is a wonderful visual aid that allows you to push a bead into whichever region of color you might need to repair. The damaged color of Camera 2 can be made to more closely match the footage of Camera 1. (Other tools go along with the color wheel, such as an eye dropper and an auto-contrast for applying an overall quick, automatic fix.)

The main thing to shoot for in color correction is this: if the color of your footage is just too far off and you feel that you're unable to balance the colors properly, all is not necessarily lost. The one thing you should always aim for, if nothing else, is to find the proper flesh tone for the people in the scene. It is easier for a viewer to accept discoloration of objects in the background than to accept greenish flesh on a pretty girl.

> **Zoom In**
>
> Part of the fun of editing is exploring the capabilities of such color correcting tools. The more you play with them, the more possibilities you'll discover, so take some time to experiment and see what's possible within the system you own!

Blur and Sharpen

"Blur" and "sharpen" are pretty self-explanatory image tools. A blur effect will soften the image, and a sharpen effect will make the image more crisp and define the edges.

You may choose to use a blur effect when you're about to transition into another scene (for example, a dream sequence). Conversely, you may wish to apply a sharpen effect when you transition out of a scene (waking from the dream sequence). Sharpen may also be used when you need to sharpen your focus within footage that was shot incorrectly—specifically, something that was shot too softly. (Again, this tool will not "fix" faulty footage, but may help make it less noticeable.)

Distortion

Several distortion options are generally available in different editing programs. With distortions, you can add a ripple effect, warp, 3D simulation, and many other types of effects. These effects are also good for transitions, to convey emotion (for example, a ripple effect could be used to overtly show a character experiencing the effect of a drug or having an emotional breakdown), or to do just about anything else you can think of. Remember, you're only limited by your own creativity here!

Keying

The keying option becomes useful when you're working with blue/green screen footage. (See Chapter 13 on the production environment and on editing effects for more information on working with a green screen.) Keying will render blue or green images shot against blue or green screens transparent, and you can layer other footage to fill in the transparent section.

Stylization

Giving your footage a different kind of style can be fun, and can possibly assist in enhancing the particular mood you're interested in setting. With the stylization tools, you can put an array of textures into the footage. Think about how different, exaggerated colors might affect the audience's experience when viewing the footage, and experiment by trying out different colors in the Stylization settings. The effect called "Finding the Edges" will heavily define or augment the natural contours of people, objects, or whatever else is in frame. Think about it—how will this graphic novel feel affect the mood of your film?

Brightness and Contrast

The brightness and contrast feature will do just what you expect it to: it will adjust the brightness of a scene or the scene's contrast. This feature will come in handy in cases such as when you may have shot something that had either too much or too little lighting, and may also help apply a particular look and feel to the footage, same as with the stylization tools.

Desaturation

Desaturization simply means to fade, or take the vitality out of, the color in your footage. It goes without saying that if you remove all the vitality from the color in your footage, you will transform it into a black-and-white movie. This could be exactly the look you want. Alternatively, you may want to increase the vitality to have an overbright scene to set a particular mood or feel. Again, experimenting with this tool is the best way to find the effect that works best for the mood you are trying to create.

Posterization

Posterization effect is the oversaturation of color that makes the image resemble a poster. In the following example, posterization was performed as a built-in effect from the pull-down menu of iMovie HD.

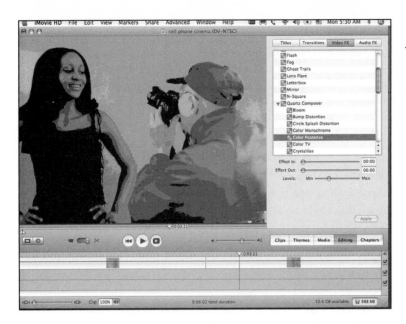

Posterization of the author's fashion shoot with the model Oma.

Practically all editing software comes with these kinds of built-in effects and limited correction tools. However, the ultimate special effects software can do all of this—and a lot more—for prosumers and professionals alike. One such program is Adobe AfterEffects, which is part of Adobe's premium production bundle.

Adobe AfterEffects is extremely user-friendly, and is the most widely used special effects software program.

Zoom In _____

A finely tuned NTSC monitor is your best friend when you're dealing with effects such as these. The monitor will show you precisely what you're doing to your footage, and is especially helpful when you're dealing with adjusting color.

Animation

The kind of animation discussed in this section will be quite different from what the state-of-the-art, professional-quality animation programs used by the big studios are capable of. In currently available desktop animation programs, it's just not possible to create a Godzilla clone breathing fire on a city or anything like that. These programs are not capable of making people in a still image move around, nor can they completely and utterly change any type of footage you've shot. These animation programs are really only good for enhancing the "magic" of your movie.

So enough about the limitations of the editing programs you may have. You want to know what they can do, right? Well, here are some examples.

Keyframing

The opening scene of your movie begins at a football game among family members in the park behind your house. You want to put in some credits during this football sequence, but you decide to make things a little bit fancy. This is when the keyframing feature comes in handy. You keyframe the path of a cartoon football to float across the already moving footage of the game.

When the football reaches center frame, you want the name of one of the players in the home movie to appear, and then the floating football will continue on its keyframed course off screen. This process will repeat with everyone's name until all the players have been mentioned.

In order to achieve this particular animated effect, you first need to obtain the image of the football. You can either download an inexpensive piece of clipart from a stock image website, or scan in an illustration of a football you drew yourself. If you're skilled with Photoshop or another photo editing program, you can select a picture of a football from within a photograph and crop it so just the ball itself exists as a separate entity. Then import the image into your video editing system and drop it into the timeline.

Depending on your video editing program, you would then select the keyframing option and literally plot out the course of this floating football by using a sort of "rubber band" which represents the path upon which the ball will fly. You give the football a starting point and an end point on the rubber band by making a mark on the band. Of course, you could get more elaborate and make the football bounce all over the frame, but that is a bit more complicated and requires some experimentation. Work within your limitations at first, and then see where you can take this knowledge as you become more adept with your animation program.

Animating Clips

Another simple animation effect you can use is keyframing to animate, or move, the video image within the confines of the screen itself. You may wish to use this effect to mimic the picture-in-picture function some televisions have. Using the same principal as the "rubber band" technique you used for the football, clips can be moved across the screen in a fixed or random pattern. They can be distorted or animated. Or they can be expanded or minimized. And to accomplish any of these effects is relatively easy—just follow the same steps as you did in the keyframing example, using the image itself instead of the football.

For those of you who would like to start using digital animation, but are unprepared to pay for it, check out Blender—a free animation software program. You can download it online at www.blender.com.

Blender is a free animation software program.

No matter what program you're using to edit or add effects and animation to your video, remember one thing. Your movie is going to be a success even if you don't have the resources that the big-budget studios and editors have. Do you know why? Because when an artist is working with budgetary or other limitations to create a story, he or she is forced to rely on his or her own imagination to bring the story to life in the best way possible. There's always a way to show what you want to show, no matter what resources you may or may not have. You just have to figure out the right way to show it.

And don't forget that, sometimes, less truly is more. Which is the scarier movie—*Alien: Resurrection* or *The Blair Witch Project*? *Alien: Resurrection* had a big budget and is filled with Hollywood special effects. *The Blair Witch Project* used no special effects, no animation, and no postproduction pizzazz. Instead the horror was left to the imagination of the audience. Keep that in mind when deciding what to show and what not to show; what to enhance with effects and what to simply imply, and leave your audience to supply the "effects."

The Least You Need to Know

♦ Neither video effects nor animation can fix faulty footage, but both can play an important part in establishing or enhancing the look and feel of the video.

♦ Simple effects, such as stop, fast, slow, and reverse, can allow you to shoot a dangerous-looking scene with little risk to your actors.

♦ While desktop animation programs have come a long way, they are still somewhat limited in what they can accomplish. But don't despair—with a little ingenuity, you can do a lot more than you may think, no matter what software system you have.

Chapter 19

Building Menus and Burning Your Movie to DVD

In This Chapter

♦ Using different types of DVD menu options from simplistic premade menus to complex customized ones

♦ Understanding how text, audio, and navigation features influence the movie-watching experience

♦ Knowing the proper archiving methods for your video

Now that you've finished all the hard work of editing your video, I'm willing to bet that you're not going to be satisfied watching it alone on your computer or monitor in your workspace. You want to transfer it to DVD, so that you and others can watch it like normal human beings in a social setting, right?

Assuming that you're going to distribute or loan your DVD out, at least to the people you know, one of the things you need to consider carefully is the impression your video will make. And we all know how important first impressions are!

What Your DVD Menu Should Have

When someone first puts your DVD into their player, they will immediately get a sense of what type of video this is. So when preparing your video for viewing, think about what kind of tone you wish to set. Is your audience about to watch a horror movie? A home video of a family event? A boating trip? The kind of menu you choose should set the tone and give the proper sense of expectation to the viewer. That's where the visual design and sound on the DVD menu come in.

In addition to its visual design, the menu of your DVD should offer selectable buttons, which allow your viewer to navigate through all the features of your DVD. The ability to quickly and easily navigate through a DVD is taken for granted nowadays, so put some thought into providing navigational options on your DVD menu.

Pregenerated Menus

So let's begin with the visual layout of your DVD menu. And because you're going to be putting a good deal of effort into it anyway, why not make it appear as close to a professional DVD as possible?

Most of the basic programs out there will offer similar DVD menu-creation options. iMovie, for example, provides a collection of pregenerated menus that will usually fit a specific theme: weddings, birthdays, vacations, and so on. On any given program, the birthday menu might be a cake with flickering candles, playing the "Happy Birthday" song as confetti floats down. Something like this is a quick fix that works well for predetermined themes, as opposed to building your own menu. (I'll talk about that in a little while.)

Many components go into a legitimate DVD menu. On any good presentation, a visual is usually accompanied by some fitting audio. We all know that audio and video go hand in hand. So for the menu of your DVD, you want to attain the immediate marriage of these two elements, alive and beckoning to your viewer, providing an inviting opening to your movie. And as with everything else, there is an art to creating an interesting, inviting menu. So let's take a look at what audio is available to us as DVD menu creators.

Music

You can change music tracks to help set a precise mood for your video, even if you're using a pregenerated menu. Because music is built into most editing systems as a controllable option, and because it can actually be one of the more essential items in customizing your DVD design, let's start there.

Let's assume that you're building a birthday DVD for your 7-year-old daughter. You've selected the pregenerated birthday menu, which is automatically playing the classic "Happy Birthday to You" song. This type of menu will work just fine for your video, and requires very little effort. But what if the birthday DVD you're building is for a black-tie cocktail party you threw for your wife? This menu probably won't set the proper tone for something a little more elegant. This is where music customization comes in.

In iDVD, there is a section where the audio file of the "Happy Birthday" song is located. All you need to do to change the song is to drag this file out of its spot, and replace it with a different song by dropping in a new audio file of your choice. (It's a simple step to grab a song from iTunes, or from wherever your music files are stored.) So now your menu may consist of confetti falling over the strains of your wife's favorite Harry Connick Jr. song, which sets more of a cocktail-party tone.

Quiet on the Set!

Remember that if you're planning to show your DVD in anything other than a family-and-friends private setting, you are responsible for choosing music that you have the right to use. This means that if you're eventually going to show your video in a public place or enter it into a film festival, you must make sure that even on the menu you are using stock audio or audio you've received permission to use.

When you drop this audio file into its place in iDVD, the first 30 seconds of the song will play, then it will automatically begin to replay. This play-replay pattern is known as *looping*. (Don't forget to fade the music at the end of the loop.)

def•i•ni•tion

For our purposes, **looping** refers here to the process of taking a finite amount of sound or video (in this example, a piece of a song) and repeating it digitally for an infinite period of time.

Zoom In _____

Of course, you may wish to use the chorus, or another section of the song, instead of the first 30 seconds. Although there's really no option within iDVD which will allow you this kind of control, there is another way to identify the specific 30 seconds of the song that you'd like the menu to repeat. You could bring the audio track itself into your video editing program, edit out the 30 seconds of your choice, and then export that as a new track. This new track will then loop within the DVD menu.

Like I've said, what you hear in your DVD menu is just as important as what you see. So let's move on to what you see … some of which can be interactive.

Text

We all take DVD menus for granted. We expect to be entertained immediately upon insertion of the disc into our DVD players, but that's not all. We also expect to have a good deal of control over what we're about to see and how we'll see it, so why not provide your viewer with the most amount of entertainment and control over the video? That's all part of the fun of watching movies at home.

A DVD could very well be designed to begin the movie the moment it's inserted into the player, but most are not. Instead, the viewer has the option to begin the movie when they select "play," or start with the "special features," or skip around in the "chapter selection" section. These options all provide the viewer with the control—the keys to your movie-watching kingdom.

No matter what editing program you use, after dropping your video file into your DVD menu, you will be given the option to place text into a few different sections. Some of these sections will end up being the buttons your viewer can select in order to navigate through the contents of your DVD. And of course, like in any word processing program, you can choose from a customizable list of fonts, colors, and point sizes to further enhance the mood of your menu, depending on the DVD menu program you are using.

In iDVD, for example, the selectable button to play your movie will appear as a blinking cursor, at which point you can fill in the text. You can write "Play All" or just "Play" or the title of the video. In fact, you can write whatever you like. The end result will be the same—when your viewer selects this word or phrase with the DVD remote, your movie will begin and will play straight through to the end.

On iDVD, you can choose from OneStep DVD production, which burns DVDs straight from your raw footage, to Magic iDVD (an automated editing program), to the more sophisticated editing options available in Create a New Project.

But what if he or she wants to jump to a specific section within the movie? It's kind of annoying to have to start your video and then fast-forward to the part he or she wants to see, right? Well, that's where chapters come in.

Chapter Markers

Creating a DVD menu without the option to jump forward or backward just isn't reasonable today. That's why DVD menus can be designed with *chapter markers*.

Again creation capabilities vary from one DVD program to another, but a stock option that nearly every program includes is the ability to create your own chapter selections within your movie.

Generally, you will need to "mark" the chapters of your movie on the timeline in your video editing program to tell the DVD where to start each new section. This is done by simply scanning your movie on the timeline, isolating wherever you want a new section to begin, and then pressing the

def•i•ni•tion _____

Chapters in DVD menus refer to distinct scenes or a group of scenes, which are delineated as specific starting points throughout the movie. If chapter selections are set within your DVD menu, your viewer can jump to those particular scenes right from the menu and begin watching from there.

"Chapter Marker" or "Marker" button. A new section will then begin at each of these spots on the timeline (unless your viewer has selected the "Play All" button, in which case your video will play straight through without stopping).

Once your movie has been exported and you've dropped it into your DVD program, an option will appear that, when selected, will open to another page where a textual list of the chapters you made will appear. At this point you can name each chapter whatever you like (more on this in a moment).

Chapter Selection

If you have used created chapters in your movie, a second button will now appear on your main DVD menu. As you did with the "Play" or "Play All" button, you can tailor the text you type over this button, as well. Maybe you will call this option "Scene Selections," or "Chapters" or whatever else works for your video. When your viewer selects this button, a submenu will open up with a list of the chapters you created. Your viewer can then choose to start viewing your video from those particular chapters instead of watching straight through.

When a submenu is created within your DVD menu, the same rules apply as those you set up for the main menu; the text will be the same, the font will be the same, and the music will be the same. So if the main menu of your wife's cocktail party shows a visual of a birthday cake, you may wish to distinguish the submenu with a different visual—a photo of her, perhaps. (You do this the same way you put a specific background into the main menu—see "Making Your Own Menu," later in this chapter for more details.)

Although it takes more time, it can be much more exciting and interesting to visually differentiate your menus and submenus from each other. Remember: you've worked hard on your video, and first impressions count. Don't bore your audience before they've even begun to watch your movie.

Submenus

As we've just discussed, setting up chapters in your movie will automatically generate a submenu in your DVD authoring program. What you'll see will be a default textual list of chapters for your movie. But don't feel that you're stuck with that list; your editing program likely provides alternative methods of chapter distinction other than textual.

One option allows you to convert each of these textual representations of chapters into visual displays. Selecting such an option (typically called "Window" or "Folder" or something similar) will transform each chapter button into a movie "window," which loops a few seconds of the footage you've designated as this chapter area in your movie. A scroll bar will appear next to this window, allowing you to search for the desired starting and end points. This is a pretty cool option, and it provides both visual interest and a more professional look to your menu.

Incorporating More Than One Show

It's your DVD and your design, so you can put as much or as little content on the DVD as you want. Connected or separate, an interesting grouping of content is another way to increase your DVD's appeal to your audience.

Let's say that you've spent a week down at your beach house with the family and captured all the important events with your video camera. Your son's surfing competition took place during this vacation, so you plan to dedicate the entire DVD to just that particular event.

But what about the boating trip that week? Or the surprise visit from Auntie Mildred and Uncle Stewart? What about the gigantic waves crashing against the beach during a lightning storm? These moments are memorable, as well, and all seem to be a significant contribution to the week.

After you've edited the four separate movies from your week at the beach house, you can put them all into your DVD presentation as one long file with chapter selections, or you can make one DVD that includes the four movies as separate entities.

Either way, it's easy to do. Export each of the movies into separate movie files, and drop them one at a time onto the DVD menu. For example, let's say that you're using iDVD. Drag your four QuickTime files one by one onto the menu. You'll see that each movie has its own buttons, unattached to anything else. Because they each have their own buttons, it should be apparent that the movies are not connected to each other. Therefore, if your audience decides to play the movie called "Boating at Sea," they would select that button, play that movie, and when it ended, they would be returned to the main menu, where all the other options appear to choose the next movie they want to see.

But don't stop there. To make your DVD even more stylish and unique, you could create four different submenus, so that each movie has its own distinct page. Or make two submenus to group together the movies that have the most in common. Try it out and see what works best to keep the content together in an interesting way.

Making Your Own Menu

Okay, you've scrolled through all the pregenerated menus in your DVD program, and none of them seem to fit just right with your project. You're finding that your work is just too specific to be contained by someone else's idea for a menu. So what do you do?

Simple. You bypass whatever pregenerated menus the authoring program offers, and design your own menu completely from scratch. And if you're making your own, what can be better than making a moving menu?

Moving Menus

Conceptualize a sort of movie trailer, something that works kind of like a commercial for your video that could hook an audience, draw them in, and make them want to see more. Grab one of the most interesting, exciting scenes of the existing clips of your movie, plop it into a new timeline, and create an enticing little piece for your menu. This piece will be used as an original and exciting moving background for your DVD menu. And because you're familiar with editing video footage from working with your whole movie, editing a little more shouldn't be much of an issue.

> ### Quiet on the Set!
>
> When choosing an exciting section of your movie to use as your DVD menu background, make sure you don't pick a scene that "gives anything away." There's nothing you can do to destroy suspense faster than sending your audience into a video already knowing what's going to happen at one of the most exciting moments.

> ### Zoom In
>
> Of course, there will be a time limit on how long your custom-made motion menu will run before it will hit the end of the loop and start all over again. With this in mind, try to choose a scene that is somewhat self-contained, and has something of a beginning, middle, and end to it.

And always be creative. Maybe jazz up your 30-second menu a bit by saturating the color, adding some effects, maybe converting it to black and white. Let's say the loop runs for 30 seconds. Perhaps your motion menu can begin with a fade-in, and then once 26 seconds or so are up, you would end at a fade out. The sky's the limit, really.

Your custom-made menu will also allow you the option of using text in a more flexible way. There are also more options for the appearance of text on the menu, because you'll be working within your video editing program, which is not as limited as the DVD program.

After you fade into the chosen section of material, for example, you could have the title of your movie materialize and last throughout the 30-second span of the video background. The title could then dematerialize with the fade-out. Maybe you'll also have some words related to the movie appear and disappear, as well, such as the actors' names. Or you could make up some of your own reviews, such as: 'The best birthday video in town.'—*The New York Times*. Once again, your only limitation here is your own imagination!

And what about audio? You can add music and/or voice-over to your customized menu, as well. There may be a particularly alluring track of audio from your movie that you want to use for the menu. Or perhaps there is a great piece of dialogue or monologue that encapsulates your movie (without giving away the ending, of course). Consider anything and everything, no matter how bizarre, to achieve the proper setup and tone for your movie.

Remember, though; you don't want this menu to be an exact chronological sequence from the movie. You want it to be an attention grabber, with some bits and pieces from your movie that will stir the curiosity in your audience without giving away too much.

You can achieve this effect by mixing music with dialogue, or put one over the other. Maybe the colors fade in and out every eight seconds, or maybe they collapse to black and white. However you want to do it is up to you. It's your movie and your DVD menu. Have fun with it!

Stills

Of course, if you've had enough of the time-consuming precision of the editing and audio mixing process, you can always use a still image as your DVD menu background and call it a day.

Generating a screen grab from a moment in your movie is one way of going about it. Just scan the footage, pause on a loveable moment (maybe when she blows out the candles), freeze it, and create a still image. You can export this still image from your existing timeline and then simply drop it into your DVD menu.

Or you could go a few steps further by creating another timeline in your movie project. In this timeline, you could line up several screen grabs, cross-dissolving from one to the next. This could make a nice menu, as well, especially if you add a track of audio to it.

Alternatively, you could also just use an existing still photograph—a JPEG, TIFF, or what have you. The most important thing to remember is that the subject of the photo should be a good representation of the content of your movie, as it is the first thing the viewer sees and therefore sets the tone.

Quiet on the Set!

Before dropping in an existing photograph as the background image for your DVD, you must first drop it into the timeline in your DVD editing program. Then select the option called "deinterlace" and export it back out. If you do not take this extra step to deinterlace the photo file, it will appear to jump around and look "jittery" on the television.

Burning Your DVD and Archiving

This is the most dangerous part of movie making, because now you need to light a match and set your DVD on fire.

Just kidding. The process of "burning" a DVD consists simply of writing the digital information of your movie onto the physical medium of the DVD. But the technical aspects are really not important, as almost all computers these days do it automatically at the press of a button. With most computers that come with DVD burners, all you need to do is follow these steps:

- After you've edited your movie to perfection, open iDVD or a similar DVD authoring program. At this point you may choose to design your menu, if you have not already done so.

- Drag the icon representing your movie file into the DVD authoring program.

- Preview everything at least once to make sure that the menus and the movie(s) appear exactly the way you want them to appear on the big screen.

- Insert a blank, writable DVD into the computer while you are still in the DVD authoring program.

- Press the "Burn" button.

If your computer has DVD burning capability, then you're that much closer to completing your project. Of course, you may not have a burner on your computer; if that's the case, it shouldn't be too difficult to track down an external burner at your nearest computer store.

> **Quiet on the Set!** _____
>
> Your local computer store offers several different types of blank DVDs for purchase. Some are labeled "+R," some are labeled "-R," along with other variations, as well. The price may vary depending on the brand, whether they come with cases (and what type of cases are included), and so on. Remember that the price is not what's important—it's the type of DVD. Check the specifications on your system to find out which type of DVD you should be burning, to avoid wasting time and money.

If your computer is not compatible with any of the external burners, or if you're just not interested in making the investment, plenty of production houses will take your material and burn copies of your movie for you—for a price, of course. There is a quick way to deliver your product to outside houses like these: capturing your movie onto a digital tape (see the section called "Other Archiving Methods").

DVD Archiving

To keep your edited movie complete and intact so that you may use it again in the future, insert another blank, writable DVD into your computer. Do not open your DVD authoring program to burn an archive DVD. Instead, just drop your movie file (in QuickTime, for example) directly onto the blank DVD icon and click "Burn." Archiving the movie this way allows the file to be burned as the QuickTime file; by comparison, if you were to take the file off a regular DVD that was burned for watching, you would lose such a significant amount of quality that it wouldn't even be worth it to try to reedit the video. With an archive DVD, you can open it at any time in the future, pull off the QuickTime file, and do whatever you wish—reedit, burn additional copies, and so on, without compromising the quality of the video.

Archiving a video file like this is also a good way to transport the work to a production/DVD burning house to make a large amount of copies, and a great way to save a draft that you may wish to recut in the future without using up storage space on your computer.

Other Archiving Methods

Another way to archive or transport footage is to export the completely edited movie back out onto a digital tape. (This is a process known as "Print to Tape" on editing programs such as Final Cut Pro.) Your video camcorder, set in VCR mode, can capture the edited footage through a FireWire, as well.

Using a transfer-to-tape form of archiving provides an even more pure form of archiving (as compared to the QuickTime archive on a DVD) because the tape captures the full quality of the movie in its uncompressed form. Keep in mind, however, that you don't want to use tape as your sole method of archive, because tape is more susceptible to moisture, changes in weather, and other climate considerations, and therefore deteriorates quicker than DVDs do. So it's a good idea to have both types of archives as your backup when you've put a lot of time and effort into making a digital movie.

Space and Quality

Writable DVDs have a limited amount of room on them. On average, you can burn a movie of approximately an hour without any significant loss of quality onto a standard DVD. If your movie is two hours long or more, you can still burn it to DVD, but you will lose some quality. It's just something to keep in mind when editing and selecting the video mode you will burn in. These modes are:

◆ **Fine:** This mode can accommodate 60 minutes of run time without compromising any quality.

◆ **Standard play (SP):** This mode accommodates up to 120 minutes of run time with some loss of quality, but not enough to be readily apparent to the viewer.

◆ **Long play (LP):** This mode accommodates 240 minutes of run time. In this mode, some loss of picture quality can be expected.

Creating your DVD and making sure to archive properly can be just as important as the actual shooting and editing stages of your movie. You don't want all of your hard work to be lost in time, or to be presented in a sloppy way to your audience.

This is show business, after all. Give some thought to your showmanship!

The Least You Need to Know

◆ DVD menus don't just provide a way for your audience to navigate around the DVD; they can also set just the right mood and tone to begin the viewing experience.

◆ Menus can be simple or complicated; pregenerated or customized; long or short.

◆ Archiving is an essential part of the moviemaking process—if your movie is archived properly, it can be reedited in the future and additional copies can be burned without any significant loss of quality.

Presenting Your Video

In This Chapter

- The right way to present your video to an audience
- Preparing your video for the Internet
- Sharing your video with the world

This is the moment you've been waiting for. All your conceptualizing, planning, and hard work has come down to this: the freshly burned DVD you're holding.

But what can you do with it? We all know that you didn't do all this work just to watch your digital video once and put it on the shelf. You want to share your talents with an audience, but who? And what's the best way to go about it?

Sharing It with the World

The way you present your video will depend on your intended audience. For example, if you need to run a presentation for a small group of investors or businessmen, you better show up with a presentation kit packed in a handsome luggage on wheels that contains not only your DVD player but a small, portable digital projector as well. If that happens only once a year,

you're better off renting the digital projector. However, if you are a traveling salesperson who does these presentations for a living, you may want to buy these presentation units.

An important consideration in using a digital projector is what to do with the sound. Practically all projectors have their own built-in loudspeakers but, placed away from the wall or screen, the audio will be muffled by the projector's own noise. A better solution is to set up a pair of portable loudspeakers right under the projected picture. This setup will reproduce better sound and psychologically will be closer to the experience of watching a movie or television.

Presentations for Individuals and Small Groups

This is a no-brainer, right? You invite a few friends or family members over to watch the unveiling of your new movie on video. Well, yes—but make it special. Remember, you put a lot of work into every aspect of your creation, from choosing just the right title fonts to the perfect music. You had one of your actors dub her lines in several times because an airplane flying overhead ruined the sound in one spot. It even took you two days to perfect the DVD menu, because you wanted to start out your video with just the right theme.

So how do you get your audience's attention from the beginning? Don't just throw your video on the television during your next get-together. Instead, how about sending out invitations to movie night? Pop lots of fresh popcorn and have ice-cold soda ready. And the finishing touch, of course—dim the lights. Creating the right atmosphere can make all the difference in presenting your digital video. Also make sure that your TV set is calibrated to show true colors.

Presentations for Large Groups

Let's face it. We all dream of a lavish red-carpet event, the premiere of our first films. But does the digital video you made really rate up there with the lights flashing and the press?

Maybe not ... at least, not yet. But why let that stop you? Think about it. Even if your digital video is just a simple piece commemorating the anniversary of a happy couple you know, wouldn't it make their day to have a screening with all their family and friends, with their names on the marquee?

Don't wait for a producer to pick up your video. Make your own movie premiere anywhere you choose, and invite whomever you want. How do you do it? It's actually pretty simple:

- Check with the management of a local movie theater. If they have the equipment to project a DVD video, you might be able to rent out the theater for a nominal fee.

- See if the independent theaters nearby are willing to support the arts.

- Gather together a group of digital moviemakers and create your own festival screening at a local venue.

- Check whether the local cable TV provider has a public access channel. You can book a special a month ahead, and then e-mail people or send out flyers to let your audience know when you will present your video. Even if your cable system does not have a public access channel, they may still consider running your show.

And now that you've finished presenting your work to a limited number of people, you may want to consider ways of distributing it to an unlimited number. The best way to do this, of course, is on the Internet.

Putting Your Video on the Internet

The greatest explosion in the world of digital video has taken place in the area of Internet applications. And while all are relatively easy to use, some allow you to share your video without burning a DVD at all.

Software Applications

If you decide to *stream* your video on the Internet, you first need to understand how to use a codec for decreasing the size of your files. Most movie files are simply too large for the web and would take too long both to upload or download. For this reason, it's important to determine the best way to reduce the file size.

In addition to the download time, many servers that stream videos only allow small

def•i•ni•tion

Streaming on the web means continuous partial downloading; that is, the receiver starts looking at the file even before it has been downloaded in its entirety. The file downloads while it is being watched, saving the viewer from a long wait before watching the video.

sizes free of charge. To avoid paying a fee for larger files, you need to decrease the size of your digital video.

Popular web applications for streaming video files include Apple's QuickTime Player (which is also available for Windows PCs), Windows Media Player, RealNetwork's RealPlayer, and MacroMedia's Flash Player.

Several other software applications are available both on the Mac and on the Windows platform that can encode your files for streaming. They are Macromedia Flash, Cleaner, and Apple's Compressor.

Sample Steps for Encoding on Apple's Compressor

It's actually quite easy to encode a video. Follow these steps for encoding a short (three-minute) video on a Macintosh computer using Final Cut Pro and Apple's Compressor.

- ◆ Open the original file where it was edited in Final Cut Pro. Pull down the File menu, click on "Export" and select "Using Compressor."

- ◆ Selecting the Compressor key opens a menu of different formats (Select Format). To make sure that the file will be small and will play on most computers, select a lower-quality MPEG-1 format with a medium speed bit rate of 1.25 Mbps (Megabytes per second). This is the file transfer speed.

- ◆ That's it. The compression process can then be watched on the Batch Monitor.

The Windows Media Player and the RealVideo Player on Windows PCs also involve only a few similarly simple steps with self-explanatory menus:

- ◆ After clicking the "Windows Media" option, select your settings, then click the "Create Web File" box in the "Make Movie" window.

- ◆ After switching to RealVideo, select your Settings, then create the RealPlayer file. Click "Create Web File" in the "Make Movie" Window.

Upon completion of the process in Apple Compressor, the video can be uploaded to You Send It (www.yousendit.com), a web service where video files can be posted free of charge for a week or for 100 downloads (only by people who receive the password-protected link to the video file). This method allows for quick, if limited, distribution.

In this sample, the video file had to be compressed because the free uploading service is limited to 100MB, and the downloading bandwidth limit is set at 1GB. For a very reasonable $4.99 a month, however, the file size is increased to 2GB for 14 days with a download bandwidth limit of 40GB. As on many websites, the moment you pay, you can begin to traffic larger files.

Receiving Video from the Internet

Large companies often stream a large amount of files to the public. All the major Hollywood studios and giants of the music industry encourage us every day to download their video and music files. Some of these are free because, just like with commercial television, they are advertiser-supported; other services are available for a fee. (Think of the $0.99 song downloading service offered by iTunes.)

Even full-length feature films have become downloadable online from Netflix and BitTorrent, just to name a couple, instead of requiring their customers to make a trip to the video store. Major television series are also available for free "on demand."

Internet TV

All these developments have led to a new type of Internet television, although some of its genres have less obvious names, such as video podcasting, vBlogging, etc. But they all mean basically the same thing: using the Internet for a new type of television service, delivering the videos you want, when you want them, either for free or for a fee.

Currently, the most popular free sites for short pieces are YouTube (www.youtube.com) and MySpace (www.myspace.com). Uploading your short videos to either of these sites practically guarantees you an opportunity to expose your work to thousands and thousands of people. Many of them may even become fans, watching your work time and again, and recommending it to others.

Mobile video networks are springing up every day all over the world, offering us news and entertainment programs, music and TV shows, again for a fee. But you can also use the mobile video networks to make and send your videos from your cell phone to a relative or a friend—or to millions of strangers on YouTube, as well.

Other Uses

The Internet has other possibilities, of course. Have you thought about starting a video blog for your friends and family members? Wouldn't it be a great way to stay in contact and commemorate those fleeting moments in the lives of those you love?

And what about selling your feature-length videos? Try sending them to Amazon.com or even to Yahoo.com, and make them available for a fee only. You may also make money by entering short digital video competitions on the web, or sending your videos to international festivals to compete for prizes. Who knows? You may even be discovered.

We live in an amazing digital world—one that offers unlimited opportunity for creativity, which will only get better with time. But now it's time for you to take this information and apply it to your digital video projects.

See you on the big screen!

The Least You Need to Know

- There are many different ways to present your digital video depending on your intended audience.

- Outputting to the Internet is a simple process and open to anyone.

- Alternative options for presentation provided by digital technologies open up new horizons and "level the playing field."

Glossary of Video Terms

A-roll Video intended for both visuals and audio in a production. Often, A-roll material contains the "main story" and provides audio even when the audience is seeing B-roll material.

AC Alternating current; commonly available electrical power in the United States.

animatics Filmed or taped versions of storyboard drawings or rough animated versions of what a final video will look like.

aperture The opening of a diaphragm that controls amount of light admitted through the lens.

B-roll Alternate or supplementary video footage; B-roll is usually cut in to demonstrate what the A-roll is explaining or narrating.

boom A pole carrying an overhead microphone projected over the set.

CCD Charge-coupled device; a type of image sensor in which the light striking the individual sensor elements produces an electrical charge proportional to the brightness of the light. Those electrical charges are amplified by attached amplifier circuits and converted to digital signals, which are then processed by the camera to reproduce images.

central dramatic question The line of action that drives the movie.

chapters Distinct scenes, which are delineated as specific starting points throughout the movie in a DVD.

chromatic aberration Color shifts in an image caused by the camera's inability to register all three channels of color information, or by faults in the lens. Single-chip video cameras are particularly susceptible to chromatic aberration.

CMOS Complementary metal oxide semiconductor; along with CCD, one of the two main types of image sensors used in digital cameras. CMOS is found in fewer video cameras than is CCD but their application has been increasing in the HDV format.

continuity The process of ensuring consistency within the scenes of a movie.

copyright A document granting exclusive rights; a form of protection provided by the laws of the United States to the creators of dramatic, artistic, and other works.

dB Decibel; a metric unit of measurement, usually in reference to sound.

depth of field (DOF) The distance between the nearest and farthest objects that appear in acceptably sharp focus.

digital zoom Uses digital technology to enlarge an image by magnifying the pixels to give the appearance of zoom at the expense of resolution. *See also* optical zoom.

documentary A film documenting reality using real people and real events.

dolly A camera support which moves smoothly on wheels across the ground or on tracks.

DV Also known as SD, or standard definition; the definition of standard DVD players and televisions.

exposition The introduction of background information about the characters and their circumstances.

eye angle An eye-level shot, usually used to convey neutrality.

f-stop The ratio of the diameter of the opening to the focal length of the lens.

FireWire (IEEE 1394) A type of high-speed cable connection for transferring video and audio data to and from digital devices.

focal length The distance from the center of the lens to the focused image when that image is at infinity (defined as 20 times the focal length or more).

focus Clarity or distinctness of an image rendered by an optical system.

genre Movie types that are characterized by common elements of subject matter, main characters, dramatic situations, and pictorial and musical style and tone.

gobo A light-blocking device, typically used to prevent illumination from a studio light striking a portion of a scene.

GUI Graphical user interface; the collection of windows, buttons, icons, and so on, that appear on your computer monitor when you launch a program.

HD High definition; much higher resolution than standard television sets.

HDV High definition video; a video format intended for the prosumer market for watching and recording high-definition (as opposed to standard definition) videos.

Hertz Abbreviated "Hz," a unit of frequency equal to one cycle per second.

high angle A shot that looks down on the subject(s), usually meant to put the audience in the superior position.

keyframing The act of applying a "mark" within a video frame to indicate the "in" and "out" points for an effect to occur.

key out To select a particular color with your editing software and then "remove" it from the digital image by making it transparent; this is how blue or green screens make actors appear to be somewhere other than the location where the scene was shot.

lavalier A small microphone worn on the body and held in place with a clip or lanyard worn around the neck.

LCD Liquid crystal display; a low-power monitor typically used on a digital camera, computer, or television screen

lens hood An accessory that attaches to the front of a lens to prevent additional light from striking the surface of the lens and causing flare; also known as "lens shade."

logline A summary of a plot in one sentence (typically in 25 words or less).

looping The process of taking a finite amount of sound or video and repeating it digitally for an infinite period of time.

megaHertz Abbreviated "MHz," a unit of frequency that is equal to one million Hertz. *See also* Hertz.

MiniDV A digital tape format that has become one of the standards for consumer and prosumer video production.

microMV The smallest videotape format, it does not use DV format. Instead, it uses MPEG-2 compression, as is used for DVDs and HDV.

motivation The wants, needs, and beliefs behind a particular character's actions that cause him or her to act or react the way he or she does.

MPEG Moving Picture Experts Group; an industry standard for compressing video and audio.

nonlinear editing (NLE) Computer-assisted editing of video without the need to assemble it chronologically.

NTSC National Television Systems Committee format, the video standard format used in the United States. Runs at 29.97 frames per second.

optical zoom Uses the optics of the lens to magnify the size of an image. *See also* digital zoom.

PAL Phase alternating line format, the video standard format used in much of Europe and Asia. Runs at 25 frames per second.

perspective How distant objects are rendered with respect to closer objects.

pixel A colored "dot"; the smallest part of a digitized image.

plot The series of events comprising a story.

preproduction The process of preparing all the elements involved in a digital video, from the writing of the script and scouting locations to the casting and rehearsals of the actors.

previsualization Forming clear images used to focus creative energy on a project; picturing or drawing out how particular scenes will look when they are shot.

production The process of "making" the movie, from setting up equipment to shooting the video.

RAM Random Access Memory. The memory the computer uses to store temporary data while you work on it and before it is written to disk for permanent storage.

release A formal, usually written, agreement that gives the moviemaker permission to use the images of the people who appear in the video.

resolution The number of pixels in an image. The more pixels, the higher the resolution, and therefore the better the picture. *See also* pixel.

S-video A cable connector used to transmit video signal

script breakdown A report that lists all the elements of a scene on a template for better organization of the production.

SD Standard definition, or the definition of ordinary television sets.

SECAM Sequential color with memory format, the video standard format once used in Eastern Europe. This format is being replaced by PAL.

shooting ratio A percentage of how many minutes of video footage are in the final cut of the film, as compared to how much footage was originally shot.

shutter speed A measurement of how long a video camera's shutter remains open.

spherical aberration A lens fault which results in reduced image quality.

Steadicam A video camera mount that provides a smooth shot, even when the camera operator is moving quickly or over a rough surface.

storyboard A series of panels that roughly depict shots and scenes for a digital video.

telephoto lens A lens that makes a subject appear larger on film than a normal lens does at the same distance away from the subject.

T-stop Transmission stop; a measurement of the amount of light that gets through a video camera's lens.

tripod A three-legged video camera support.

video effects Software applications that can alter original video footage.

white balance A calibration function on a video camera to record and display true colors based on a balanced white image.

wide-angle lens A lens that has a wider field of view than a normal lens does; it includes more subject area.

zoom A video camera's ability to change the view so that the subject appears either "near" or "far."

Resources

Books

Baldwin, Paul and John Malone. *The Complete Idiot's Guide to Acting.* Indianapolis: Alpha Books, 2001.

Dancyger, Ken and Jeff Rush. *Alternative Scriptwriting: Successfully Breaking the Rules, Third Edition.* Burlington, MA: Focal Press, 2002

Dancyger, Ken. *The Technique of Film and Video Editing History, Theory and Practice, Fourth Edition.* Burlington, MA: Focal Press, 2006.

Greenberg, Steven. *The Complete Idiot's Guide to Digital Photography.* Indianapolis: Alpha Books, 2005.

Irving, David and Peter Rea. *Producing and Directing the Short Film and Video, Third Edition.* Burlington, MA: Focal Press, 2006

Mamet, David. *On Directing Film.* New York: Penguin Books, 1991.

Press, Skip. *The Complete Idiot's Guide to Screenwriting.* Indianapolis: Alpha Books, 2004.

Steiff, Josef. *The Complete Idiot's Guide to Independent Filmmaking.* Indianapolis: Alpha Books, 2005.

Software

Adobe Premiere: Video production software (www.masterfreelancer.com/wsstore/wec001.html)

Avid DNA Family: Nonlinear editing software family (www.avid.com/products/dna/index.asp)

Character Pro 5: Character-development software (www.masterfreelancer.com/wsstore/wec001.html)

Cinescore: Professional soundtrack creation software (www.sonycreativesoftware.com/products/showproduct.asp?pid=1013)

Dragon NaturallySpeaking Preferred 9: Voice-recognition software (www.digitalriver.com/v2.0-img/operations/scansoft/site/html/dragon/stndrd_9.htm)

Dramatica Pro 4.1: Cinematic creative writing software (www.screenplay.com/products/dpro/index.htm)

EP Budgeting 6: Movie budgeting software (www.writersstore.com/product.php?products_id=1780)

Final Cut Studio 2: Nonlinear editing software and an integrated postproduction studio (www.apple.com/finalcutstudio/)

Final Draft 7: Professional screenwriting software (www.finaldraft.com/products/final-draft/index.php)

FrameForge 3D Studio 2: Real-world previsualization and storyboard software (www.frameforge3d.com)

Gorilla 4: Movie management software (www.junglesoftware.com/home/)

Hollywood ScreenWriter 3.0: Script formatting software (www.screenplay.com/products/hs/index.htm)

i-Listen: Speech dictation software (www.macspeech.com)

Montage 1.2.2: Screenwriting software for Macintosh OSX (www.marinersoftware.com/sitepage.php?page=104)

Movie Forms Pro Interactive: Complete package of movie forms (www.movieforms.com)

Movie Magic Screenwriter: Scriptwriting and formatting software (www.screenplay.com/products/mms/index.htm

Movie Outline: Screenplay outlining and writing software (www.movieoutline.com)

Movie Plan: Investment software (www.movieplan.net)

Production Studio Premium: Postproduction software (www.adobe.com/products/creativesuite/production)

Showbiz Film & TV Contracts: Software for fill-in-the blank forms (www.writersstore.com/product.php?products_id=1464)

Sony Media Software: Professional digital audio production suite (www.sonycreativesoftware.com/default.asp)

StoryBoard Quick 5: Storyboarding software (www.powerproduction.com/quick.html)

StoryView 2.0: Outlining software (www.screenplay.com/products/sv/index.htm)

Truby's Blockbuster: Step-by-step story building software (www.truby.com/software.html)

Vegas 7+DVD Production Suite: Media production toolset (www.sonycreativesoftware.com/products/product.asp?pid=404)

Writer's DreamKit 4.1: Step-by-step fiction writing system (www.screenplay.com/products/wdk/index.htm)

Free Web-Based Software

Celtx: Preproduction media application (www.screenplay.com/products/wdk/index.htm)

Filmmakers Software: Software, downloads, and templates (www.screenplay.com/products/wdk/index.htm)

Digital Video Masterpieces and Technical and Commercial Breakthroughs

This list gives you a sample of some seminal digital video works; it is far from being complete, and certainly you will discover dozens of other examples after reviewing these.

Caouette, Jonathan: *Tarnation*

Figgis, Mike: *Time Code*, *Hotel*

Linklater, Richard: *Waking Life, A Scanner Darkly*

Lucas, George: *Star Wars Episode III: Revenge of the Sith*

Rodriguez, Robert: *Sin City*

Sokurov, Alexander: *Russian Ark*

Vinterberg, Thomas: *The Celebration*

Von Trier, Lars: *Dogville*

Winnick, Gary: *Tadpole*

Sample Contracts and Forms

The contract and forms in this appendix are samples, and are meant for educational use only.

Sample Simple Contract or Deal Memo

Description of and Assignments of Interest of Profits in "TITLE," A Feature-Length Digital Video

Description of the Work

JOHN DOE ("Doe"), doing business as DIGI-VID PRODUCTIONS ("Digi-Vid") for the production and distribution of a feature-length digital video color motion picture tentatively titled "TITLE" ("the film"), shall be its director, co-producer, and editor. The leading actors in the film will be Jane Green, Mike Gray, Tim Silver, Joe Black, Fred Orange, Don White, Emma Brown, Ann Scarlet, Dave Violet, and Adam Blue. The crew will consist of Andy Noise (co-producer, sound), Jennifer See (camera), Steve View (camera), Jack Slate (production), and Sara Tint (makeup).

The tentative budget for the production of the film, exclusive of distribution costs, is $20,000, and Doe agrees to contribute the full amount.

The shooting schedule for the film is on an approximate twelve (12) week period beginning on or around January 1, 2008, in and around Indianapolis, Indiana. The shooting period is expected to last until approximately April 1, 2008, and the editing period thereafter is expected to be approximately three (3) months.

Salaries

The following people shall be paid $1,000 each for their work as actors in the film: Jane Green, Mike Gray, Tim Silver, Joe Black, Fred Orange, Don White, Emma Brown, Ann Scarlet, Dave Violet, and Adam Blue.

Interests

The first moneys received by Digi-Vid for the film will be first applied to payment of all outstanding accounts payable for the production and distribution of the film until paid in full; thereafter, all moneys received by Digi-Vid for the film will be paid by Digi-Vid as follows:

- Director, co-producer, editor (Doe) 40 percent
- Co-producer, sound, supporting actor (Noise) 15 percent
- Production assistant (See) 2 percent
- Production assistant (View) 2 percent
- Production assistant (Slate) 2 percent
- Makeup supervisor (Tint) 2 percent
- Leading actor (Green) 5 percent
- Leading actor (Gray) 4 percent
- Supporting actor (Silver) 4 percent
- Supporting actor (Black) 4 percent
- Supporting actor (Orange) 2 percent
- Supporting actor (White) 2 percent
- Supporting actor (Brown) 2 percent
- Supporting actor (Scarlet) 2 percent
- Supporting actor (Violet) 1 percent
- Supporting actor (Blue) 1 percent
- Points (reserved for contributing bands) 10 percent

All moneys (salaries and percentage points) will be payable to each of the persons set forth in parentheses after each of the positions only in the event each of these persons performs the customary services expected for his/her position through the completion of the production of the film. Any person not providing such services will receive no salary or percentage points, unless otherwise agreed by the producers. Any person, after earning his percentage, may assign all or any part of the same by written notification thereof to Digi-Vid.

By signing this agreement, the parties hereto agreed to all terms and conditions set forth herein on this _____ day of _____, 2007.

Signature_____

Date_____

Sample Cast and Crew Release Form

I accept all the conditions and provisions of the following release form covering my work on the tentatively titled production "TITLE" and which is being produced by Digi-Vid Productions ("Digi-Vid").

Ownership

I assign to Digi-Vid the ownership and all rights to use, exhibit, distribute, assign, license, and otherwise promote the products of my work on the production. I also waive any and all claims to copyright, patent, or other ownership of my work products on the productions.

I agree to keep confidential all written, creative, technical, and financial detail of the production unless authorized or requested by Digi-Vid to disclose such information.

Liability

I indemnify Digi-Vid, the owners of any locations used, and the owners of any uninsured equipment against any claims and demands of personal injury, damage to property, and death resulting from my work on the production. I understand that I am responsible for all necessary personal injury, death, and liability insurances, and am responsible for any damage caused by my actions and by my personal property used during my work on the productions. I accept full responsibility for all personal risks during my work on the production.

Compensation

Unless it is otherwise in writing, I am volunteering my services for the productions and will receive no monetary compensation. I understand that I will receive credit under the following name in the screen credits of the completed production:

Name for Screen Credits_____

Signature_____

Date_____

Sample Location Release Form

Location Release

This permission is in connection with the motion picture tentatively entitled "TITLE," I (we) hereby grant to the production and its successors, assigns, and licensees, the right to photograph, reproduce, and use (either accurately or with such liberties as may be deemed necessary) the exteriors and interiors of the premises located at _____, and to bring personnel and equipment onto the premises and remove same.

Possession of the premises is granted on or about _____, 2007, and may continue until the completion of the proposed scenes and work, estimated to require about _____ days of occupancy over a period of _____ days.

In the event of illness of actors, director, or other essential artists and crew, or weather conditions, or any other occurrence beyond the production's control that prevent the work from beginning on the designated date, or in the event of damaged or imperfect film or equipment, the right to use the premises at a later date to be mutually agreed upon will be granted.

This agreement includes the right to reuse the photography in connection with other motion pictures such as the production, its successors, assigns, and licensees shall elect, and, in connection with the exhibition, advertising, and promotion thereof, in any manner whatsoever and at any time in any part of the world.

The production agrees to hold me (us) free from any claims for damage or injury arising during its occupancy of the premises and arising out of its negligence thereon, and to leave the premises in as good order and condition as when received (reasonable wear and tear, and use herein permitted excepted).

I (we) acknowledge that, in photographing the premises, the production is not in any way depicting or portraying me (us) in the motion picture, either directly or indirectly. I (we) will not assert or maintain against the production any claim of any kind or nature whatsoever, including, without limitation, those based upon invasion of privacy or other civil rights, defamation, libel or slander, in connection with the exercise of the permission herein granted.

I (we) represent that I (we) are the owner(s) and/or authorized representative(s) of the premises, and that I (we) have the authority to grant the production the permission and rights herein granted, and that no one else's permission is required.

Signature_____

Date_____

Index

M

T